PERFECT EXPOSURE

There was a Door to which I found no Key:

There was a Veil past which I could not see:

The Rubaiyyat of Omar Khayyam,

FITZGERALD TRANSLATION

With any luck, there are some keys in this book; and perhaps some veils may be lifted, or rent. At the risk of bathos, the picture is by Roger W. Hicks, using a Nikon F with a 90–180mm/f4.5 Vivitar Series 1, shooting on Kodak Ektachrome 200 film; an incident light reading was taken with a Variosix F meter.

PERFECT EXPOSURE

FROM THEORY TO PRACTICE

ROGER HICKS AND FRANCES SCHULTZ

David & Charles

For M.G.

A DAVID & CHARLES BOOK

First published in the UK in 1999

Reprinted 2000

A catalogue record for this book is available from the British Library.

ISBN 0 7153 0814 9

Book design by Paul Cooper
and printed in Singapore by C.S. Graphics Pte Ltd
for David & Charles
Brunel House Newton Abbot Devon

CONTENTS

THE MISTERIE OF EXPOSURE
INTRODUCTION AND ACKNOWLEDGEMENTS

Learning about exposure is rather like learning about photography – or, for that matter, about life itself. There are three stages. The first stage, once we have ceased to rely on the knowledge and goodwill of others, is bewilderment: everything seems impossibly difficult, or very nearly so. The second stage, after a few consistent successes, is a sort of know-it-all certainty. We cannot see what all the fuss is about. Everything which once seemed so incomprehensible, now seems obvious; we give cocksure advice to anyone who asks. The third stage is when we realise just how little we really do know. At this point, though, we should at least (and at last) know what we need to learn, and where we may have a chance of learning it.

This is why we have used the mediaeval spelling of 'misterie'. It once implied an understanding of a craft or art: there was the 'misterie' of painting, for example, or the 'misterie' of building. These misteries were mixtures of solid theory, rules of thumb, practical guidelines based on experience, and secret signs whereby practitioners of a given misterie might recognise one another and affirm their expertise to those in the know.

Those who have studied the misteries of photography, making the transition from entered apprentice through journeyman to master, inevitably absorb a good number of rules of thumb and practical tips, along with a good deal of jargon which often seems useful only to exclude those knowlessmen who have not served their time. The

TANKARD WITH ASPARAGUS AND ARTICHOKES
In photography, the end pretty much justifies the means; the aim is to get pictures which you (and with any luck, other people) like. This is a studio shot, lit with a single light to camera left. Exposure was determined via an incident light reading (Variosix F) with the dome pointing straight at the camera.
GOLD-TONED CONTACT PRINT FROM GANDOLFI VARIANT 5X7IN, 210MM F/5.6 APO-SIRONAR-N, ILFORD ORTHO PLUS AT EI 25. (RWH)

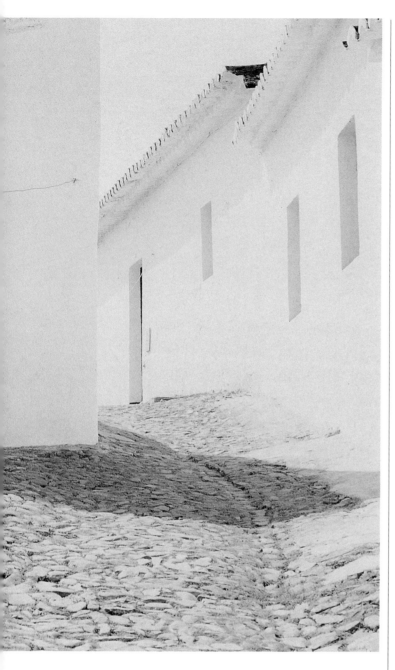

STREET SCENE, MERTOLA
Even the most extreme over-exposure can sometimes work. This was a mistake –
Roger thought he had ISO 100 film in the camera, not Kodak Elite 200 – and in
addition it was deliberately over-exposed by 1 stop (as compared with an incident
light reading using a Variosix F), so the total over-exposure was 2 stops. Even so,
it works.
NIKON F, VIVITAR SERIES 1 35–85MM F/2.8.

Even so, our ambition must always be a picture which is perfect in all respects, including exposure, even if we cannot always achieve that perfection. The principal route to perfection is practice; indeed, as the proverb says, 'Practice makes perfect'.

Informed practice is, however, going to lead us much faster towards perfection than either uninformed practice, otherwise known as blind experiment, or empty practice, where we spend so much time testing different films and developers and techniques that we never take any real pictures. Everyone knows photographers of both kinds, and indeed may have fallen into the same traps themselves, so this is a book about a better way of doing things.

It makes no pretence to being the ultimate text on the subject, but we do believe that it contains more useful information on practical exposure, and on the theory behind practical exposure, than is readily available elsewhere. If you are currently less than happy with your grasp of exposure technique, then using the information in these pages as a supplement to actually taking pictures should result in quite a rapid improvement in that area; and the more you practise, the more you will improve in other areas as well. This brings us back to the theoretical and technical side of things.

METERING FOR DIFFERENT MEDIA

Not only can most 'errors' be used creatively: another major problem is that the criteria for perfect exposures vary widely, according to whether you are shooting colour slide, colour negative, black and white for prints, or black and white for transparencies. Indeed, it is impossible for a single metering program to deliver the best possible quality in all four. To confuse matters still further, one ought to mention cinematography (which receives very little coverage in this book) and the behaviour of Polaroid and similar direct-positive materials (see pages 129–31).

You have to begin by considering the brightness range of the scene in front of the camera. In the 1940s, empirical research determined that the important parts of a 'typical' scene cover a brightness range of about 128:1, or 7 stops. Although this research has never been bettered, individual scenes can vary enormously from this average, and all kinds of cautions and caveats need to be entered. We shall return to these throughout the book, but meanwhile let's just accept that 128:1 range, and look at how it can be recorded using different photographic media.

MONOCHROME TRANSPARENCIES

Black and white transparencies can, in theory, represent the

PUTTING EXPOSURE IN CONTEXT

It is all too easy to forget that exposure is only one link in the chain that eventually connects the original subject to the final viewer – and not necessarily the most important at that. For many pictures, such as family snapshots or hard news or exotic locations, the most important single factor is the subject matter: a proud grandparent will overlook technical shortcomings in the first picture of a new grandchild, and no editor is going to reject a picture of a flying saucer landing in Times Square simply because it is badly exposed. And aesthetically, composition must stand at least alongside exposure; better (in most cases) a superbly composed but technically imperfect shot, than one which is technically perfect but which has neither content nor pleasing composition.

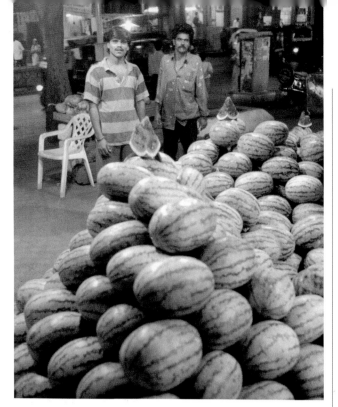

MELONS, MULUND
For difficult lighting conditions – and night shots in the Bombay suburb of Mulund are difficult – the safest bet is fast colour negative film, with exposure that errs on the generous side.
LEICA M2, 35MM F/1.4 SUMMILUX, KODAK ROYAL GOLD 1000 AT EI 800, INCIDENT LIGHT READING WITH GOSSEN VARIOSIX F. (RWH)

very widest range of tones. Depending on the film and the processing, the clearest highlights can transmit ten thousand times as much light as the deepest blacks, and maybe even more. In practice, the usable range is much less than this, for two reasons.

One is that even if the film can hold this sort of brightness range, we are likely to be dazzled by the brightest highlights long before we could cease to find detail in the shadows. It is, however, entirely feasible, with the right film, to sustain a brightness range of around 1,000:1, and quite possibly more, so we can fairly easily hold both highlights and shadows for a subject with a brightness range of 128:1.

The second reason is the question of 'the right film'. Most modern monochrome transparencies are produced via reversal processing, and in practice it is quite difficult (though not impossible) to achieve a density range in the transparency of much more than 100:1, especially with home-processed slides from negative films.

Even so, transparencies typically demonstrate tremendous subtlety in both highlights and shadows, with strong tonal differentiation in the mid-tones, so they have a unique charm of their own.

HESKETH V1000
The inherent tonal range of a motorcycle – from deep black paint and dull black tyres to gleaming chrome – is considerable. If you are willing to print on a slightly soft grade of paper there is, however, no real need to increase exposure and cut development, provided you get the exposure right to begin with. This means giving enough exposure to get some detail in the wheels and black areas.
LEICA M2, 90MM F/2 SUMMICRON, ILFORD FP4 RATED AT EI 80, INCIDENT LIGHT READING WITH LUNASIX. (RWH)

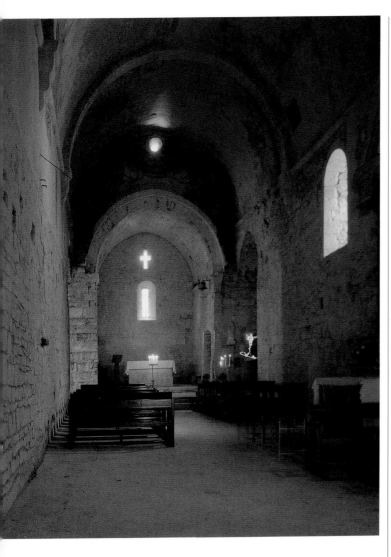

CHURCH, SOUTH OF FRANCE
Some Polaroid films suffer badly from reciprocity failure. The metered exposure (incident light at several locations within the church, using a Gossen Variosix F) was 1 minute at f/22, but the actual exposure was 5 minutes at the same aperture.
TOHO FC45A, 120MM F/6.8 ANGULON, POLAROID SEPIA ISO 200. (RWH)

MONOCHROME NEG/POS PROCESSES

Many monochrome negative films can record a very wide range of subject brightnesses on a one-to-one basis. In other words, you can record a subject brightness range of 1,000:1 or more, with a negative density range which is similar. If you are willing to forego the 1:1 relationship, you can record an even wider range, as much as 10,000:1 or more.

The problem in making a black and white print, however, is that the paper has nothing like this tonal range. With modern, glossy papers, the brightest paper-base white reflects about 150 times as much light as the deepest possible black; in other words, the brightness range is 150:1, a log reflection density range of 2.17. Toning may increase this slightly: a density range of 2.3, which is a brightness range of 200:1, is achievable with some papers.

In a well made glossy print, the range from the lightest tone in the print to the deepest shadow is not normally quite this great, but it is typically 100:1 or better. This is close enough to 128:1 that it is not worth worrying about – the actual difference between 100:1 and 128:1 is about ⅓ stop. Admittedly, the relationship between the tones in the subject and the tones in the print will not be one-to-one – this is discussed in much greater detail in Chapter 4 – but the proportionality can be made to look entirely acceptable.

In practice, therefore, it is quite possible to over-expose a negative film by quite a considerable extent, certainly by 2 or 3 stops, and still to get a print which most people would regard as excellent.

Minimal exposure and the 'first excellent print'

When L.A. Jones and H.R. Condit of the Kodak research laboratories did their magnificent research on exposure in the 1940s, the criterion they used was the 'first excellent print'. Prints made from negatives with a wide range of exposures were shown to large numbers of people, and they were asked to choose the first really good print – or to be more accurate, the one which marked the turning point between the ones that weren't very good, and the ones which were substantially indistinguishable from one another.

Because they were dealing with contact prints, the penalties for over-exposure were not great. Essentially, the main differences were that shadow differentiation differed slightly between the 'first excellent print' and subsequent excellent prints, and that contact printing took longer.

Even so, the advantages of minimal exposure – the negative which gave the 'first excellent print' – were significant. A negative with less exposure allows a smaller aperture for greater depth of field, or a shorter shutter speed for better action stopping, or both.

If you want to make enlargements, the advantages are even greater. First, over-exposure increases grain. Second, over-exposure decreases sharpness. Both of these factors can be significant with roll film, and are of considerable importance with 35mm and smaller formats. Third, it is possible to make entirely acceptable contact prints from negatives which are wildly over-exposed: far too dense, in fact, ever to allow projection printing.

SPICE MARKET, ISTANBUL

Metering in a bazaar is always demanding, because lighting varies from uncorrected fluorescents to tungsten to oil lamps to daylight. The exposure here was based on a spot skin-tone reading from the man on the left, plus ⅔ stop to reduce the greenish cast from the fluorescents; over-exposure with greenish fluorescents almost always looks better than under-exposure.

LEICA M2, 35MM F/1.4 SUMMILUX, FUJI RSP RATED AT EI 2500 AND PROCESSED AS FOR EI 3200, MINOLTA SPOTMETER F. (RWH)

It is, however, worth remembering that if you are prepared to sacrifice some sharpness and fineness of grain, you can over-expose by anything up to a stop, or sometimes more, and still get negatives which can be satisfactorily enlarged, even if they are somewhat dense; and if you intend to make contact prints, you can over-expose by a couple of stops or more and still get excellent prints. Contact printing on POP has the additional advantage that POP is self-masking, so contrast does not matter much either, as long as there is plenty of it. There is more about this in Chapter 13.

Original pictures and reproductions

A very important point, which needs to be made here, is that in a photographic book or magazine it is impossible to reproduce perfectly the full range of subtleties which can be seen in an original picture, whether it be a transparency or a high-quality print.

Sometimes, it is true, an indifferent print can look better in reproduction than it has any right to do, with the copy better than the original, but a really good picture will almost always have a greater tonal range and better tonal differentiation than is feasible in reproduction. This is why it is very important to go to original exhibitions as often as possible, so that you can see what really good pictures look like.

COLOUR TRANSPARENCIES

The image in a colour transparency is made up of dyes, and the maximum density is unlikely to be as great as the density of a silver image; but the distinction is more theoretical than practical, and a log density range of 3.0 (1,000:1) is both readily achievable and more than adequate for all practical purposes. The maximum density of transparency films in general has gone up enormously over the years, though modern density measurements of old transparencies can be misleading because of density losses over time.

The problem is that colours are represented satisfactorily over a far smaller range, typically 5 stops at most: a range of 32:1. Shadows which are more than 2 or 3 stops darker than a mid-tone will be represented as shades of grey; and although white highlights can be held with extraordinary subtlety over a very wide range, coloured areas which are more than a stop or two brighter than a mid-tone will be represented as shades of yellow, before they burn out completely. While most people can live with shadows which hold little detail, without real colour, large areas of sickly yellow or clear film are rarely acceptable.

FLOWERS

This is a studio shot; the flowers are backlit by a single snooted flash head. The three exposures are each 1 stop apart, and all three 'work', even on the contrasty Fuji Velvia film used – but each has a different feeling to it. The left-hand exposure is the metered version: a spot reading of the petals on the upper right quadrant of the right-hand flower.

NIKON F, VIVITAR SERIES 1 90–180MM F/4.5, SPOT MASTER 2. (RWH)

This radically affects our metering. With black and white, we can normally afford to expose for the shadows, secure in the knowledge that we can represent a long tonal range. This ability to record 7 stops or more means that we are unlikely to have big areas of burned-out highlights. If we are shooting colour slides, on the other hand, we have to expose principally with a view to the highlights, which otherwise will burn out to nothing.

Perhaps needless to say, most 'professional' automatic cameras are set to give the best possible exposure (which will not necessarily be perfect, remember) with colour slides. They may even give a fair proportion of perfect exposures, provided the photographer has no particular wish to create a different mood by increasing or decreasing the overall exposure, and if the subject is not too far out of the ordinary.

With black and white, however, the best that automation will normally give is adequate exposures, though doubling the exposure (halving the exposure index) should significantly increase the number of perfect exposures for subjects of normal contrast. Of course, film speeds are determined in a way that takes account of these differences, but they can only do so on an overall, general sort of basis; they cannot allow for much refinement.

COLOUR NEGATIVES

Like monochrome negative films, colour negative films can record a very wide range of subject brightness; and rather surprisingly, they can also record colours across that very wide range. The problem is that as soon as you make a print (or a transparency, for that matter) from the negative, you are back to the same situation as already described for original transparencies: you can hold colour across only a relatively limited range.

The intriguing thing is that you can take your limited-range print from pretty much anywhere on the wide-range negative. Film speeds are defined in a way which precludes anything more than minimal under-exposure (½ stop, or 1 stop at most) but over-exposure can go a long way before it becomes a major problem: typically 2 or 3 stops, sometimes even more. This is how 'multi-speed' films work: a film with an ISO speed of 800 can be rated ⅔ stop under (EI 1250) or as much as 3 stops over (EI 100) without too much loss of quality. A conventional ISO 200 film can equally well be rated at anything from EI 50 or less to about EI 320, without great loss of quality.

As with conventional monochrome negative films, sharpness will deteriorate with anything more than modest over-exposure, but because the image is composed of dye rather than silver, grain will actually become finer. Many regard the loss of sharpness as a fair trade-off for finer grain, so rating (for example) an ISO 160 film at EI 100 is a common professional trick.

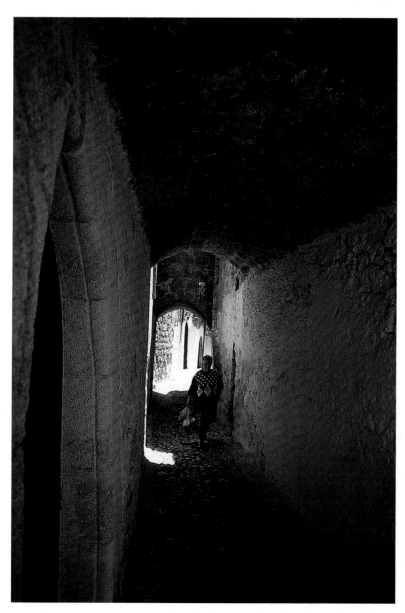

ALLEY, RHODES OLD TOWN
This is hardly a fair way to test a film, because it is a long way from a 'standard' subject. It is, however, a good test of latitude. This was, believe it or not, Kodachrome 25, with a guessed exposure; from memory, 1/30 second at f/1.4. When you shoot a lot of a particular film (and Roger is very fond of Kodachrome 25), you often find that you can guess exposures with surprising accuracy.
LEICA M2, 35MM F/1.4 SUMMILUX)

NEW YORK
Fortepan 200 has a wonderfully vintage tonality and grain which seems to complement New York perfectly; this was shot from the top of the Empire State Building. Exposure was based on an incident light reading with a Sixtomat Digital, with the film rated at EI 125.
LEICA M2, 35MM F/1.4 SUMMILUX. (FES)

This means that for colour negatives, metering is pretty uncritical, and that even a crude auto-exposure program will work adequately. Indeed, you can get away with no metering at all (and a fixed shutter speed, and no diaphragm control), provided all your errors are likely to be on the side of over-exposure. This is how single-use cameras, the modern descendants of the box camera, work.

CINEMATOGRAPHY

Unlike a conventional print, where the eye has time to explore the tonal nuances of a picture, cinematography is a moving target. Because the eye is always attracted first to highlights, it is to these that exposure is normally pegged. This is true in monochrome as well as in colour. Of course, a shot which is held for a very long time, with little or no subject movement, is more akin to a projected colour slide.

DIRECT POSITIVE PRINTS

Pos/neg processes allow a degree of latitude, in that you can choose to extract differing amounts of information from the negative. By choosing different grades of paper, and varying printing time, you can achieve a range of different effects.

FAMILY SNAPSHOT

This is, by any objective standard, a pretty bad picture. But it is the last picture of Frances's parents on the day they left Guadalupe, where we had all lived for five years; and it is the last picture of the four of us together before Artie (her father) died. At this point, content is more important than composition or exposure.

LEICA M2, 35MM F/1.4 SUMMILUX, ILFORD XP2 AT EI 250, SELF-TIMER, INCIDENT LIGHT READING WITH LUNAPRO F.

Direct positive prints, whether monochrome or colour, do not allow this degree of freedom. In this respect, they are more like transparencies: the biggest risk is an excess of over-bright highlights, so exposure needs to be determined according to the highlights, not the shadows.

Also, a monochrome direct positive cannot encompass the same tonal range as a monochrome transparency, and indeed its range is so limited that many photographers are quite happy to use monochrome Polaroids to give a good idea of the optimum exposure for colour transparencies. Colour Polaroids are a very good guide indeed to the response of most colour transparency materials.

PHOTOGRAPHIC DYSLEXIA

The differences between transparencies, negatives and direct positives are a good example of the way in which all too often in exposure we have to think 'backwards'. The logic is not difficult: it is just holding the ideas in your head that can be a problem. This is what we have called 'photographic dyslexia'.

It begins when you first take up photography, and find that a bigger lens opening means a smaller number, so that f/2 is bigger than f/5.6. Thereafter, it does not necessarily become any more obvious. An over-exposed slide is too light, which is pretty much intuitive. An over-exposed negative is too dark, and that is really not much of a problem either – but you can also make an over-exposed print from an over-exposed negative.

A much more reliable guide than an individual print is a contact sheet, where you can see that correctly exposed negatives produce correctly exposed prints, while under-

RDORJE SEMS.DPA
If your aim is a lith derivative or something similar, exposure is not very critical –
and as sharpness and grain are not important, you can afford to err on the side of
over-exposure. This was shot on Fuji Reala colour negative film, over-exposed by
⅔ stop.
NIKON F, 90–180MM F/4.5, VIVITAR SERIES 1, INCIDENT LIGHT READING WITH VARIOSIX F. (RWH)

THE FLIGHT OF THE BUMBLE-BEE

At this point, it may seem that exposure determination is much like the famed aerodynamics of the bumble-bee, which is widely reputed to be unable to fly, at least when considered theoretically.

The answer is of course that the bumble-bee can fly, just as exposure determination is feasible. You do need to take account of quite a number of variables, but you do not need to be overwhelmed by them.

Inevitably, you have to over-simplify to some extent: you just cannot take all the possible variables into account, and it is a grievous mistake to imagine that you can. It is quite possible to simplify everything to a point which is readily handled intellectually, and which with practice allows an almost instinctive control – a process often known as internalisation.

Even so, you still have to keep an awful lot of things in mind simultaneously. You have to think about the final picture; about the negative (where appropriate); about the subject and how it is lit; about the metering technique; and (above all) about the effect you want to achieve in the final picture. This last is particularly important, and brings us back to the point made at the beginning of the chapter about what constitutes a 'perfect' image.

Ansel Adams coined the unhappy word 'previsualisation', the first syllable of which is redundant. The word you need is 'visualisation', no more and no less, and the meaning of the word is pretty simple at that. It means that before you take the picture, you ought to have in mind the result that you want. This may sound obvious, but to be honest: how often do you just shoot, and hope it will come out? We do.

Some people can see the picture in their mind's eye, but are unable to describe it. Others can describe it, even if they cannot genuinely visualise it. Yet others will need to adopt a somewhat mechanistic path, describing to themselves what they want and working out how to achieve it.

The first path cannot, by definition, be put into words. The second might work like this: 'Warm colours, desaturated, maybe a bit fuzzy, sunset, shimmering haze... .' And the third might say, 'Well, I want to be able to render *this* highlight convincingly, and *that* shadow; how do I do it?'

Our intention in this book is to describe in words and with pictures the ways in which you can achieve different effects. We freely admit that there are better photographers in the world, and that some of our photographs are of more use as examples than as inspiration; but we hope that in conjunction with the text, they will shed some light on a difficult and complex subject. Before we go on to look at the numerous different aspects of exposure, therefore, we need to look at a few more basic definitions.

exposed negatives produce over-exposed (dark) prints and over-exposed negatives produce under-exposed (light) prints. With neg/pos printing, you need to train yourself to think of the whole process, so that over-exposure gives you light final pictures, and under-exposure gives you dark ones.

Another piece of mental gymnastics which can all too easily trip you up is film speed adjustments. If your images are normally *over*-exposed, you need in future to *reduce* the diaphragm opening or use a *shorter* shutter speed – concepts which most people have no difficulty in handling – or to *increase* the film speed setting on your meter, because a faster film needs less light and the meter will therefore recommend *less* exposure. Adapting to the idea that you actually have to increase film speed in order to reduce exposure readings is not something which comes naturally to most people, including us.

By the same token, of course, if your images are normally *under*-exposed, you need in future to *increase* the diaphragm opening or use a *longer* shutter speed, or to *decrease* the film speed setting on your meter, because a slower film needs more light and the meter will, therefore, recommend *more* exposure.

Ultimately, you could say, it's as simple as the last two paragraphs; and indeed, if you shoot enough film, and pay any attention at all to your results, you can refine your exposure by a simple process of trial and error. There are, however, two reasons for going into the subject more deeply: first, to save time and money – it's always easier to understand the practice if you already understand the theory – and second, out of sheer intellectual curiosity.

THE CHARACTERISTIC CURVE

If you really want to understand the theory of exposure (which makes the practice of exposure a lot easier), then the first thing you need to understand is the D/log E curve. This is the basis of all sensitometry, and it is also known as the characteristic curve and as the H&D curve.

It is called a D/log E curve because it is a graph of density (D – the darkening of the film) plotted against the logarithm (log) of the exposure (E). It is also known as a characteristic curve because it concisely summarises the characteristics of a particular film/developer combination, at a particular time and temperature. And it is known as an H&D curve in tribute to Ferdinand Hurter (a Swiss) and Vero C. Driffield (a Briton), who in 1890 originated the whole science of

STILL LIFE WITH DEAD BIRD
Mme Muscat's pet cat came out ahead in a contest with her pet bird; her daughter, Marie Muscat-King, wanted to photograph it before they buried it. She had no lighting equipment with her, no particularly suitable lenses, and no slide film. So she arranged a still life – for which the term *nature morte* was particularly appropriate – and photographed it by natural light, giving just enough exposure to hold the light plumage.

NIKKORMAT FTN, 135MM F/2.3 VIVITAR SERIES 1, AGFA COLOUR NEGATIVE FILM AT ITS RATED SPEED OF ISO 200, INCIDENT LIGHT READING WITH WESTON EUROMASTER.

photographic sensitometry. Their notebooks, intriguingly, are preserved in the Royal Photographic Society library.

The principle is simple enough: film is affected by light. The D/log E curve tells you how – but before we go in to this, it is worth pointing out that understanding the D/log E curve is a very different matter from trying to reproduce the sensitometry involved for yourself. In order to get reliable results, you need a standardised white light source, and a densitometer, and some experience in using it. You also need a developer of known activity and freshness, preferably checked against test strips exposed under known, constant conditions. Even if you could muster all this, there is the fundamental question of why you would want to bother.

Photography is as empirical as anything gets, and the golden rule is, 'What works for you, works for you'. A great deal of the testing which is carried out by amateur photographers (and even by some professionals) is a clear example of 'pseudo-precision'. The results that many people get are not particularly meaningful, for three reasons. First, most people have a shaky grasp of experimental procedure. Second, the test conditions are rarely fully standardised. Third, the real world rarely corresponds to the test conditions.

We shall return in due course to meaningful (and usually easy) tests which you can do yourself, but as mentioned elsewhere, it can be all too easy to get so caught up in 'testing' that you lose sight of taking pictures. On the other hand, testing really can help, as long as you understand the theory behind what you are doing – which itself involves understanding the numerous approximations, averages and general fudges which are built into film speeds and meters, and which are covered more thoroughly in Chapter 6.

SOUGIA GORGE
A picture like this is a demanding test of film and exposure, as you want shadow detail without losing colour saturation. In practice, some shadow detail had to be abandoned; the exposure given was ⅓ stop more than recommended by an incident light reading in full sun, cross-checked with a spot meter reading of the underside of the overhang. Fortunately, the sky was at its maximum blue in front of the camera.

LEICA M4P, 35MM F/1.4 SUMMILUX, VARIOSIX F. FUJI SENSIA ISO 100. (RWH)

INTERPRETING THE D/LOG E CURVE

Look at the D/log E curve below, and at how the exposure (log E) relates to the density (D). There is always some density in any processed film, due to the light absorbed by the film base itself and to the 'fog' which appears even in unexposed film when it is developed. This is sometimes referred to as the D_{min} or minimum density of the film, or as 'fb+f', short for 'film base plus fog', as described on page 23.

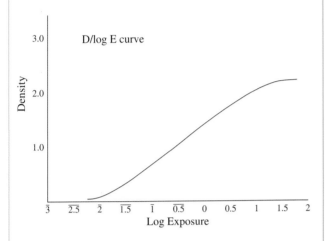

At first, exposure has no effect: not enough light reaches the film to affect it. Then comes the threshold, the first point at which the light begins to register. The curve begins to rise, but slowly at first: quite large increases in exposure result in relatively small increases in density. This is the 'toe' of the curve, where the darkest part of the subject is recorded: in normal parlance, the 'shadows', though of course it may just be dark areas.

Sooner or later, the relationship between exposure and density becomes more or less linear: for a given increase in exposure of (say) ⅓ stop, there will be a constant increase in density. This, logically enough, is known as the 'straight-line portion' of the curve.

Eventually, the curve begins to flatten out again: this is the area known as the 'shoulder'. More and more light is required to achieve a given increase in density. Sooner or later, the curve levels off: no matter how much light you pour on, there will be no increase in density. This is the maximum density or D_{max}. With extreme over-exposure, the density may even begin to decline again: this is called solarisation, because it was first seen when an image of the sun appeared on a negative as a clear spot rather than as a black one. This effect is sometimes qualified as 'true' solarisation, in order to distinguish it from pseudo-solarisation (the Sabattier effect), which is achieved quite differently.

Thus far, the D/log E curve is familiar and comprehensible; but we can learn a lot more from it than this mere description. First, there is the question of the units along the side. One axis is density – by definition, a logarithmic progression which expresses ratios only, without specific units – and the other is the logarithm of the exposure, measured in lux-seconds, as described below and opposite.

NUMBER	1	2	3	4	5	6	8	10	20	30	40	50	60	80	100	200	300	400	500	600	800	1,000
LOGARITHM	0.0	0.3	0.5	0.6	0.7	0.8	0.9	1.0	1.3	1.5	1.6	1.7	1.8	1.9	2.0	2.3	2.5	2.6	2.7	2.8	2.9	3.0

LAMP SHOP, MARGATE

Polaroid Sepia film has a long, gentle slope to its characteristic curve which enables it to handle contrasty subjects easily; and 'flat' pictures almost always look better in sepia than in shades of grey. Roger shot this with a Rigby pin-hole camera; exposure was based on an incident light reading with a Lunapro F at the back of the room (the left of the picture).

DENSITY

The density of a negative is quite easily measured with a densitometer. You start off with maximum transmission and then measure how much light is blocked as compared with this. If ¹⁄₁₀ of the light gets through, this is a density of 1.0, because the log of 10 is 1. If ¹⁄₁₀₀ gets through, this is a density of 2.0, because the log of 100 is 2. And if ¹⁄₁₀₀₀ gets through, this is a density of 3.0, because the log of 1,000 is 3.

Working with logs may involve dredging up memories from your schooldays; if you recall, a log is a number expressed as a power, normally of ten. Thus 100 is 10^2, so the log is 2; 1,000 is 10^3, so the log is 3; and (for example) 200 is $10^{2.3}$, so the log is 2.3. Traditional log tables are normally given to four significant figures, but for photographic use two significant figures are adequate. The table in the box above gives logarithms from 0.0 to 3.0 (1 to 1,000).

The important thing about logs is that they make it easy to deal with the way that we actually work in photography. Each 1 stop change in exposure means doubling or halving the exposure, so an 8 stop change means 512x. If we tried to represent this on a linear scale, we would find that the first three stops – 8x – would occupy just 8/512 or ¹⁄₆₄ of the scale.

With a log scale, 512x is a log range of 2.4 and 8x is a log range of 0.7, so the first 3 stops occupy about ⅓ of the scale. This is much easier to follow. The same argument applies to densities.

A densitometer is a highly specialised variety of light meter. 'Maximum transmission' does, however, require a bit of qualification, because if you put no film at all in the gate of the densitometer, the transmission would be 100 per cent. But, of course, the film base has some density, and film base plus developed emulsion – including unexposed but developed emulsion – has still more density or 'fog'.

Even a clear film base absorbs a small amount of light, and film base is often tinted grey to reduce halation; it therefore absorbs up to 1 stop of light (2x absorption, D=0.30, the log of 2). On top of this, fog typically accounts for anything up to ⅔ stop (D < 0.20). These two are combined to give 'film base plus fog' (fb+f), as described in the box opposite. All densities take fb+f as a base line, ie as 100 per cent transmission. This is not unreasonable, as it represents the maximum amount of light that is ever going to get through that particular film, even if a stop or more is being absorbed by the 'clear' areas.

EXPOSURE

Exposure is typically measured in lux-seconds. The scale is

CATHEDRAL, OLD GOA

Ilford XP2 has a fairly gentle slope to its D/log E curve, but a very long density range. Modest under-exposure (½ to 1 stop) is acceptable, and over-exposure of up to 2 stops will result in finer grain but decreased sharpness. This was rated at EI 500, ⅓ stop faster than the ISO speed, based on a Spotmaster 2 reading of the arch overhead, and other spot readings to check the tonal range.

NIKON F, 35MM F/2.8 PC-NIKKOR. (FES)

normally logarithmic, for exactly the same reasons as given for log density units. The characteristic curve is normally plotted across the range of ¹⁄₁₀₀₀ lux-second to 1 lux-second. The bar across the top of the logs reminds you that these are tenths, hundredths and thousandths, and not tens, hundreds and thousands.

Lux-seconds sound fairly forbidding, but actually they are not all that hard to understand. Another name is the metre-candela-second, which gives the game away. The candela is an updated standard candle: for those who are interested, it is defined in terms of a perfectly radiating 'black body' at the melting point of platinum, which has a luminance of 60 candelas per square centimetre.

A metre-candela is the light of one candela at one metre, and a metre-candela-second is what you get when you expose your film to one metre-candela for one second.

CONVERTING LOG DENSITY RANGES

Although photographers normally describe relative brightness in terms of stops or ratios, logs are pretty much essential for understanding sensitometry. The first and easiest thing to remember is that a 1 stop change is a log density change of 0.3, so ⅓ stop is 0.1 and 2 stops is 0.6. You can therefore look at a log density range and convert it into stops, or vice versa, without too much effort and with more than enough accuracy for all practical purposes. For example, 1.8 log units is 6 stops – just divide 1.8 by 0.3 – while 4 stops is 1.2 log units, 4x 0.3.

Converting either set of figures to ratios is pretty much something you learn by rote. The one which is easiest to remember is the 'typical' subject range of 7 stops, 2.1 log density units, 128:1, and you can then work up or down from there. For example, 5 stops (1.5 log density units) is 2 stops

less than 7 stops and is therefore 32:1, while 10 stops (3 log density units) is 3 stops more. From this, with a little mental effort, you calculate 128:1, 256:1 (1 stop more), 512:1 (2 stops more), 1,024:1 (3 stops more) – which is close enough to 1,000:1, the figure that the logs would give you. For convenience, a table is given below, but you should soon find that you rarely need to refer to it.

The observant may have noticed that the ratios are very close to ISO arithmetic film speeds, which makes them easier to remember – like ISO speeds, of course, they are in ⅓ stop rests (actually, the factor between them is the cube root of 2, approximately 1.26). Where we have given two figures, it is because the number is rounded one way for the ratio and the other for the film speeds. Photographically, the differences are trivial.

LOG	0.0	0.1	0.2	0.3	0.4	0.5	0.6	0.7	0.8	0.9	1.0	1.1	1.2	1.3	1.4	1.5
RATIO	1:1	1:1.3	1:1.6	1:2	1:2.6	1:3.2	1:4	1:5	1:7	1:8	1:10	1:12	1:16	1:20	1:25	1:32
STOPS	0	⅓	⅔	1	1⅓	1⅔	2	2⅓	2⅔	3	3⅓	3⅔	4	4⅓	4⅔	5

LOG	1.6	1.7	1.8	1.9	2.0	2.1	2.2	2.3	2.4	2.5	2.6	2.7	2.8	2.9	3.0
RATIO	1:40	1:50	1:64	1:80	1:100	1:128 (125)	1:160	1:200	1:256 (250)	1:320	1:400	1:500	1:640	1:800	1:1,000
STOPS	5⅓	5⅔	6	6⅓	6⅔	7	7⅓	7⅔	8	8⅓	8⅔	9	9⅓	9⅔	10

PENDANT ON VELVET

Black velvet and black flock are often held to be 5 stops down from a mid-tone, but they are not; they are more like 4 stops down, or 4½ if you are lucky, so you need to keep exposure to a minimum if you want a true, deep black. You can of course work 'backwards': exposure determination here was 5 stops less than a spot meter reading off the black flock, though 1 stop less than an incident light reading would have given the same result.

NIKON F, 90–180MM F/4.5 VIVITAR SERIES 1, FUJI ASTIA, SPOT MASTER 2. (FES)

You can see from the curve on page 22 that in order to get over the threshold, most films have to receive something between ¹⁄₁₀₀₀ and ¹⁄₁₀₀ lux-second (log $\overline{3}$.00 to log $\overline{2}$.00). At ¹⁄₁₀₀ lux-second (log $\overline{2}$.00), the toe of the curve should be well under way, and at ¹⁄₁₀ lux-second (log $\overline{1}$.00) the straight-line portion should have started. At around 1 lux-second (log 0.00), density is likely to be quite substantial. Although the straight-line portion may start to peter out around D=1.5,

most go on to 3.0 or 3.5 or even more. For normal negatives intended for enlargement, the maximum usable density is normally well under 2.00; the printable log density range on grade 2 paper is around 1.1 to 1.3, depending on enlarger lens flare, but there is more about this in Chapter 13. Longer density ranges are, however, required for some 'alternative' processes.

SLOPE

Some D/log E curves are steeper than others, obviously enough, and the slope of the curve relates to contrast in an almost intuitive way. With a contrasty film, density builds rapidly with exposure: quite modest increases in log E lead to big increases in D. With a low-contrast film, on the other hand, quite large increases in log E lead only to modest increases in D.

The earliest view of D/log E curves was that the slope of the straight-line portion should be 45 degrees, ie a 1 stop increase in exposure led to a 1 stop increase in density, and that the entire exposure should be on the straight-line portion. For contact prints, this is perfectly acceptable, especially if they are to be printed on printing-out paper (POP), where the self-masking effect controls contrast in a magical way.

For enlargements, though, a gentler slope to the curve is the norm, and here you have the problem of quite how you measure the slope. If it genuinely were straight, this would not be a problem, but it is not straight. You therefore have to take some kind of average slope. The various ways of doing this are given in the box on page 26. As long as you stick with one particular system – gamma, CI or G-bar – the terms can to a large extent be used interchangeably: the higher the number, the steeper the slope. We have used G-bar, which is all but identical to CI. The optimum slope depends on the subject matter; and on what is needed to get the best out of the photographer's materials, equipment and technique; and (perhaps most of all) on the photographer's preference. This is where things can start to look frighteningly technical, but after a while an understanding of slope becomes second nature. Do not worry if you do not immediately understand

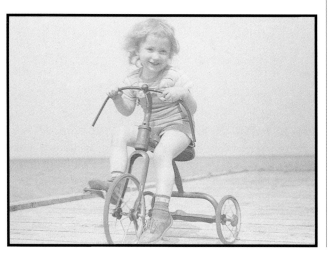

BEACH, GOA

Ansel Adams said that the negative was the score, the print the performance. Arguably, with a transparency, the subject is the score and the slide is the performance. The orchestration is for camera, lens, film and exposure meter, and Frances chose just enough exposure to hold the trunk of the tree without washing out the sky: a reading from the deep blue sky, plus ½ stop extra exposure.

NIKKORMAT FT2, 35MM F/2.8 PC-NIKKOR, SIXTOMAT DIGITAL.

FRANCES ON TRICYCLE

When colour films first became popular – this is an Anscochrome from the late 1940s, taken by Frances's late father – they were often over-exposed because the metering and exposure techniques of the time were biased towards shadow readings. Even when correctly exposed, however, contrast and saturation were modest, and many pictures have faded significantly over the years.

(W.A. SCHULTZ, NO TECHNICAL INFORMATION AVAILABLE)

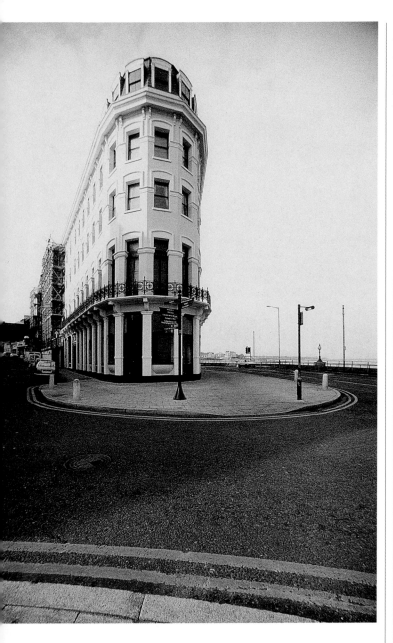

BIGGLES NIGHT CLUB

The shape of a film's characteristic curve is what gives it its tonality, and the tonality of Polaroid instant 35mm films is unique. This is Polagraph, a high-contrast material not intended for general photography which nevertheless is capable of very interesting results. With relatively high-contrast subjects like this, the only rational thing to do is to bracket ½ stop either side of the indicated incident light exposure.

NIKKORMAT FT2, 35MM F/2.8 PC-NIKKOR, INCIDENT LIGHT READING WITH SIXTOMAT DIGITAL. (FES)

MEASURING THE SLOPE

All measures of slope are, in effect, the tangent of the angle of the slope relative to the horizontal axis: the steeper the slope, the higher the number.

The oldest and crudest measure, gamma (γ), relies on a straight line, or upon the best guess at a straight line. Ilford's \bar{G} or G-bar specifies two points on the D/log E curve and draws a line between those, while Kodak's CI or contrast index is calculated with a sort of protractor affair. CI and G-bar are normally so close as to be effectively identical, and both are lower than the gamma figure.

If you are interested, and this paragraph can safely be ignored if you are not, the original G-bar or average gradient was devised by Jones, as in Jones and Condit. It is drawn as a straight line between the point at which the slope of the toe reaches 0.3x the average gradient, and a point 1.50 log units along the horizontal axis. The figure of 1.50 was chosen as representing a brightness range of 32:1, which was taken as the average brightness range of the light hitting the film; which it is, for an 'average' subject brightness range of 128:1 (page 47) and an 'average' flare factor for the 1940s of 4 (page 82).

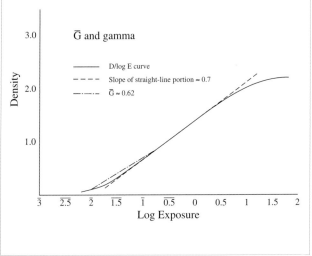

D/LOG E CURVES FOR COLOUR FILMS

A conventional colour film is, at its simplest, made up of three separate emulsions, sensitised to red, green and blue. Each emulsion has its own characteristic curve, and the important thing is that all three should march in step. If they were of different shapes, then colours would vary with exposure. In fact, this can happen with outdated or badly processed film: you get a colour cast in either the highlights or the shadows,

the next two paragraphs. When you need them, you can come back to them, and you will find them a lot easier.

An average sort of G-bar for a negative for enlarging is about 0.62, but a subject with a long brightness range (longer than the 128:1 taken as 'typical') will require a flatter slope (a lower G-bar) if it is all to record in the print. Equally, a subject with a limited tonal range may benefit from a steeper slope (a higher G-bar). Condenser enlargers normally work best with lower-contrast negatives than diffuser or cold-cathode enlargers because of the Callier effect (see page 165).

A subject with a long tonal range, destined to be printed using a point-source condenser enlarger, might print easiest on a normal grade of paper with a G-bar of 0.55 or less, while a subject with a short tonal range, destined to be printed using a cold-cathode enlarger, might benefit from a G-bar of 0.7 or higher; and contact printing (especially with 'alternative' processes) may well call for negatives with a G-bar of 1.0.

but not in both. Suppose, for example, that the shadows were a bit green, but the highlights were neutral. You could correct the shadows by adding magenta to the final image, but although you would then have neutral shadows, you would have magenta highlights.

This is one reason why colour films are more difficult to 'push' or 'pull' (change the speed rating) than monochrome films: the curves get out of step. The other reason is that most colour film processing is highly automated, and changing developer times is very inconvenient.

COLOUR NEGATIVE AND REVERSAL FILMS
Colour negative films normally have long, very straight straight-line portions, while the D/log E curve of a reversal film is normally much more S-shaped and (of course) it runs 'backwards'. In other words, the maximum density occurs at zero exposure, and the minimum density comes with over-exposure.

DEVELOPMENT INHIBITORS
A further factor which is relevant to the D/log E curves of colour films is the use of development inhibitors. If the colour-sensitive layers in a film are not contrasty enough, the resulting image will be dull and desaturated. If they are too contrasty, however, the final image may well look unnatural, like a television with the colours turned up too far. An additional problem is that when one layer of the film is exposed to a pure colour – blue, say – the other layers are also affected, to a lesser extent, and this leads to an inevitable degradation of colours. The same is true for all colours.

It is, however, possible to build the dye precursors so that as they develop, they release chemicals which inhibit development. This allows reduced contrast with improved saturation, and also inhibits development of other layers (the inhibitors diffuse through the emulsion) so that colours are purer. These inhibitors are why modern films can be made so much more saturated and contrasty than they used to be, without being garish in the way that the old Orwo emulsions were in the 1970s. Development inhibitors appeared first in colour

ISLANDS, GREECE
A common piece of advice with distant, hazy subjects is to include some foreground so as to give 'bite' and depth. As is clear from these two pictures, though, foreground and background can each detract from the other; the picture which has no foreground, entirely on the toe of the curve (it is a transparency, remember) is more successful.
LEICA M2, 35MM F/1.4 SUMMILUX, KODAK ELITE 200, VARIOSIX F. (RWH)

negative films but are now increasingly common in transparency films as well.

A refinement of this trick, introduced by Fuji with Reala colour negative film, is adding a cyan-sensitive layer to the conventional red-/green-/blue-sensitive layers. The interaction of this layer with the other layers during development improves red/green differentiation and lowers contrast while retaining colour saturation.

CHANGING THE SHAPE AND SLOPE OF THE D/LOG E CURVE
The basic shape of the D/log E curve is inherent in the material, but the emulsion designer can do a great deal to affect the shape, with long or short toes, more or less

MISTY ROAD
Exposure on a misty day is astonishingly critical. At ½ stop more than this exposure (which was based on an incident light reading), the colour saturation was weak and lacklustre; at ½ stop less, the whole scene was unpleasantly murky. This is to a large extent a consequence of the strong S-shape of the characteristic curve of a reversal film, which means that tonal separation is best in the mid-tones.
GANDOLFI VARIANT WITH MPP 6X9CM ROLL-FILM BACK, 150MM F/4.5 APO-LANTHAR, FUJI PROVIA, LUNASIX. (FES)

HAND-COLOURING PALETTE

Velvia is a superb and unmatched film; but this is not the same as a universal film. In the studio, lighting ratios must be tight and exposure control precise – fall-off is clearly visible in this shot – and it would be a brave, or more usually foolish, photographer who used Velvia outside on a sunny day.

LINHOF TECHNIKA 70, 100MM F/5.6 APO-SYMMAR, VELVIA RATED AT EI 32, INCIDENT LIGHT READING WITH VARIOSIX F. (RWH)

straightness in the straight-line portion, and more or less shoulder. In some cases, there is really no straight-line portion at all, just an S-shape as the toe changes to the shoulder. It is also quite possible to put distinct kinks or bends into the straight-line portion, typically by blending two or more emulsions with different characteristics or by coating them separately as a bipack.

Modern 'high-tech' films mostly employ monosize crystals – that is, crystals which are very similar in size – unlike the older emulsions, which have a mixture of crystals of different sizes: the bigger the largest crystals, the faster the film and the bigger the grain. Monosize crystals are much more efficient, and give a better speed/grain ratio, but unsurprisingly they also tend to be of fairly uniform sensitivity, so they have less inherent latitude. It is therefore normal to use two emulsions, either mixed or coated as a bipack, to give more latitude.

Mixed emulsions are self-explanatory, except for the note that the properties of two mixed emulsions are not always

CRACKED MUD, PORTUGAL

This is a difficult shot to meter and to expose, because you need good differentiation in both the highlights and the shadows, but the mid-tones are not so important. The most convenient way to do it is to use a film with a long recording range (here, Ilford XP2 rated at EI 250) and to do a certain amount of burning and dodging during printing.

NIKKORMAT FT2, 90MM F/2.5 VIVITAR SERIES 1 MACRO, INCIDENT LIGHT READING WITH SIXTOMAT DIGITAL. (FES)

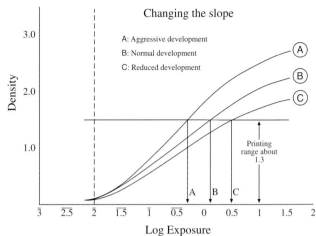

Changing the slope

A: Aggressive development
B: Normal development
C: Reduced development

Printing range about 1.3

Density

Log Exposure

density. The disadvantage of these films was a loss of sharpness because of the two thick emulsion coatings. Modern bipacks are much thinner than the old double-coated films, a side-benefit of colour film coating technology, so loss of sharpness from double-coating is no longer a significant problem.

Although the photographer has no control over the basic shape of the D/log E curve, except by buying one film instead of another, the shape can be modified somewhat and the slope can be modified drastically by the choice of developer and development conditions.

Toe

Development has little effect on curve shape, though highly restrained developers will depress the toe and thereby effectively reduce speed: restrainers reduce fog by preventing development of unexposed grains. The classic restrainer is potassium bromide, though numerous organic compounds (especially benzotriazole) can also be used. Increasing development will increase toe slope, thereby increasing effective speed, but the toe shape remains unchanged.

Slope

The slope of the straight-line portion (and to a lesser extent, as already noted, of the toe) can be increased by using stronger developers; or by increasing the

precisely what you would expect from knowledge of the two separately, while the principle of a bipack is the same as the old double-coated snapshot films, which coated a fast emulsion on top of a slow one. This meant that under-exposure would give you some sort of image on the fast emulsion, while over-exposure would give you some sort of image on the slow emulsion even if the fast emulsion was hopelessly over-exposed: you just printed through the surplus

MERTOLA CITY WALLS
If you scan and output your images, instead of printing them conventionally, you may notice a loss of both shadow detail (as a result of 8-bit scan depth – 12-bit is better) and highlights (because ink-jet output is less subtle and continuous than silver). Mid-tones are, however, well differentiated.
ACUPAN 200 RATED AT EI 125; INCIDENT LIGHT READING WITH VARIOSIX F. NIKON F, 35–85MM F/2.8 VIVITAR SERIES 1. (RWH)

DOOR OF POWDER MAGAZINE
The tonal range here is considerably greater than it seemed at the time, from the brightly lit stucco to the right of the outer arch to the deep shadows under the hinges. The film is SFX with an orange filter, rated (with the filter) at EI 100 for exposure determination with an incident light reading.
NIKKORMAT FTN, 90MM F/2.5 VIVITAR SERIES 1 MACRO, SIXTOMAT DIGITAL. (FES)

PALM SHADOWS

By using Ilford SFX and a deep red tri-cut filter, Frances was able to darken the shadows (which are lit by blue skylight) and lighten the parched grass, while retaining normal tonality in the background foliage and darkening the blue sky. Filters can create the impression of more or less contrast than you would expect from the characteristic curve.

NIKKORMAT FT2, 35MM F/2.8 PC-NIKKOR, INCIDENT LIGHT READING WITH SIXTOMAT DIGITAL IN SUN.

development time; or by increasing the development temperature; or by more vigorous agitation. Anything which increases the slope will inevitably have more effect on the highlights (the densest part of the negative) than on the shadows, as seen in the diagram opposite.

For a given film/developer combination, there is a limit to how much you can increase the slope of the curve in this way. As development becomes more aggressive, fog rises. This is because more and more unexposed grains are developed, and contrast sooner or later begins to fall again. The point at which contrast reaches a maximum is called 'gamma infinity'. In practice, it is not always very steep: gamma infinity can be as low as 1.0.

Shoulder

As already mentioned, the straight-line portion of the D/log E curve typically extends well beyond the useful range of printing densities, especially with modern films which are designed to be 'pushable' (ie designed to give extra speed with extra development), so what might be called the 'inherent' shoulder of the film is irrelevant for pictorial purposes. It is, however, possible to put the shoulder lower on the curve quite easily.

Any developer is more rapidly exhausted in the highlights of the negative than in the shadows, because it has more silver to convert. A 'compensating' developer makes use of this by being used in such concentrations that development in the highlights is greatly slowed and density there does not continue to build anything like as fast as in the shadows. This inevitably results in some compression of the mid-tones, but it means that more highlight detail can be captured, albeit not in the same linear relationship as on the straight-line portion of the curve. At this point, we need to look in more detail at how the various subject tones are recorded on the negative, and this is the subject of the next chapter.

SHADOWS, HIGHLIGHTS AND SPEED

We have already seen how the dark areas of the subject (generally referred to as the shadows) are recorded on the toe and lower part of the characteristic curve, with mid-tones on the straight-line portion and highlights either on the shoulder or on a continuation of the straight-line portion. Many photographers prefer to use a compensating developer in order to get the right sort of shoulder, but it cannot be emphasised strongly enough that this is an aesthetic or pictorial decision: scientifically, there is no such thing as a

BROADSTAIRS HARBOUR
The camera (a Linhof 612) was loaded with Velvia, a poor choice for against-the-light subjects out of doors, even on a winter's day; but this picture was impossible to resist. The best compromise came from rating the film at EI 32 and taking an incident light reading with a Variosix F at right angles to the subject/camera axis.
(RWH)

'right' way to represent highlights. It is, however, worth adding that the eye can differentiate subtle variations in highlight density far more easily than variations in shadow density. At a near-white, the eye can see a variation density of 0.005, which is less than most densitometers can measure; but at densities of 2.00 or below, in normal lighting, differences of as much as 0.10 can pass unremarked.

A moment's thought reveals that film speed, in terms of minimum acceptable exposure, must inevitably be intimately bound up with the lower part of the curve. Indeed, one of the reasons why Hurter and Driffield started their historic work was in order to define film speeds.

The criterion they chose, and which was used by several subsequent speed systems, was threshold or inertia speed – that is, the first point at which the film is affected at all by light. While this is better than nothing, it is not very reliable,

because threshold speed does not bear a particularly close relationship to usable speed. Obviously, a long-toe material is likely to have less useful speed than a short-toe material, even if the inertia speed point is the same. Besides, it was open to a great deal of fudging by dishonest film manufacturers who wanted their films to look faster than they were. What was needed instead was some way of determining minimum useful speed.

WALL IN THE PELOPPONESE
These two exposures on Fuji Astia are ⅔ stop apart – and to be quite honest, both would be entirely serviceable for almost all applications, though both for projection and for scanning the lighter one would probably be slightly preferable.
NIKKORMAT FT2, VIVITAR SERIES 1 90MM F/2.5 MACRO, INCIDENT LIGHT READING WITH VARIOSIX F. (FES)

THE FIXED DENSITY SYSTEM
The original DIN (Deutsche Industrie Norm) speed criterion of the early 1930s set a simple speed point: a density of 0.10 above film base plus fog. At this density, the worst of the toe is over, and you are recording useful shadow detail. It is, however, an arbitrary point. It could have been set as low as 0.05 (or lower, though that would have been a less certain indicator of useful speed) and it could have been set at 0.15 or higher.

As soon as you set such a criterion, though, you realise that development plays a major part in determining film speed. By prolonging development, you increase the slope of the toe along with the slope of the straight-line portion. Actual shadow detail does not change very much, but speed could easily be doubled (or halved) by increasing (or decreasing) development time. The price you would pay, however, would be negatives of widely varying contrast.

FRUIT
Velvia is rated at ISO 50, but because of the shape of the characteristic curve its effective speed ranges from EI 32 on a sunny day to EI 80 in the studio with a subject having a low contrast range. Here, it was rated at EI 40 using an incident light meter (Courtenay Flashmeter 3) to determine exposure.
LINHOF TECHNIKA 70, SCHNEIDER 100MM F/5.6 APO-SYMMAR. (RWH)

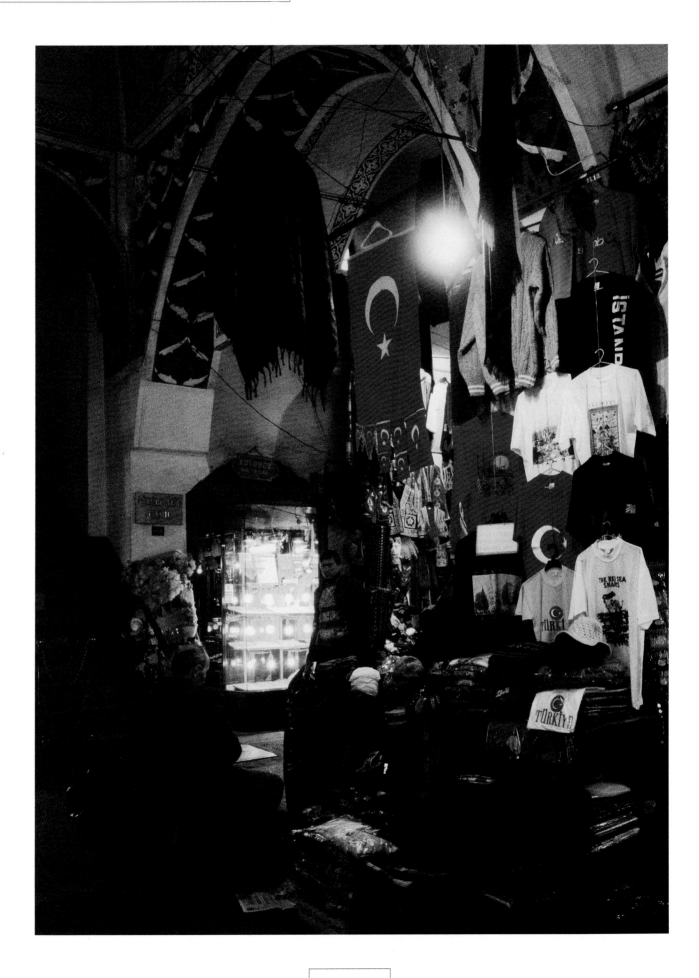

GRAND BAZAAR, CONSTANTINOPLE
In a shot like this, flare suppression is important – though the slight flare imparted by the 28mm f/1.9 Vivitar Series 1 helps to increase the effective speed by 'flashing' the shadows. Exposure determination was based on a spot reading of the light stonework inside the arch, using a Minolta Spotmeter F, with 1 extra stop over the reading.
NIKKORMAT FTN, FUJI RSP RATED AT EI 2500 AND PROCESSED AS FOR EI 3200. (FES)

The original DIN standard got around this by standardising on development for maximum contrast (gamma infinity, see page 31). Although negatives would rarely be developed like this for normal use, it did provide a useful, standardised speed point. This system continued until 1958, when development conditions were amended, and in 1961 the DIN criteria were harmonised with ASA (American Standards Association) and BS (British Standard), which are covered below. Before we look at that, though, we should look at the fractional gradient system.

THE FRACTIONAL GRADIENT SYSTEM

A much superior system to the DIN fixed density point was devised by Kodak around the beginning of World War II; in fact, by the indefatigable L.A. Jones once more. The logic is that the minimum useful speed point is when the slope of the toe becomes steep enough to differentiate tones usefully. The best way to define that slope was as a fraction of the slope of the straight-line portion of the D/log E curve.

Purely empirically, the members of the Kodak research department found that when the tangent of the slope of the toe was 30 per cent of the tangent of the slope of the straight-line portion (measured from the speed point to a point 1.5 log exposure units further along the curve), they had a useful

GRAND BAZAAR, CONSTANTINOPLE
Exposure determination here was based on an incident light reading in the middle of the alley, with the dome of the Sixtomat Digital held at shoulder level and pointing straight upwards. We knew this would burn out some of the shops to some extent, but we wanted plenty of detail everywhere.
NIKKORMAT FTN, SIGMA 15MM F/2.8 FISH-EYE, FUJI RSP RATED AT EI 2500 AND PROCESSED AS FOR EI 3200. (FES)

speed point. This is easier to understand with the aid of an annotated D/log E curve (below left).

The empirical testing was done (like all the rest of the empirical testing) by making large numbers of prints under carefully controlled conditions, and then asking very large numbers of observers which they thought was the best print. The prints which were described as 'best' were then traced back to the various negatives and their sensitometric characteristics, and these were chosen as the basis for defining the speed point.

As already mentioned, their system was known as the 'first excellent print' system, because under their conditions – contact printing – over-exposure carried few if any visible penalties, while under-exposure soon led to empty shadows and poor tonality. The 'first excellent print' was the one which received the least exposure while still being regarded as equal in quality to those that had received more.

Again as already mentioned, such so-called 'psycho-physical' testing upsets some people, who say that it is not scientific enough, but this immediately begs the question as to whether there is a better way of doing things. It also invites the somewhat heretical thought that the prints used for the psychophysical testing were not necessarily very good. In other words, people were being asked to choose the point at which prints started to get worse, rather than the best possible

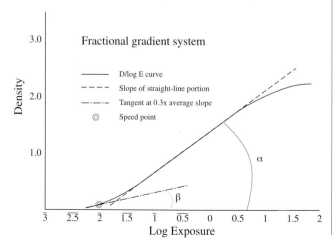

Fractional gradient system

— D/log E curve
– – – Slope of straight-line portion
–·–·– Tangent at 0.3x average slope
◎ Speed point

Density

Log Exposure

prints. The implications of this are considerable, in that a skilled printer might well get significantly better prints under somewhat different development and printing conditions. We shall come back to this later.

THE RETURN OF FIXED DENSITY CRITERIA

Despite the theoretical superiority of the fractional gradient criterion, which was embodied in both American and British standards after World War II, speed determinations based on a fixed density criterion are easier to make and to calculate – or at least, they were until powerful computers became everyday tools. In 1959, therefore, the retrograde step was made of standardising on the old DIN criterion of D=0.1 above film base plus fog (fb+f). A standard developer was specified, and the slope of the D/log E curve was specified as follows.

The speed point of 0.1 above fb+f was the left-hand point, and the right-hand point was 1.3 log exposure units to the

FIREPLACE, ST HUBERT
Today, Roger would shoot this on Astia; but in 1993, when Astia was not available, he used Fuji RDP. Exposure is extremely critical if you want to hold texture and detail both in the sooty chimney and on the light sunlit areas; exposure was the average of limited-area readings off both, using a Lunasix.

NIKON F, SIGMA 70–210MM F/2.8 APO.

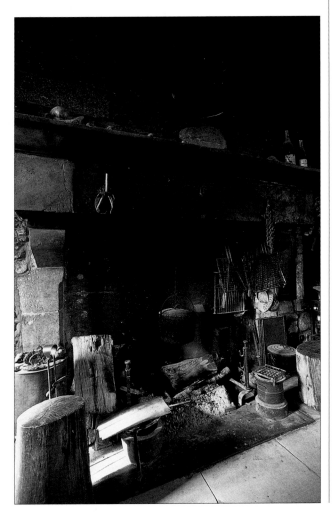

right; this corresponds to 20 times the exposure at the speed point, which can be criticised as being unrealistically short and can lead to interesting results with curves which are strongly S-shaped, or which have kinks in them. The standard said that this increase in exposure should give an increase in negative density of 0.8, so the slope of the curve is 0.8/1.3, or just under 0.62.

Today, the same speed point, exposure and density criteria are used for the current ISO (International Standards Organisation) standard, but it is permissible to use any developer provided that the choice is clearly stated. This means that one film might have ISO speeds from 100 to 200 in different developers, while another film might range from 250 to 800.

At the time of writing, the freedom to use different developers was a fairly recent innovation and most manufacturers had stayed with 'normal' developers, especially Kodak D-76 and Ilford ID-11, but a few had already taken advantage of the new standard to use speed-increasing developers, thereby gaining an extra ⅔ stop or so. Unsurprisingly, few if any had switched to fine-grain developers to give lower speed figures, though at the time of writing Maco 100 was sensitometrically very similar to Foma 200.

VARIATIONS IN FILM SPEED

Emulsion manufacture is something of a black art at the best of times, and film speeds are permitted to vary from batch to batch by up to ⅓ stop in either direction. In other words, an ISO 100 film might actually be anything from ISO 80 to ISO 125. This is as true for colour slide films as for negative films.

For most practical applications, variations of ⅓ stop do not

MINAS SANTOS DOMINGOS, PORTUGAL
Sometimes, it can be hard to decide which exposure you like best. These three are a full stop apart on Fuji RA Sensia II. The lightest looks best on a light box, the darkest looks best through a lupe, and the middle exposure (taken from an incident light reading with a Variosix F) is probably best for projection. Because of the limited tonal range, all should reproduce well.

NIKON F, VIVITAR SERIES 1 90–180MM F/4.5. (RWH)

CALCULATING FILM SPEED

The actual calculation of arithmetic film speeds for negative films is surprisingly simple, though the numbers look forbidding at first sight. Just divide 0.8 by the exposure E (in lux-seconds) at the speed point of 0.1 above fb+f. That's all. Thus, if the speed point falls at bar 2 (0.01) then the film speed is 0.8/0.01 or ISO (arithmetic) 80. At bar 2.3 (0.005) it would be 0.8/0.005 or ISO (arithmetic) 160.

The choice of 0.8, at first seemingly inexplicable, probably derives from the earlier means of establishing speed as 1/E, and then giving an exposure index which was four times greater, to allow for exposure errors. With the trend towards minimum exposure, 0.8/E gives a small but empirically useful safety factor.

Log film speeds, particularly popular in Germany, are calculated as 10xlog(1/E). Taking a speed point of 0.01 lux (bar 2 on the D/log E curve), 1/E is 1/0.1=100; the log of 100 is 2; and 10x2 is 20. Equally, at 0.005 lux, 1/E is 1/0.005=200; the log of 200 is 2.3; so the log speed is 10x2.3 or 23. Each increase of 3 represents a doubling of the film speed.

Film speeds for reversal materials are obtained somewhat differently, as the whole range of the transparency must be taken into consideration. Bear in mind, too, that the D/log E curve is 'backwards', so the maximum exposure point is taken as the one that yields a minimum density of 0.2 above fb+f, and the minimum exposure point is taken as either the point where the shoulder of the curve begins (ie where the change in the slope of the curve changes from positive to negative) or as 2.0 above minimum density, whichever is lower. The two speed points corresponding to these points are multiplied together, and the speed of the film is the square root of this product. In other words, it is their geometric mean.

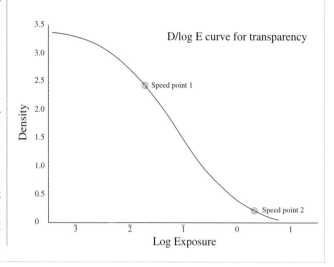

matter very much, and in practice they are rarely this great anyway. To make life still easier, variations are skewed by all the better film manufacturers in the appropriate direction: if the nominal speed is 100, the vast majority of negative film will be ISO 100 or slightly above, while the vast majority of colour slide film will be ISO 100 or slightly below. This translates into slight extra density in both cases.

It is, however, theoretically possible (though profoundly unlikely) that one unfortunate photographer might try to shoot a single subject on two rolls of film from two different batches, one of which was ⅓ stop slow and the other of which was ⅓ stop fast. Even then, the ⅔ stop variation would be unlikely to matter in monochrome.

'Professional' and 'amateur' films

In order to avoid the possibility described above, the actual speed of 'professional' colour films is normally printed on the information slip which comes with the film, or on the box itself. Increasingly, though, films which are not of precisely the standard speed are simply reclassified as 'amateur' films; it is unusual today to find 'professional' films which are not of the stated speed.

It is, therefore, no longer necessary to batch-test professional colour films, as it used to be in the 1960s and even the 1970s – though for useful savings, if you are shooting a great deal of film, it may still be cheaper to buy 'amateur' film and batch-test it, rather than buy 'professional' film. Batch-

WHITE HOOD

A spot reading off the hood provided the basis for calculating exposure; the actual exposure was 2 stops less, which did not darken the flesh tones too much and preserved plenty of texture in the hood.

LEICA M4P, 90MM F/2 SUMMICRON, KODAK ELITE 100, SPOT MASTER 2. (RWH)

testing, of course, reveals any requirement for weak colour correction (CC) filters as well as variations in film speed.

As for batch-testing monochrome films, this verges upon the obsessive. Yes, if you are the most precise and exacting worker in the world, and if you insist on printing only on a single grade of paper, and if you can keep development conditions (including developer ageing) absolutely constant, you will just about see a difference in the final prints from negatives which display a ⅓ stop variation in speed. In the real world, because of developer variations, ⅔ stop is the least you are likely to notice, and (as already noted) you are profoundly unlikely to encounter these. It certainly makes sense to refine your metering and development technique to suit a particular film type, but once you have

done that, you really should not need to re-test the film every time you buy a new batch. If you change film types, it is a different matter.

If you insist on batch-testing, then you can do so more than accurately enough with a test target of the type illustrated on page 70, which has a brightness range of about 32:1. Fog levels, and the density levels for the three patches (black velvet, 18 per cent grey, unexposed and fixed matt photographic paper), should be within about 0.03 of each other for the two batches.

Uniform shifts in density indicate variations in film speed; different shifts in density for the different patches indicate changes in curve shape or (more likely) variations in your development regime. A density shift of 0.05 corresponds to ⅙ stop, which is the least worth worrying about.

DOOR AND TYRE, PORTUGAL

PolaBlue is a presentation material rated at ISO 8, with extremely narrow exposure latitude. It is not recommended for normal photography. Frances is rather fond of it. This was the darker bracket, ½ stop less than the incident light reading; at the metered exposure, there was no significant texture in the wall.

NIKKORMAT FT2, 35MM F/2.8 PC-NIKKOR, SIXTOMAT DIGITAL. (FES)

EPIDAVROS

Two-thirds of a stop of under-exposure (as compared with an incident light reading taken in full sun) concentrates attention on the graphic shape of the theatre and reduces the impact of both the tourists sitting in the shade and the scaffolding at stage right.

NIKKORMAT FTN, 35MM F/2.8 PC-NIKKOR, FUJI ASTIA, SIXTOMAT DIGITAL. (FES)

AGEING

Films lose speed as they age, but the rate at which they do so varies enormously according to how the speed is achieved (ie through grain size, grain shape, sensitising dyes, sensitising salts, developer accelerators or whatever) and how they are stored: films which are kept in a cool, dry place will retain their sensitivity much better than those which are stored in warm or humid conditions (though of course most films are hermetically sealed against humidity). Strictly, according to ISO standards, the manufacturer's film speed should be an average from several batches, including some which have been aged for months or even years.

A rule of thumb, given by Dunn, is to assume a speed loss of $\frac{1}{3}$ stop per year, but this is almost certainly too high for a well stored modern film and possibly a little low for a film that is stored really badly.

As well as speed loss, ageing also tends to bring an increase in fog, and in extreme cases it may be advisable to add a little benzotriazole restrainer to the developer and to give at least a stop or two more exposure. Benzotriazole considerably reduces effective film speed, so it should not be used with elderly exposed films where latent image regression (effectively, a decline in speed) will already be a problem. The best approach with films which have been lying around for a decade or two is fairly aggressive development in a speed-increasing developer. The image may be foggy and grainy, but you are likely to have enough there to print, which you may not have with gentler treatment.

SPEED ADJUSTMENT

'Pushing' black and white films in order to get a higher effective speed is something that photographers have done since the dawn of gelatine emulsions. It is, however, important to distinguish between true speed gains and increased toe slope.

In the days when the ISO developer was standardised, there was no doubt that some films could be persuaded to give genuine speed increases, sticking to every ISO criterion except the choice of developer. The actual speed increase depended very much on the film and developer, but normally, $\frac{2}{3}$ stop was about the best you could hope for. In other words, an ISO 400 film could be persuaded to give a true (toe) ISO speed as high as 650, or an ISO 125 film might give a genuine ISO 200, using a speed point of 0.1 above fb+f. Very rarely, you could get a whole stop of extra speed, or even a fraction more, but that really was unusual.

The mirror image of this was that fine-grain development normally entailed a speed loss of anything from $\frac{1}{2}$ stop upwards; 1 stop was regarded as normal and acceptable, in return for finer grain.

Today, two factors complicate this equation. One is that, as already noted, manufacturers can use any developer they like to arrive at the ISO film speed. The most noteworthy player at the time of writing was the Czech manufacturer Foma, whose ISO 800 film was indeed ISO 800, but only in what most manufacturers would regard as a speed-increasing

developer: a formula such as Ilford Microphen or Paterson Varispeed. In more conventional developers, the speed might fall to ISO 650 or ISO 500; with fine-grain developers, it could fall well below ISO 400. Foma's ISO 200 film was likewise ISO 125 to 160 in normal developers, and could fall below ISO 100 in some.

The other complicating factor – and indeed, the reason why the ISO standard developer was dropped – is that modern 'high tech' films are often far more sensitive to developers than the emulsions of yore, so a standardised developer might give speed criteria which are quite in-appropriate in the real world. This is true whether the films in question improve their speed/grain ratio by means of controlled crystal growth, or by loading development accelerators into the emulsion.

Development accelerators work in several ways, some affecting the absorbency of the gelatine and others affecting the surface charge of the light-sensitive crystals, but this is of little practical interest to the working photographer and indeed the precise mechanisms of some accelerators are still disputed by cutting-edge research chemists.

Development accelerators, incidentally, are one of the

APPROACH TO TOPKAPI PALACE
Paterson's Acupan 200 is adequate at its rated ISO speed, which is correct when used with the recommended developers (especially Paterson FX39), but an extra ⅓ stop for 35mm and ⅔ stop for 120 will improve the tonality without undue penalties in sharpness and grain; and if you use a fine-grain developer, add another ⅓ stop to each. Exposure was 3 stops more than indicated by a limited-area reading of the dark building on the centre right, rating the film at EI 160.
NIKKORMAT FTN, 35MM F/2.8 PC-NIKKOR, SIXTOMAT DIGITAL. (FES)

reasons why pre-soaks are often a bad idea with modern films: there may be some danger of the accelerators leaching out, and effective speed falling as a result. The idea of using a pre-soak to increase the compensating effect of a developer (see page 31) is not wrong, but it is risky, and it may require quite a lot of trial and error to make it work properly. It is a much better idea to use a compensating developer to begin with, and to put the film straight into that. With old, thick-emulsion, cubic-crystal films without development accelerators, pre-soaks might have done some good; with modern thin emulsions and modified gelatines, and more especially with 'high tech' monosize-crystal emulsions, they are either of no value, or slightly harmful.

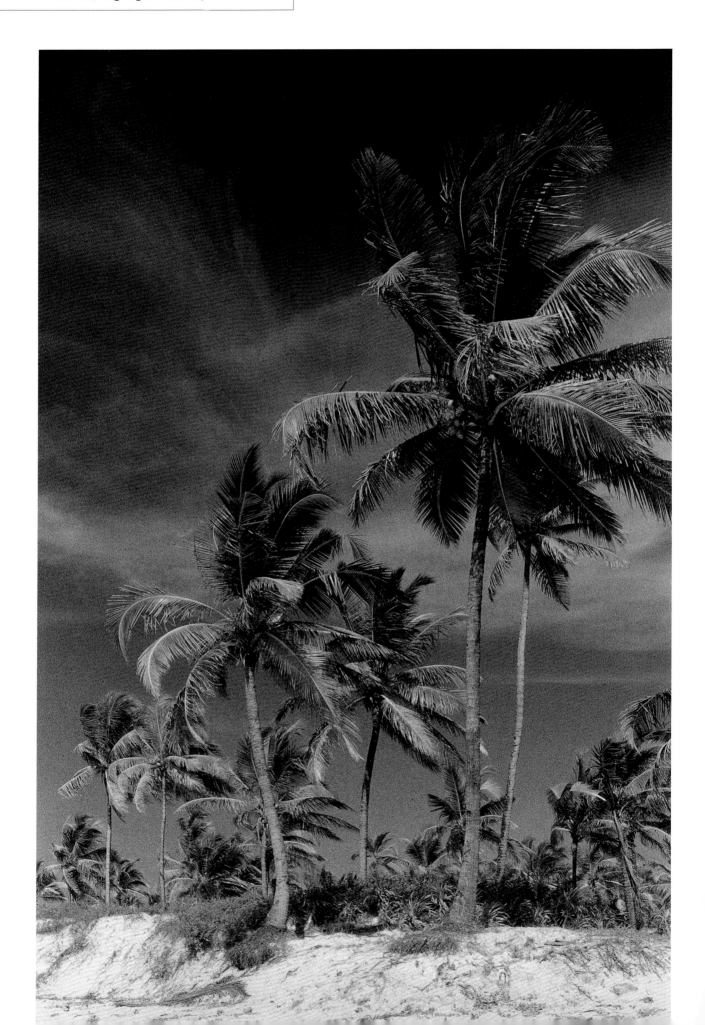

COCONUT PALMS
Because of its extended-red sensitivity, Ilford SFX has a recommended EI instead of an ISO speed. We habitually use it with either a deep red tri-cut 25A filter (as here) or with a true IR filter (see page 106). With the 25A, an EI of 50 (including the filter value) works well for us with incident light readings. The sand needed to be burned in about 1 stop in printing.
NIKKORMAT FT2, 35MM F/2.8 PC NIKKOR, SIXTOMAT DIGITAL. (FES)

In other words, the only way to see if you get true, usable speed gains with a genuine increase in shadow detail is to test the film as described in the next chapter; but before we go on to that, we need to look at 'pushes' which provide usable images without an increase in true speed (defined as shadow detail, densities of 0.1 above fb+f).

'Pushing' by increasing slope

On page 30, we described the various methods of increasing contrast – and this, in effect, is what most 'pushing' consists of. An under-exposed film has a good deal of the important information on the toe of the curve, where the slope is gentler than on the straight-line portion. This detail can be recovered by printing just the toe of the curve on an ultra-hard paper, or alternatively, the slope of the toe can be increased so that the image will print on a more conventional grade, as seen in the three curves on page 30.

The penalty for increasing the slope is, of course, that anything which is on the straight-line portion of the curve will become very contrasty indeed, and will need to be printed on very soft paper. Normally, with a pushed film, you just throw away any brighter highlights than the ones which interest you, and accept that they will be burned out. The interrelationship of speed and contrast is therefore intimate, and to try to study either in isolation is meaningless.

Increasing the slope does not much increase the true film speed, defined as the ability to capture shadow detail, but it does make an under-exposed film easier to print. It is not, however, correct to say that there is no speed increase at all, because a density of 0.10 above fb+f will be reached with less exposure than it would without pushing.

To a very large extent, talking about the 'true' film speed of a pushed film is a waste of time: too much depends on how you push it, and regardless of how you define things, the proof of the pudding is in the eating. In particular, if you are prepared to forgo shadow detail, then you can rate films at quite ridiculously high speeds because you end up printing what would normally be the highlights – faces, for example – off the toe of the curve, where in effect they are recording as shadow detail.

This may be a little hard to visualise, but if you think about it, you realise that with a maximum 'push' there is no detail in anything darker than the faces (ie they are, in effect, the darkest tones which are registering) and that there is not much differentiation in anything lighter (ie they are the lightest areas with detail in the image). This is why, for surveillance photography of light-skinned villains, an ISO 400 film may be usable at EI 10,000 or so.

'Push' films

One last point concerns films which are specifically designed for push processing, partly by tailoring the shape of the D/log E curve via emulsion design and partly by incorporating development accelerators. Instead of quoting an ISO speed on the box, they normally have an EI which is considerably above the true ISO speed. Classic examples include Fuji Neopan 1600 (actual ISO around 500 or 650), Kodak TMZ P3200 (actual ISO 1000), and most recently Ilford Delta 3200 (ISO speed up to 1250).

In practice, these 'push' films really do deliver useful shadow detail at EIs considerably above their actual ISO speeds, possibly even at the rated EIs, but as with any other film, they do eventually run out of shadow detail: even though Kodak gives development instructions for rating TMZ as high as EI 25,000, there is no real shadow detail at this speed or even at EI 6400, 2 stops slower.

Even before we worry about shadow detail, though, we should look at just how 'typical' our 'typical' subjects are; and this is what is covered in the next chapter.

BIGHI HOSPITAL, ACROSS KALKARA CREEK
Sometimes, all you can do is guess – and bracket. You only see light like this a few times in a lifetime, and it lasts only a few minutes. What does the cost of half a roll of film matter, if you use it to record something you will remember all your life?
LEICA M2 35MM F/1.4 SUMMILUX, FUJI SENSIA II ISO 100. (RWH)

SUBJECTS AND IMAGES

So far, we have looked at the recording side of things – at what the film or print can record. The next thing to examine is in one way even more fundamental: this is the nature of a 'typical' subject, and how it is recorded in a photograph.

We have already seen a number of places where we are reduced to approximations, best guesses, personal preference and cases of 'Well, it won't matter much anyway', and this chapter contains some more of them.

REFLECTIVITY

The best place to start is with reflectivity – that is, with the amount of light which a given surface reflects. And the best place to start on reflectivity is with the distinction between specular and diffuse reflections.

A specular reflection is what you get from a mirror (which is *speculum* in Latin – and remember, Roman mirrors were of metal). True specular reflections are rare in nature, but commonplace in the man-made world: anything of polished metal will give a true specular reflection. The word 'specular' is, however, used more widely to mean a reflection which

MONO LAKE

Unless you have a grey grad with you – which Roger did not when he shot this – you often have to compromise on sky brightness. Any less exposure would have darkened the snow too much, but as can be seen, the distant hills and sky are on the edge of over-exposure. It does not matter too much with a wintry shot like this, but with a summer shot and white sand in the foreground, it can be a problem.

WRIGHT 6X17CM, 90MM F/8 SUPER ANGULON, KODAK EPD ISO 200, INCIDENT LIGHT READING WITH VARIOSIX F, ⅔ EXTRA STOP GIVEN.

catches the light and reflects it towards the observer: water is a common example, and without make-up, skin can give highlights which are sufficiently bright to be considered specular.

The difference between a true specular reflection and a reflection off water or skin is that a true specular reflection cannot be suppressed with a polariser, unlike a reflection from water or skin or anything which is not truly specular. The distinction normally matters only when you are using a polariser, which is why it is convenient in photography to lump together true specular reflections and 'specular' highlights on other subjects. 'Specular' is used in this more relaxed sense in the rest of the book, with the term 'true specular' being used to describe reflections off polished metal.

Normally, however, when we talk about reflectivity, we are talking about diffuse reflectivity. A perfect diffuse (or 'Lambertian') reflector absorbs none of the light falling on it, and reflects 100 per cent, so that it appears equally bright from all directions. Perhaps needless to say, no such thing exists in the real world. One of the best diffuse reflectors which we see at all often is photographic paper, which can reflect around 90 per cent of the light falling on it. So can fresh-fallen snow. At the other extreme, black flock or black velvet reflects rather less than 1 per cent of the light falling on it. In fact, the

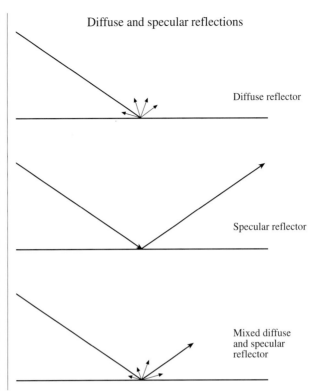

Diffuse and specular reflections

Diffuse reflector

Specular reflector

Mixed diffuse and specular reflector

PARTHENON

Exposure was based on a spot reading of the rock of the Akropolis, taken as a mid-tone, to allow the Parthenon to read lighter. Other readings were taken of the sky and the foreground foliage to confirm the tonal range.

MPP MK. VII, APO-LANTHAR 150MM F/4.5, FUJI ASTIA, MINOLTA SPOTMETER F. (RWH)

difference in reflectivity between white photographic paper and black velvet is just over 100:1, a log brightness range of just over 2, or about 6⅓ stops.

We now have an interesting little paradox. A specular surface is commonly referred to as having a reflectivity of more than 100 per cent, because 100 per cent refers to a diffuse (Lambertian) reflector. This is clearly meaningless in one sense, but useful in another, in that the brightness of a specular highlight is frequently far greater than the brightness of the brightest diffuse highlight.

A glossy print can seemingly be blacker than a matt one. As long as the light shining onto the black surface is not reflected straight at our eyes (or at the camera), it can be reflected away entirely, and the surface appears deeply

BEACH SHACK, GOA

The trick with a subject like this is to retain detail in the shadows without burning out the highlights. A low-contrast, high-saturation film is needed – this was Astia – and Roger gave 2½ stops more exposure than indicated by a Minolta Spotmeter F reading of the darkest shadow under the eaves of the hut.

LEICA M4P, SUMMILUX 35MM F/1.4.

and intensely black. This is why a glossy print can have a brightness range of well over 100:1, and why black acrylic sheeting can be used as an almost magically deep black background.

Reflectivity and angle of light

The reflectivity of any real-world surface depends on the angle at which the light strikes it, as compared with the angle at which we view it.

A mirror or a lake demonstrates the reflectivity of a specular surface in a way that is in the strictest sense blindingly obvious, if it catches the sun right. Scientifically, the angle of reflection (ie the angle at which the light is reflected) is equal to the angle of incidence (ie the angle at which the light strikes the surface), but this merely formalises a matter of everyday experience.

Although the variation of reflectivity of a diffuse surface is less obvious, it can be demonstrated easily enough by standing with your back to a light source and holding up a piece of white paper so that the light falls full on it. As you rotate the paper about a vertical axis, its apparent brightness falls.

Perfectly diffuse surfaces are, however, effectively non-existent – most have some element of specularity – and so are single, point light sources with no 'fill', so a great deal will depend on the direction of the light, the diffuseness of the light and the direction from which you look at the subject.

'Double lighting'

Ignoring specular reflections, the maximum reflectivity range of any subject under even, diffuse lighting is likely to be about 100:1, or maybe a little more. The point is, though, that we rarely have even, diffuse lighting, though an overcast day comes close. Even then, some areas may well be significantly shadowed: the interior of a house, for example, cannot be as well lit by daylight as the exterior.

The harder and more directional the light, the deeper the shadows will be. On a sunny day, even if there is a little haze to soften the light, the differences can be quite large. When you are standing in the sun, the intensity of the light falling on your sunlit side can easily be four times the intensity of the light falling on your shadowed side. Suddenly, a maximum reflectivity range of 100:1 can be transformed to a maximum subject brightness range of 400:1. Even if the actual reflectivity range is only about 30:1, it can jump to 120:1 when you take the lighting into account.

There is no real term for this, but 'double lighting' is as good as any, and it is something you have to take into account when you are metering.

Studio lighting

In the studio, where the light is under your control, you can adjust the lighting ratios so that the subject brightness range is

pretty much whatever you want. A common problem, though, is that with the subject chosen, you do not want the sort of lighting ratio which will give you a decently wide brightness range. You can either live with this (which generally works perfectly well in colour) or you can – through film choice, manipulation of exposure and (in the case of black and white film) prolonged development – increase the actual or apparent contrast range of the picture. There is more about this on pages 30 and 155.

TYPICAL SUBJECTS

As mentioned earlier, a 'typical' subject is taken to have a brightness range of 128:1, 7 stops, a log range of 2.1. It is also assumed, again on the basis of extensive empirical evidence, that the tones within the picture are reasonably evenly distributed, so that the overall scene reflects something between 12 and 18 per cent of the light falling on it. This may seem quite a wide range, but it represents a variation of only ½

GLASSES

These vivid 'neon' glasses cried out to be photographed – but how? Eventually they were side-lit on black Perspex acrylic sheeting, which allows an absolutely black background but reflects only the glasses. Exposure was based on an incident light reading (Courtenay Flashmeter 3), with the ISO 50 Velvia film rated at EI 32 to make the glasses as light as possible.

LINHOF TECHNIKA 70, SCHNEIDER APO-SYMMAR 100MM F/5.6. (RWH)

CRUMPLED PAPER

In the Peloponnese, where this was photographed, the hard Mediterranean sun meant that this 'still life' had a 'typical' 128:1 brightness range; but on a hazy day in the UK, the shadows would have been much flatter and it would have been closer to 64:1. On an overcast day, it could fall to 16:1.

NIKKORMAT FT2, VIVITAR SERIES 1 90MM F/2.5, PATERSON ACUPAN 200 RATED AT EI 200 AND DEVELOPED IN FX39, INCIDENT LIGHT READING WITH SIXTOMAT DIGITAL. (FES)

stop, which is not really very much.

Many thousands of observations went into the establishment of these averages, but they suffer from two (or perhaps three) fundamental drawbacks. The first is that most or all of them were taken within 200 miles or so of Rochester, New York. The second is that we all have plenty of experience of subjects with broader or narrower tonal ranges and which may reflect more or less light overall. And the

third is that the 128:1 range excludes both light sources and specular highlights. It is perhaps easiest to examine each objection in turn, and in reverse order.

Light sources and specular highlights

It is quite possible for a landscape which includes the sun to have a brightness range of 1,000,000:1 or more. Even if the sun is not in shot, specular reflections can again be vastly brighter than the general brightness of the subject. Normally, though, the area of the image that is occupied either by light sources or by specular reflections is such a tiny part of the overall scene that it can safely be ignored. This is why this was referred to as a possible objection, rather than an actual one.

Subjects with a long tonal range

Consider for a moment a black cat stalking through the snow. Neither the tonal range nor the overall reflectivity is at all typical. The actual brightnesses of the cat and the snow might well be at or near the limits of the recording ability of a black and white film, and rather beyond the limits of a colour print, while the overall reflectivity of the scene would depend very much on the proportion of snow to cat which was metered. With an old-fashioned, broad-acceptance selenium-cell meter (see page 94) the chances are that the snow would be afforded very much more weight than the cat, while with a spot meter, whether in camera or separate hand-held, the cat might be afforded much more weight than the snow. Either would be a disaster.

If the meter is calibrated on the assumption that the overall

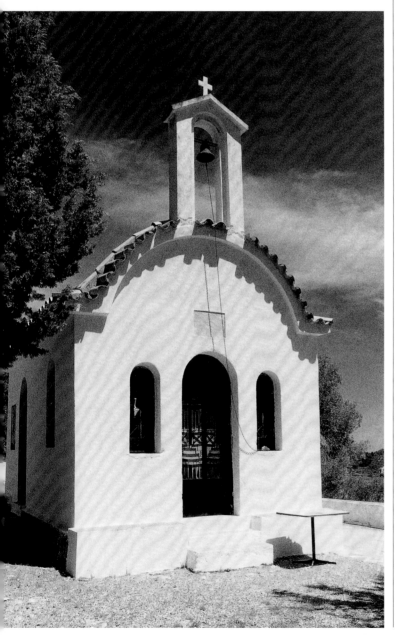

ROSE

The brightness range of this still life is for the most part very small; even the highlights on the metal vase are not very bright. In monochrome, the result would be hopelessly flat, but in colour you can use the colour itself to provide the contrast.

CALUMET CADET, 203MM F/7.7 KODAK EKTAR, FUJI RDP2 ISO 100, INCIDENT LIGHT READING WITH VARIOSIX F. (FES)

CHURCH

To hold texture in bright whitewashed walls, you need to cut the exposure indicated by an incident light meter (in this case a Variosix F) by about 1 stop. A compensating developer will help compress the tonal range; some mid-tones will be lost, but this is not necessarily very important in a picture like this, where the highlights and shadows contain the principal interest.

NIKKORMAT FTN, NIKKOR 35MM F/2.8 PC-NIKKOR, ILFORD SFX AT EI 50 INCLUDING FILTER FACTOR. (FES)

scene reflects 12 per cent of the light that is falling on it, and the scene actually reflects 90 per cent, then the meter will recommend under-exposure by almost 3 stops. Assuming that you are shooting a transparency or direct positive, the result will be leaden grey snow and a cat which is a solid, blocked-up black blob, while a negative will end up thin and grossly under-exposed.

A major problem for many novices is that the correction factor required is counter-intuitive. There is so much light around on sunlit snow that the inevitable temptation is to think that the meter is over-reading, and to give a bit less exposure in order to compensate. This makes things even worse, of course.

Suppose, however, that the meter reading was entirely off the cat. The meter design is still based on the assumption that the scene reflects 12 per cent of the light falling on it, while the cat may reflect two per cent or less – at most, one-sixth of the 'average' reflectance. If it is two per cent, the meter will therefore recommend over-exposure by about 2½ stops. In fact, some spot meters are calibrated to 18 per cent reflectivity, a photographic mid-tone, and this will result in over-exposure by a little more than 3 stops.

Again, assuming you are shooting a transparency or a direct positive, the result will be a grey cat against a completely burned-out white background. A negative would be grievously over-exposed, though you would be better placed to get a print from a negative that was 2 or 3 stops over-exposed than you would from one which was 2 or 3 stops under-exposed.

Even if the negative is perfectly exposed, it will require some interpretation at the printing stage. Any sort of automatic printer will try to give you a print which more or less reproduces the old 18 per cent grey average, so you will get a dull, grey print from either negative. The problems of contrast control are another matter again, and are dealt with elsewhere (see page 63).

It might seem that over-exposure is (at least for negatives) a more desirable state of affairs than under-exposure, and within reason, so it is; but over-exposure also brings the disadvantages of increased grain (except with chromogenic films), decreased sharpness and a different tonal rendition from a correctly exposed image, especially in the shadows. These points, too, are covered elsewhere (see page 14).

It is also worth adding that some modern in-camera meters can do remarkably well with long tonal ranges like this; but while they can give acceptable exposures surprisingly often, they may be of rather less use when it comes to producing perfect exposures.

Subjects with a short tonal range

Subjects with a shorter tonal range than 128:1 present far fewer problems than those with a long tonal range, but they do have their own characteristics. Obviously, if our exposure aim point is somewhere in the middle of the range that the film can handle, then we simply have more latitude: a bit of over-exposure or under-exposure will not matter at all.

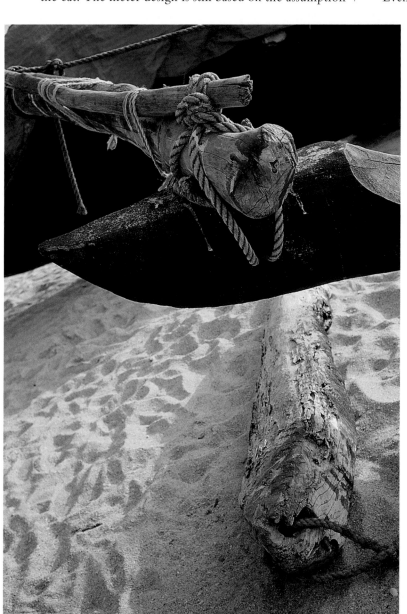

FISHING BOAT OUTRIGGER, GOA
This exposure is right on the limits of what can be captured on Astia, a famously forgiving film. Spot readings (with a Minolta Spotmeter F) confirmed that the total tonal range was around 5 stops, from the darkest part of the outrigger to the lightest part of the sand; the exposure given was ⅓ stop more than the average of the two, which generally gives better results than a straight average.
LEICA M4P, SUMMILUX 35MM F/1.4. (RWH)

DEAD BIRD
The tonal range here is very small, but a hard paper (grade 4) allowed a perfectly satisfactory print from a normally exposed negative. Exposure determination was by an incident light reading with a Variosix F, rating Acupan 200 at EI 125 and developing normally in FX39.

NIKON F, 90–180MM F/4.5 VIVITAR SERIES 1. (RWH)

This is not how exposure meters and film speeds work, though. For a number of good reasons, as noted on page 14, the aim is normally to give the minimum possible exposure. There is, therefore, considerable latitude for over-exposure but very little for under-exposure, if we determine exposure in the usual ways. Also, as we shall see later in the chapter, the rendition of the shadow areas in particular will vary quite widely according to how we expose the film.

Geographical location

Rochester, New York, is about 43° north of the equator. This obviously affects how high the sun rises above the horizon – it is never directly overhead, as it can be at noon in the tropics – and it also affects the climate: on a cloudy day, there is a

GODOWN ROOF, GOA
Because the tonal range is extremely small, an exposure range of 1 stop or more would give adequate results for reproduction or printing; for projection, choose an exposure which will most nearly match the other exposures in the sequence, or give two exposures, one at ½ stop more than an incident reading, the other at ½ stop less.

LEICA M4P, SUMMILUX 35MM F/1.4, FUJI ASTIA, VARIOSIX F. (RWH)

smaller brightness range for a typical subject than there is on a sunny day. For that matter, the brightness range is usually greater in the middle of the day than it is in the morning or the evening. The latitude and climate of Rochester, New York, have to be borne in mind when considering the conditions under which Kodak's researchers arrived at their entirely empirical 128:1 tonal range, which is now taken as 'average'.

If you go farther north, the tonal range is typically even lower, though again, it varies widely from summer to winter and with the weather. Go farther south, on the other hand, and as you approach the equator the tonal range becomes wider. Any scene taken in late morning or noon in the desert is likely to be very much contrastier than 128:1, though as the day winds on, haze or dust may soften contrast somewhat.

All of this was recognised in the old days of exposure calculators, where the data to be entered included latitude, time of year, time of day, subject and lighting conditions. Using the old British Standard tables (BS 935:1948) for the conditions outside Roger's study, we took a base value of 64 (nearby subject in light shade on a cloudy-bright day) and added 1 for latitude, time of year and time of day and another 6 for back lighting to get 71, then subtracted 31 for ASA 100 to get 40. We then looked this up and got ⅟₆₀ second at f/2 or f/1.9. Then the sun came out...

Back to the calculator, and changing 64 to 61 for hazy sun to give us (finally) 37, or ⅟₁₂₅ second at f/4 or f/4.5. If we'd been in Los Angeles or southern Japan, the latitude correction (for the same season, etc) would have been 0, making a change of about 1 stop in the direction of increased exposure. These calculations were for negatives; if we had been using transparency material, we'd have had to decide between back light for lighting effect, and back light for shadow detail.

It might seem that all this precision means that exposure tables are more reliable than meters, but of course, this is not so. How do you distinguish between distant, semi-distant, nearby and close-up subjects? What is the difference between light shade and heavy shade? When does cloudy-bright

SOPHIE
The effect of over-exposure varies with the light source. We have always found that with electronic flash, you need a very heavy warming filter such as an 81EF (which was clearly not used here). Sunlight, on the other hand, seems to remain more neutral.
NIKON F, 90–180MM F/4.5 VIVITAR SERIES 1, FUJI ASTIA. (RWH)

become cloudy-dull? The same source from which we took the exposure calculations, an old *Focal Encyclopedia*, reckoned that 'accurate' results were obtainable 45 per cent of the time with calculators, 87.8 per cent of the time with extinction meters (now long obsolete) and 97.3 per cent of the time with photo-electric meters. These figures seem pretty optimistic, not to say excessively precise, to us.

Admittedly, we are now back to the difference between adequate exposures and perfect exposures, and admittedly the exposure tables deal more with quantity of light than with quality; but even so, there is a good case to be made for treating the traditional 128:1 figure with some reserve. The best thing you can say about it is that if you can represent even a 128:1 slice of an overall scene with a black and white print having a tonal range of 100:1 or more (or for that matter with a tonal range of much better than 50:1), you will have produced a pretty good print by the standards of most people.

indeed more) instead of 128:1.

Also, the overall reflectance of even an 'average' scene can vary quite widely: one has only to think of the whitewashed houses of so many Greek towns, and to compare this with (say) Paris, where honey-coloured stone and a surprising amount of greenery conspire to soak up the light. The overall reflectivity in the Greek street scene might very often exceed 18 per cent; the overall reflectivity in a street scene in Paris might equally often fall below 12 per cent. It is by no means unrealistic to say that one scene might have twice the tonal range, and twice the reflectivity, of the other.

For the majority of people, these differences do not matter very much. With modern materials, and modern meters, we should get an adequate exposure of either. This is, however, a long way from saying that we can get a perfect exposure of either. We come back to visualisation, and this involves a whole sequence of considerations: what we want, how we meter in order to get what we want, and what equipment and materials we choose in order to affect matters further – to say nothing of how we process (and print, if need be) our images.

SUBJECT BRIGHTNESS AND IMAGE BRIGHTNESS

In a perfect world, you might think, relative subject brightnesses would be represented one-for-one in the final image. Thus, if a skin tone in the real world is 1½ stops brighter than a grey card held alongside it, the skin tone in the photograph would also be 1½ stops brighter than the grey card in the photograph.

This is known as the Goldberg condition, but a moment's thought will show that because both film and paper can have D/log E curves of different shapes, the Goldberg condition

Tonal range and reflectivity
At the conclusion of the above explorations, we can say with some confidence that while a tonal range of 128:1, and 12 to 18 per cent reflectance, are useful averages, they are no more than that. In practice, tonal ranges quite often go well over 1,000:1, and in southern climes, even 'average' scenes may well be 256:1 (or

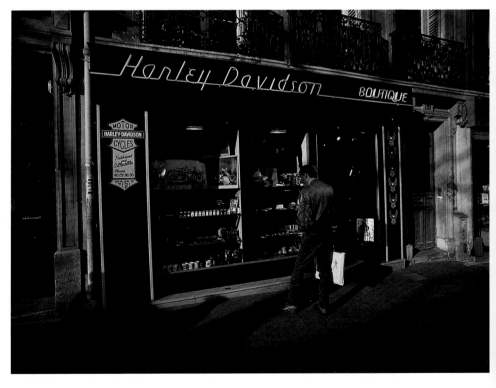

HARLEY BOUTIQUE, PARIS
The setting sun gives a curious light: contrasty, and yet surprisingly forgiving of over- and under-exposure. The exposure here was as indicated by an incident light reading pointing towards the sun, which makes it about ⅔ stop dark; this gives rich, glowing colours which seem to suit sunset light well.
LEICA M2, SUMMILUX 35MM F/1.4, FUJI RF ISO 50, LUNASIX. (RWH)

FLOWERS ON WALL, MONTREUIL
This was given an extra ⅓ stop exposure, as
compared with an incident light reading with a
Variosix F, for an airy, spring-like feel.
LINHOF SUPER TECHNIKA IV, 105MM F/3.5 SCHNEIDER
XENAR, FUJI RAP ASTIA. (RWH)

can be met via a high negative gamma and a low paper gamma, or vice versa. A little more thought will show that the likelihood of the two characteristic curves matching perfectly is slight; and a little more thought still will raise the question of what happens at the toes and shoulders of the two curves.

In fact, there is an important question to consider before you even start to wonder about the Goldberg condition and about whether this is, in any case, the pictorial optimum. It is the inevitable flattening of contrast which takes place in an optical system, before the image is even recorded on film.

Flare

Any lens will demonstrate some flare, a slight flattening of contrast in the image it projects as compared with the contrast of the original scene. The camera, too, may demonstrate flare. After all, film is fairly light coloured, and while it is being exposed, light is being reflected back off it, after which it can bounce around inside the camera and be reflected back onto the film.

In the nature of things, flare is much more obvious in the shadow area of the image, which inevitably reduces the overall contrast range. Careful selection of cameras and lenses is obviously the starting point for flare control, but there are several ways of minimising its effect in any camera/lens system. Two of the most important are keeping all optical surfaces sparkling clean, and using as deep a lens shade as is practicable.

If flare is a problem, it can be countered by using contrasty materials and (in the case of monochrome negatives) by over-developing slightly in order to build contrast back up – though the effect will not be quite the same as keeping contrast losses to a minimum in the first place, because the shadows will still be lighter than they should be. There are, however, times when flattening contrast with the aid of flare is a positive advantage, and indeed Tiffen Ultra Contrast

Filters won an Academy Award for the almost magical way in which they do this without destroying definition.

The point is, though, that film speed is determined by shadow speed – and if, because of flare, there is more light in the shadows than there should be, the effective film speed is increased. Fractional gradient criteria (see page 35) lessen the influence of flare considerably, but with a fixed density criterion, a flary lens will appear to give a higher film speed than a low-flare lens, which is why soft-focus lenses often require at least ⅓ stop less exposure than conventional ones.

HOW TONES ARE REPRODUCED ON FILM

Three sets of diagrams make it much easier to visualise how tones are recorded on film. The first is a compression–expansion diagram, which we make no apology for reproducing from a previous David & Charles book, *The Black and White Handbook*. The second is a so-called 'windmill diagram', and the third is a set of D/log E curves under different conditions.

The compression-expansion diagram

As soon as you see it (below), this is almost intuitive. The subject brightness range is compressed into the image brightness range, principally by flare. To simplify matters, we have represented a tonal range of 128:1 (2.1 log range), in evenly distributed steps, which is compressed by a lens with a flare factor of 2 to an image brightness range of 64:1 (1.8 log range). The shadows, inevitably, are what is principally compressed by flare.

This 64:1 image brightness range is then compressed into the negative density range. Again, we have chosen a typical value of about 20:1 (1.3 log range). Shadows are again compressed slightly more than mid-tones and highlights, because they fall on the toe of the curve, though if we increase exposure so that the entire exposure range is on the straight-line portion of the curve, all tones would be equally compressed.

Finally, in the print, the shadows are 'opened up' again as the density range of the negative is expanded back to maybe 100:1. From all this, it is clear that the tones in the final print are something of an approximation to those in the original subject. The diagram shown is fairly impressionistic, but accurate enough to give a good idea of what is going on.

Windmill diagrams

Taken in conjunction with a compression–expansion diagram, a windmill diagram (opposite) gives a pretty good idea of how

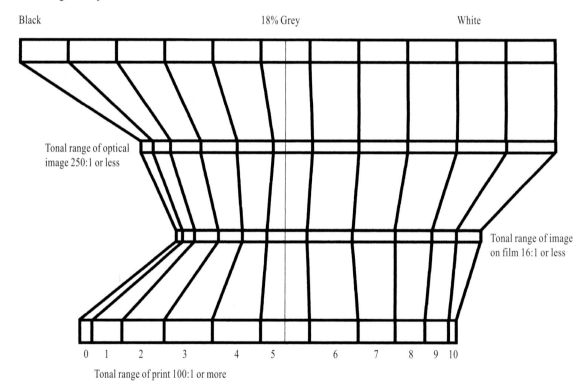

Tonal range of subject 1000:1 or more

Black 18% Grey White

Tonal range of optical image 250:1 or less

Tonal range of image on film 16:1 or less

0 1 2 3 4 5 6 7 8 9 10

Tonal range of print 100:1 or more

IDEALISED REPRESENTATION OF TONAL COMPRESSION AND EXPANSION

The line along the top in the diagram represents the tonal range of the subject. Zones 1 to 9 represent the maximum that a film can capture; Zone 0 represents shadow detail which will record as clear film, while Zone 10 represents highlights which will be recorded as a maximum black.

Principally because of lens flare, the optical image – the next line down – has a smaller tonal range; the dark values are said to be compressed. A still smaller tonal range can be captured on film, the third line down, and because of the 'toe' and 'shoulder' of the D/log E curve, both shadow and highlight tones are still further compressed. Finally, when the image is printed onto the paper (the bottom line) the shadows are expanded to something nearer their original values, while the highlights are once again slightly compressed.

This is only a sketch: the exact details will depend on the flare of the lens, the choice of negative material and how it is processed (in other words, the shape of the D/log E curve), and also the choice of printing material.

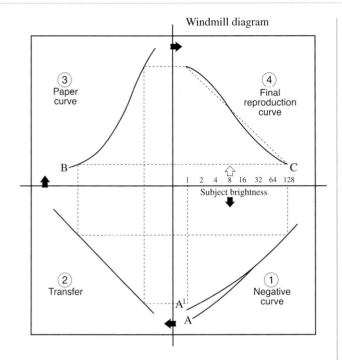

Windmill diagram

Curve 1 shows a subject brightness range of 128:1, log range 2.1, reduced by flare to an image brightness range of 64:1, log range 1.8. This 1.8 image brightness range gives a negative with a log density range of 1.3; very crudely, the slope can be calculated as 1.3/1.8 or about 0.72.

Curve 2 assumes a subject brightness range of 256:1 or log range 2.4, reduced by flare to an image brightness range of 128:1 or log range 2.1; the required negative density range does not change, so the slope of the D/log E curve must be gentler. In fact, by the same crude criterion which takes no account of toe shape, it is now 1.3/2.1 or about 0.62.

Curve 3 shows a subject brightness range of 256:1 again, but this time with an effectively flare-free lens so that the image brightness is also 256:1 or log range 2.4. Again, the required negative density range is 1.3, so the slope is 1.3/2.4 or about 0.54.

The final curve, number 4, shows a subject with a limited brightness range – just 64:1 – which was shot with a lens having a flare factor of 4, bringing the image brightness range down to a mere 16:1 or log density range of 1.2. If this is to give us our required negative density range of 1.3, the slope must be an impressive 1.3/1.2 or close to 1.1.

Interestingly, these figures are all borne out by common recommendations. In particular, view camera users (with their contrasty lenses and flare-reducing bellows) habitually curtail development by quite a long way to get the slope of the D/log E curve down, while 1940s recommendations for snapshot developing and printing typically assume gammas of 0.8, 0.9 and even 1.0 to compensate for the flat, flary, uncoated lenses and imperfectly blacked camera interiors of the period.

tones are distorted by both film D/log E curves and paper D/log E curves, working in tandem.

Square 1 shows a subject with a brightness range of 128:1 which maps onto D/log E curve A[1], modified for flare from the basic film D/log E curve A. Square 2 is just a transfer scale, while square 3 maps the negative density range onto a print characteristic curve B. Finally, square 4 shows the overall reproduction curve C, with the shadows and the highlights compressed slightly but the mid-tones reproduced more or less accurately. This diagram takes a little thinking about, but if you take each square in turn, it makes sense; after which, the whole thing makes sense at once.

Subject brightness, flare and slope

The curves shown below pretty much recapitulate what was said in Chapter 2, but they may mean more now that you have seen how subjects can vary widely in brightness range: you can clearly see how variations in slope can accommodate different subject brightness ranges and different flare factors.

RECULVER TOWERS

The tonal range in this fish-eye shot is plainly enormous, from the deep shadow at the top to the sunlit scene outside; but a soft paper (grade 1) allowed a normally developed negative to be printed adequately. There is, however, some flare, which helps to flatten the contrast range.

WRIGHT 4X5IN, ZODIAC FISH-EYE LENS, ILFORD FP4, SPOT READINGS WITH MINOLTA SPOTMETER F TO CONFIRM BRIGHTNESS RANGE. (RWH)

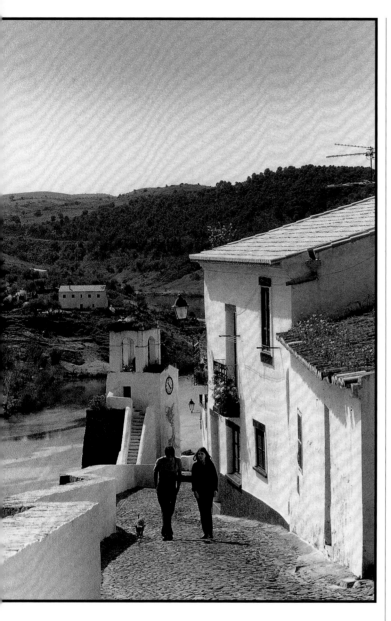

HAGIA SOFIYA
First, the tonal range is enormous. Second, no tripods are allowed, so fast film is the only option: this is Fuji RSP rated at EI 2500 and processed as for 3200. An incident light reading from the camera position, with the meter pointing away from the window, meant that the windows would burn out; but it gave plenty of interior detail.
LEICA M2 SUPPORTED ON CAMCANE MONOPOD, 35MM F/1.4 SUMMILUX, GOSSEN VARIOSIX F. (RWH)

which rather neatly illustrates why shadow density criteria are a less useful way of determining film speed than fractional gradient criteria.

'BREAKING THE RULES'

By now, it should be apparent that there are very few absolutes in exposure determination. Far from alarming you, however, this should prove liberating.

The first and most important realisation is that if you are not getting the best possible results, you are not necessarily doing anything wrong, nor is your equipment necessarily defective. All that has happened is that the numerous approximations and best guesses that have been made by the

SPECULAR REFLECTION
In the picture without the bread knife, the tonal range is very limited and had to be expanded by increasing development by around 50 per cent. The bread knife adds a specular reflection, but this would lie outside the recording range of the film anyway, so the film was still developed for extra contrast; trying to accommodate more detail in the blade would have led to a flat, dull picture. Exposure determination was by incident light reading with the dome of the meter at right angles to the camera/subject axis.
LINHOF TECHNIKA 70, 100MM F/5.6 APO SYMMAR, ILFORD 100 DELTA RATED AT EI 64, GOSSEN VARIOSIX F. (RWH)

MERTOLA STREET WITH COUPLE
Although it would have been possible to hold some detail in the girl's clothes, by reducing development time, it would have been at the expense of flattening all the contrast elsewhere; so we stuck to normal development (in Paterson FX39) and exposure as indicated by a Sixtomat Digital, rating Paterson Acupan 200 at EI 100.
NIKKORMAT FT2, 90MM F/2.5 VIVITAR SERIES 1 MACRO. (FES)

In any attempt to establish realistic working film speeds, or to design exposure meters, there must be some attempt to allow for a standard flare factor. Historically, this was 4x. In other words, a subject brightness range of 128:1 would be reduced to 32:1 at the film plane. A more realistic modern figure might be 2x, reducing a subject brightness range of 128:1 to 64:1 at the film plane. For that matter, a multi-coated view camera lens in a well made bellows camera may effectively have a flare factor of 1, ie effectively no flare, leaving the image brightness range at 128:1 as well. The mid-tones and highlights are, of course, affected very little by flare,

manufacturers of film, paper, cameras and meters are not working all that well for you. You should therefore have no compunction about altering EIs for any sort of film, colour or mono, or about altering development conditions for black and white films.

The second realisation should be that you can either work everything out from first principles, every time, or you can (in many situations) simply adopt rules of thumb. Even if the correction afforded by a rule of thumb is not perfect, it will be in the right direction, and the exposure will be better than if you had not exercised it. Wherever possible, we have given

TREES AND LAKE

You can find pictures almost anywhere: this was taken from a motorway service station near the Scottish border. Frances used Ilford SFX, because it was what she had in her Nikkormat, though HP5 would have given much the same effect. Exposure was as indicated by an incident light reading with a Sixtomat Digital, rating the film at EI 400 with no filter, and the print is on grade 3½ paper.

VIVITAR SERIES 1 90MM F/2.5.

such rules of thumb all through this book, but to make life easier, they are summarised (with page references) in Appendix II.

FILM TESTING

More nonsense has probably been written over the years about film testing than about anything else. It is certainly true that each individual photographer can usually benefit by establishing a personal exposure index or EI (which may or may not correspond to the ISO speed), and by adjusting processing times to give a negative which prints well on a middling grade of paper; but equally, the sort of testing

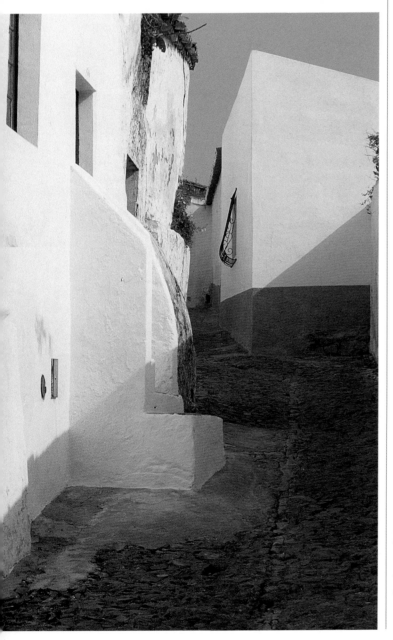

which involves 100 sheets of 4x5in film and countless pictures of grey cards is for most people a complete and utter waste of time.

Between this extreme, and the other extreme of sticking slavishly to the manufacturers' published speeds and development times, there are two intermediate approaches to film testing. One is a process of continuous refinement – in other words, just taking pictures – and the other is formal testing. The former can be used without the latter, but the latter must be combined with real picture-taking if it is to have any value.

FACTORS AFFECTING RESULTS

Before looking at testing in detail, it is also worth pointing out that photography involves many stages and elements, and that all of them are interdependent.

To begin with, some lenses are contrastier than others. While we were working on this book, Roger was caught out on this. He normally uses Leicas in 35mm, where the extra contrast of the lenses is often reckoned to be worth a paper grade in contrast. When he shot the same film as he shoots in his Leicas, but using zooms, there was a detectable loss of sparkle and contrast. To some extent, this can be recovered by increasing development time in monochrome, or by choosing a contrastier film in colour. Unfortunately, he neglected to do either.

Then there are calibration errors, in both shutter speeds and lens apertures. Many shutters run slow at their higher speeds, often as much as $\frac{1}{3}$ or even $\frac{1}{2}$ stop. Maximum lens apertures are often overstated on cheap zooms, or simply inaccurate at smaller openings, and we once had a 120mm f/6.8 Schneider Angulon where the diaphragm pointer was bent and indicated f/32 at f/22.

Processing is not so exact a science as many pretend, and small colour and density variations are not unusual between even top professional labs. In monochrome, variations can be still greater: that staple of so many photographers, Kodak D-76, increases significantly in pH with use and storage, and the degree of aeration involved in mixing it can affect pH

STREET, MERTOLA
You need to know your lenses as well as your films. This was shot with an old 1970s Vivitar Series 1 35–85mm f/2.8: flare has flattened contrast and opened up the shadows. Any less exposure would not look more saturated, but merely darker. Our 35mm f/2.8 PC-Nikkor would have given far more contrast.
NIKON F, KODAK EKTACHROME 200 PROFESSIONAL, INCIDENT LIGHT READING WITH
VARIOSIX F. (RWH)

CRACKED MUD
While we were working on this book, Kodak announced a considerable expansion of Kodachrome processing capacity. The old, slow Kodachrome 25 remains a stunning film to this day, and if processing is not too inconvenient it warrants serious consideration.

NIKON F, 90–180MM F/4.5 VIVITAR SERIES 1, INCIDENT LIGHT READING WITH VARIOSIX F. (RWH)

SUNSET ON OUR HOUSE
If you have a few frames on the end of a film, 'waste' them on experimenting with different lighting conditions. It does not matter if the picture has no artistic merit: what you want to find out is how a given sort of light records on the film. This was shot with the sun just above the horizon, using a straight incident light reading.

CAMERA AND LENS FORGOTTEN, VARIOSIX F. (RWH)

significantly from batch to batch. It also cycles up and down in pH with keeping, so anyone who uses neat D-76 is unlikely ever to produce fully repeatable results. Variations are less significant when it is used diluted, in all fairness.

Or again, different people time development in different ways (from starting to fill the tank, or from when the tank is full; to starting to empty it, or to when it is empty) and thermometers commonly disagree by up to 0.5°C. And then different enlargers and enlarger lenses affect contrast to different degrees.

The only valid results, therefore, are the ones which you find out for yourself; and although you can carry them across into other combinations of film, developer, lab, camera, lens and so forth, you need always to be on the lookout for departures from what you expect, as witness the story about the Leica lenses and the zooms above.

MONOCHROME FILMS: REFINING DEVELOPMENT AND EXPOSURE

For the moment, we shall ignore colour – that will be dealt with on page 68 – and we shall also ignore the precise mechanism of metering; we shall just say, 'using your usual methods'. It may be that your usual methods have changed by the time you finish this book, but unless you understand the

CASTLE, MERTOLA

We sat on the roof of the hotel with the camera on a tripod, trained on the castle. As the light changed, we took a sequence of pictures (bracketed 1 stop each way, each time). The rest of the time, we drank *vinho verde* and ate crisps. Shooting half a roll of film like this will tell you a great deal about how it behaves at twilight. Exposure determination was via a spot reading of the castle keep; this was 1 stop over.

NIKON F, 90–180MM F/4.5 VIVITAR SERIES 1, KODAK EKTACHROME E200, SPOT MASTER 2. (RWH)

VIEUX CARRÉ, NEW ORLEANS

We find it hard to resist films which are described by the manufacturers as being unsuitable for general photography. This is a duplicate from Polachrome HC; a duplicate because Polaroid emulsions are notoriously tender and easily damaged by reproduction houses.

NIKKORMAT FT2, 35MM F/2.8 PC-NIKKOR, VARIOSIX F INCIDENT LIGHT READING. (RWH)

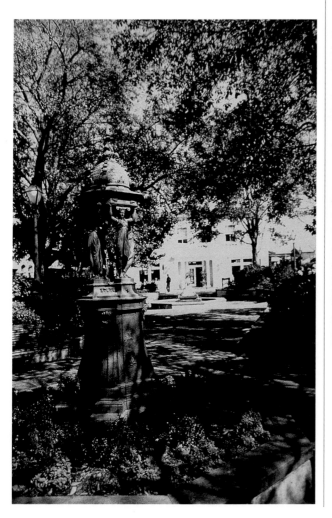

intimate interrelationship of exposure and development, you cannot do much about refining your exposure technique. The test could not be simpler. It is this. Are you happy with your prints? If not, why not?

You can add one qualification, which is, that your prints should be reasonably easy to make on a reasonable grade of paper, ie not excessively hard or excessively soft. The definition of 'excessive' is, however, up to you. Some people have an almost religious belief in grade 2 paper, and refuse to

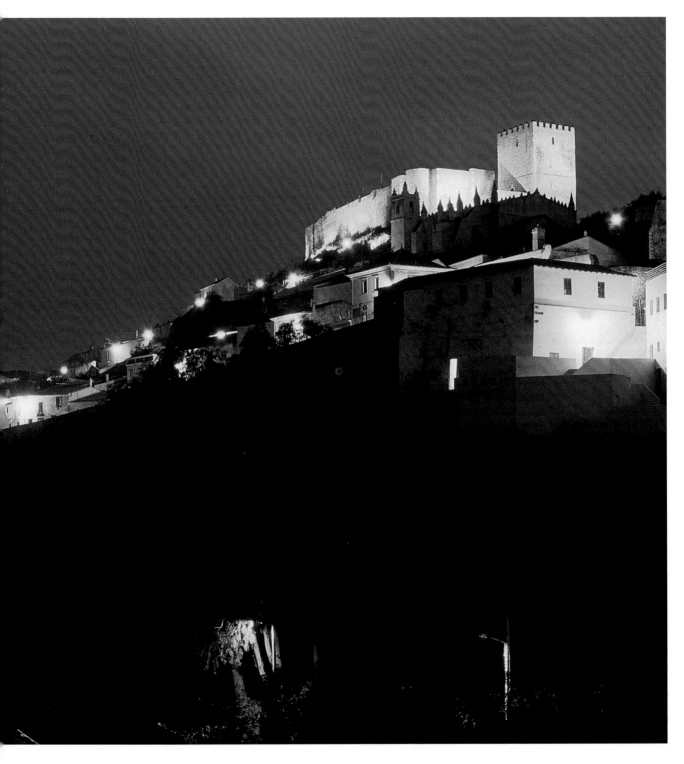

print on anything else. If you are like that, you will have to take considerably more pains to get consistent negatives than if you print on variable-contrast paper.

You can go about your testing with one of two types of print. The easiest approach for most people will be to work from one made from a negative of an 'average' sort of subject: one with a good distribution of tones from shadow to highlight, but without an unusually long or unusually short tonal range. The other possibility, if you specialise in a particular type of photography, is to use a typical negative of one of your typical subjects. Someone who habitually photographs nudes in a studio will usually want different negatives from someone whose delight is woodland scenes and leafy glades.

The most usual sin in inferior prints is flatness or muddiness. Even if the negative is perfect, the print may be muddy because of a dirty enlarger lens; or unsafe safelights (leading to fogging and overall veiling of the image); or

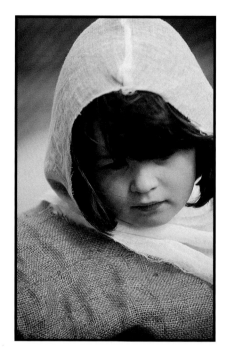

GIRL WITH HOOD

Skin tones are paramount to some photographers, unimportant to others. For children, high-saturation films are often very effective, but adults who tend to a florid complexion can go purplish if under-exposed even slightly – as this shot had to be in order to hold texture in the cap.

LEICA M4P, 90MM F/2 SUMMICRON, KODAK ELITE 100, LUNASIX. (RWH)

exhausted or contaminated developer (leading to poor blacks, again sometimes with veiling); or 'snatching' the print out of the developer before it is fully developed (poor blacks); or insufficient exposure of the negative (poor blacks again); or the choice of too soft a grade of paper. Of course, these faults (which are covered more fully in our *Black and White Handbook*, also from David & Charles) may exist singly or in combination.

The Manichaean twin of muddiness is excessive contrast, leading to a 'soot and whitewash' appearance. This is harder to achieve with a good negative, but you can do it with excessively hard paper or by over-exposing and then 'snatching' the print before it is fully developed.

The third common problem is 'empty' shadows. This is no problem when it is the effect that you want, but equally,

the appeal of many pictures does lie in the richness of their shadow detail. Again, you can achieve this effect even with a perfect negative by poor printing, usually by choosing excessively hard paper. If you do, your highlight detail may be ideal, but shadow detail will still be lacking.

The fourth problem is uncontrollable highlights, which simply remain at paper-base white without any hint of gradation. Once again, overly hard paper will enable you to get this effect from a perfect negative, in a print which exhibits good shadow detail.

Now, a lot of these problems come down to choosing the wrong grade of paper, which immediately suggests that you can make life easier for yourself by aiming for negatives which will always print on a middling grade – typically, 2 or 3. But if your enlarger lens is sparkling clean; if you have no problems with unsafe safelights; if your developer is fresh and clean; if you always develop the print fully; and if you still cannot get a good print, regardless of how long or how short the enlarger exposure time may be, or what paper grade you use – in that case, your negative is probably at fault.

Examining the negative

First of all, is the detail you want on the negative? If shadow detail is not there, it cannot print. The only reason why it will not be there is because you are under-exposing. The only way to remedy this is to increase your exposure, and the easiest way to do this is to set a lower exposure index (EI) on your meter or to dial in some sort of compensation. Because a slower film requires more exposure, setting a lower film speed on your meter will mean that it recommends more exposure. You may also increase exposure by changing your metering technique, but this is something for later in the book.

Normally, a 1 stop increase in exposure levels – in other words, halving the ISO speed – is a good starting point. You may later decide that you can creep back up a little, by ⅓ stop or even ⅔ stop, or you may find that you need to lower the EI even further; but the results you get will almost certainly be better than the ones you had before, so your first step is in the right direction.

Next, does the negative look to be of reasonable contrast and density? This is harder to judge than you might think, because some films look a lot thinner than others for a given printing density. Also, the

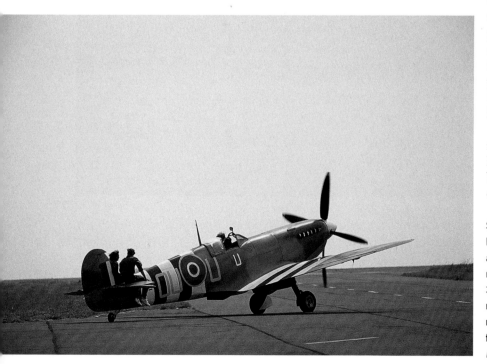

SPITFIRE

Be realistic in your expectations. No film on earth could add interest to this dead white sky, though matters were not improved by using a very flat, low-contrast Russian 300mm f/2.8 lens. A contrastier film would merely have made the sky whiter; the Spitfire would still have looked much the same. This was one of the highest-saturation films of its day, Fuji RF ISO 50.

NIKON F, INCIDENT LIGHT READING WITH LUNASIX. (RWH)

negative densities which correspond to changes in contrast of even a full grade do not necessarily look that different to the naked eye.

Things are not helped by the fact that the examples in books are normally wildly exaggerated. The typical illustration, as in our own *Black and White Handbook*, shows nine negatives. The middle negative in the middle row is correctly exposed and developed. To its left, there is one which is correctly exposed but under-developed, and to its right, there is one which is correctly exposed but over-developed. The top row consists of three under-exposed negatives, developed for the same times as the middle row, while the bottom row consists of over-exposed negatives, again developed for the same times.

There are two problems here. One is that an under-exposed and over-developed negative, or an over-exposed and under-developed negative, can often give better results than a 'correctly' exposed and developed negative, depending on the results you want. The other is that the differences are pretty subtle, so they have to be exaggerated for publication by gross over- and under-exposure (typically 2 stops, sometimes 3) and by gross over- and under-development (typically 50 per cent and 200 per cent). If your negatives are this far out, either on exposure or on development, then they are pretty bad!

SLIPPERS, GRAND BAZAAR, CONSTANTINOPLE
Although Fuji RSP is excellent for many subjects, this is not one of them. Increased saturation and better blacks are all but essential: a slower film would have been far more successful.
LEICA M4P, 90MM F/2 SUMMICRON, INCIDENT LIGHT READING WITH VARIOSIX F. (RWH)

ACROSS THE GOLDEN HORN (OVERLEAF)
A good rule of thumb for recording lights at night is to apply the 'sunny 16 rule' (see page 189). If you reckon the lights would be bright enough to show in daylight, use the sunny 16 rule; otherwise, give 1 or 2 stops more to make sure they read. Remember, too, to allow for reciprocity failure (see page 188), though many modern films are astonishingly resistant to this. Bracket if feasible; this is the central estimated exposure.
LEICA M2, 90MM F/2 SUMMICRON, KODAK EKTACHROME E200. (RWH)

Judging negatives is, then, a matter of experience; but negatives which are ridiculously thin or ridiculously dense, or patently flat or patently contrasty, argue that you are either under-developing or over-developing. For thin, flat negs, increase your development, and for overly contrasty negs, decrease your development.

Remember that increasing development may give an increase in effective film speed for your purposes, and that decreasing development may give a decrease. The reason that we say 'may give' is because actual shadow detail is going to be

FIRE HYDRANT
When you first try a new film, try to shoot as wide a range of subjects as possible with it. Polished metal is a good indicator of how it will handle highlights, and of what the grain is like. Try over- and under-exposure, too, to see what happens to colour saturation. This is 1 stop down on an incident light reading using Kodak Elite 100.

LEICA M4P, 90MM F/2 SUMMICRON, VARIOSIX F. (RWH)

affected far more by exposure than by development, and any increase or decrease in effective speed is going to depend very much on the importance of shadow detail in your images.

Printing

If the negative has detail in both shadows and highlights, it should print satisfactorily on one grade of paper or another. That is, you should be able to get shadow detail and highlight detail, and a good range of tones in between. If it requires a very soft grade, then the chances are that it was developed for too long, and if it requires a very hard grade, then the chances are that it was not developed for long enough.

To change your development times, begin with either 15 per cent less or 50 per cent more than your usual time, rounding to the nearest half minute. In other words, if you normally develop for six minutes and your negs seem over-developed (requiring a soft grade of paper), then cut development time by 15 per cent (0.9 minutes, rounding to

five minutes' development time), or if they are flat and require a harder grade, then increase it by 50 per cent (three minutes, giving nine minutes' development time). Of course, leave everything else the same: developer, developer dilution, temperature, agitation. Changing more than one variable invalidates the whole procedure.

It may well be that 15 per cent and 50 per cent are overly large adjustments, and that you will overshoot: where you formerly needed hard paper, you will now need soft, and vice versa. But this is the best way to do artillery ranging, which is closely akin to what you are doing. Once you have straddled the target, it is much easier to guess at a development time (or range) which gives you the results you want. And make no mistake: it is a guess. No developer designer will tell you otherwise. It will be an informed guess, but a guess is all it will ever be.

The alternative to 15/50 is to increase or decrease your development time in half-minute steps (or one-minute steps if your initial developing time is eight minutes or more), until you get to a negative which prints easily on grade 2 paper. This approach works equally well.

Remember that these test negatives do not have to be timeless masterpieces; you can either 'waste' a roll of film, or shoot your test subject on the end of a roll of general subjects, even if the other subjects on the film have not been 'typical'. We often shoot our back garden gate, where the black rubber

lid of a dustbin and a little whitewashed garden ornament (a leftover from a previous owner, we hasten to add) provide useful references for highlight and shadow detail.

The second iteration
Once you have changed your film speed or your development time, or both, as necessary, ask yourself the same question as before. Are you happy with the prints? By now, if you are not, you should have to make only very small adjustments to both speed and development: perhaps ⅓ or at most ⅔ stop in speed and half a minute in development. Anything less than half a minute is not normally meaningful,

PELOPPONESE

At sunset, it is not just light levels that change: so does the colour of the light, along with the overall mood. These two pictures were taken less than ten minutes apart. Exposure was based on direct light readings from the sky using a Variosix F without the incident light dome.

MPP MK VII WITH HORSEMAN 6X12CM BACK, 150MM F/4.5 APO LANTHAR, KODAK EKTACHROME EC100 FILM. (RWH)

unless development times are very short (below five minutes or so), in which case you may wish to decrease the temperature or increase dilution in order to get a more manageable time: excessively short processing times greatly

increase the risk of uneven development. You will now have established a personal regime for both exposure and development for normal subjects (or for the subjects you normally shoot). Any variations thereafter should relate only to unusual subject matter or to obtaining particular effects.

TESTING COLOUR SLIDE FILMS

The only meaningful way to test colour slide films is by taking pictures with them – preferably quite a lot of pictures. After a while, you should get a feeling for whether you would prefer your pictures to be a little lighter or a little darker. The next step is simple: set a different film speed on your camera or meter, or dial in some exposure compensation. Only very rarely will you need to depart by more than ⅓ stop from the

manufacturer's recommended speeds, setting (for example) EI 40 instead of ISO 50, or EI 80 instead of ISO 64.

Of course, if your pictures are inconsistent – some too light, some too dark – then your metering technique is probably at fault, and this is dealt with at greater length throughout the book. The other possibility is that your lab is at fault or, if you process your own, that you are at fault, though faulty processing will also signal its presence by wild swings in colour balance as well as density, and by poor, greyish blacks.

There is also the point that sometimes you actually *want* more or less density than 'normal'. You might well decide to cut exposure by ½ to 1 stop if you are photographing whitewashed walls, in order to hold a little more texture in them, or to increase exposure by the same amount if you are photographing a subject where you want to emphasise glaring light and blasting noonday heat. Make your best guess, and expose accordingly.

TESTING COLOUR PRINT FILMS

For the reasons given on page 16, exposure really is not very critical with colour print films. If you find that you often get weak, greenish blacks, or if you are always looking for more shadow detail, then just reset the film speed on your camera or meter. In general, ⅔ stop or even a whole stop of extra exposure will give you better results, especially with faster films: reset ISO 400 to EI 250 or even 200, for example, or dial in ⅔ stop or 1 stop exposure compensation.

Time and again, however, the problems which people experience with colour print films are the fault of sloppy labs, rather than poor negatives. Always check the negative to see if it is good and 'meaty' and whether there is obvious shadow detail. If it is there on the neg, but not on the print, then the lab is at fault. Ask for a reprint, or change labs.

BRACKETING

To a certain extent, bracketing is an uneasy subject to introduce into a book on exposure. At its extreme, you can simply shoot a dozen exposures, all different, and choose the best – so there is no need for a book on exposure at all. At the other extreme, refusing to bracket your exposures can be a very false economy: better to waste a little film than to lose a possibly irreplaceable picture. Also, bracketing can give you a real feeling for how a film responds to different lighting conditions, thereby helping you to acquire the experience you need to make the almost instinctive corrections which result in perfect exposures.

Although we are reasonably confident of our own exposure technique, we still tend to bracket many shots whenever feasible. In effect, we have four levels of bracketing. One is the grab shot, where you have to get it right first time, sometimes without much opportunity for metering; and generally, we do get it surprisingly right. The second is where we are unsure which of two renditions will work best, and therefore shoot both: one at what we reckon to be the 'safe' exposure and one which we reckon will emphasise the effect

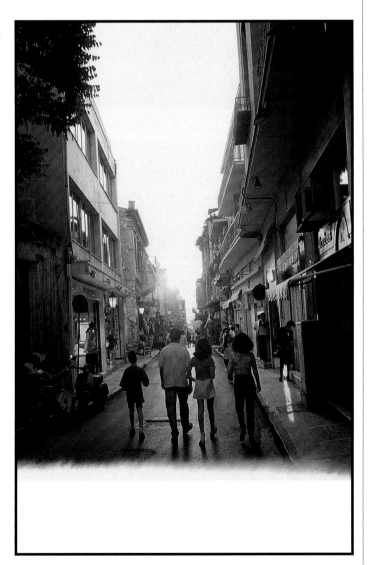

FAMILY IN STREET, ATHENS
It happens to us all... Roger had just finished loading his Leica when he saw this family walking into a science-fictional sunset. He grabbed the shot, estimating the exposure, but it was (almost) on the first frame of the film. The second frame, with the same exposure, had lost the poses.

LEICA M2, 35MM F/1.4 SUMMILUX, KODAK EKTACHROME E200.

we need. The third is when the exposure genuinely is tricky – especially backlit shots – where we will normally bracket both over and under. The fourth is when we want to match a series of transparencies, shot under different lighting, as closely as possible, and here we may shoot as many as five brackets, including the best guess.

Bracketing rests

The 'rests' or exposure differences between brackets will depend on the film and the subject matter. With a contrasty film like Fuji Velvia in the studio, we will typically shoot ½ stop or even ⅓ stop brackets if we have a tricky exposure problem or if we are trying to match a series of transparencies.

TAVERNA, ATHENS

A point made elsewhere in the book is that with very fast slide films, generous exposure – even 1 stop over – normally gives a more attractive result than a 'normal' exposure or (worse still) under-exposure. Colour shifts due to mixed light sources are reduced, there are fewer murky shadows and the overall result is happier. If you want lots of darkness, use a slower film whenever possible.

LEICA M2, 35MM F/1.4 SUMMILUX, FUJI RSP RATED AT EI 2500 AND PROCESSED AS FOR EI 3200, INCIDENT LIGHT READING WITH VARIOSIX F AT SUBJECT POSITION. (RWH)

OVER-EXPOSED BOAT

Wilful over-exposure is a part of getting to know a new film. Sometimes, you may even get pictures you like; this has a sort of pastel charm to it.

LEICA M2, 90MM F/2 SUMMICRON, FUJI ASTIA. (RWH)

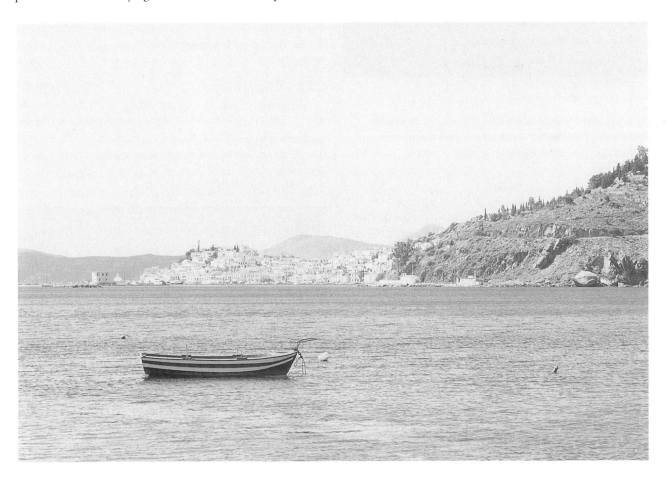

mistake next time. Most people periodically mistake one film for another, and expose ISO 100 at 200 and vice versa. If you do that, and it gives you a good picture, you have learned something.

FORMAL TESTING

The only films which it makes sense to test other than empirically are black and white films – and even then, formal testing is far from essential. In particular, there are plenty of books on the Zone System (see page 74) which tell you how to do exhaustive testing. The main problem with them is that they are so exhaustive, we believe, as to be substantially meaningless, as well as being tedious in the extreme.

The problem with most Zone System testing is that it is designed to be carried out without densitometers. Trying to work simply by comparison with known densities – most particularly, by comparison with 18 per cent grey cards – is to make sensitometry a lot more difficult and time-consuming than it needs to be. If you really want to do formal testing, we strongly urge you to either buy, borrow or hire a densitometer. They are alarmingly expensive, in that even a modestly priced model like the Heiland TRD-2 illustrated on page 180 is comparable in price with a medium-range camera body, but they can tell you more, and faster, than almost anything else.

Although a densitometer is easiest to use and will give the best results, you can get meaningful comparisons of film densities with an enlarging analyser. Most models, including the Colorstar 3000 which we use, give log density readings of negatives projected onto the baseboard. These will differ somewhat from the readings which you get from a trans-mission densitometer, but they are a great deal better than nothing, or than comparing grey cards.

The other expensive piece of equipment which is highly desirable for detailed testing is a spot meter. There is more about these in Chapter 7, but for the moment, suffice it to say that while most true spot meters read a 1 degree spot, wider acceptance angles of 5 degrees or even 7.5 degrees can be quite adequate for the following tests.

CELT

This picture benefits from high saturation, but if it were any contrastier, the pectoral cross would be too dark and the bag strap would lose all texture.

LEICA M4P, 90MM F/2 SUMMICRON, KODAK ELITE 100, INCIDENT LIGHT READING WITH LUNASIX. (RWH)

With a forgiving film like Fuji Astia on location, we will typically bracket ⅔ stop (if the lens in question permits it) or a full stop. With negative films, we normally only bracket in the direction of over-exposure, a minimum of 1 stop and sometimes 2 stops.

Remember that your maximum distance from the best possible exposure (or from a matching exposure on another negative) is one half of your bracketing rest, so with a ⅓ stop rest you are going to be within ⅙ stop of the best possible, and with a ⅔ stop rest (the optimum for most slide films, most of the time) you will be within ⅓ stop.

Take credit for your mistakes

There is an old saying that you are not judged by the pictures you take, but only by the pictures you show people. An extension to this is that if you make a mistake, and it looks good, take the credit for it – and remember how to repeat the

TEST TARGET

Black flock, an 18 per cent grey card, and a piece of photo paper.

CATH MILNE
We very rarely make soft prints in conventional black and white, but sepia-toned images are another matter: very low maximum densities and very soft gradation often seem ideal for certain subjects.

NIKON F PHOTOMIC TN, 35MM F/2.8 NIKKOR, ILFORD HP5 RATED AT EI 320 AND DEVELOPED IN PERCEPTOL, EXPOSURE AS INDICATED BY CAMERA METER. (RWH)

THE MANI
An important part of testing any black and white film is its response to filters. This is Ilford XP2, shot with a deep red tri-cut filter (25A) and rated at EI 50 including the filter factor. The very beginnings of infra-red effects are visible – notice the lightening of the foliage – while the hazy sky is lent considerable texture and the honey-coloured stone of the sunlit side of the distant Mani tower is lightened considerably.

NIKKORMAT FT2, 35MM F/2.8 PC-NIKKOR, INCIDENT LIGHT READING WITH VARIOSIX F. (FES)

If you cannot arrange access to either a densitometer or a spot meter, then your ability to do meaningful, detailed testing will be considerably curtailed.

Making a test target
A quick, easy way to make a test target is to fasten three similarly shaped rectangles to a single piece of cardboard or wood. The size is not critical, but making each of them 8x10in is a good start. If they are too small, it will be impossible to take densitometer readings, though an analyser will still work.

One rectangle – the middle one – should be an 18 per cent grey card. These are available from many sources, including Kodak and Paterson Group International. If you do not want to fix it permanently to the target, use four small squares of self-adhesive Velcro so it can be detached for use elsewhere.

To one side of the 18 per cent grey card, put a piece of black velvet or (better still) some sort of black flock material; we used Fablon self-adhesive black flock. This should read about 2½ to 3 stops down from the grey card, using a spot or narrow-angle meter.

To the other side, put a piece of matt white photographic paper which has been fully fixed and washed without exposure or development. This should read about 2 stops up from the 18 per cent grey card, or maybe a little more. The reason for using matt paper is to minimise the effect of reflections from the light sources.

RESTAURANT, PARIS

'Empty' shadows can be used creatively; here, they focus attention on the three posters in the window, which look like the same reflection in three mirrors. Exposure was 1 stop less than indicated by an incident light reading with a Sixtomat Digital.

NIKKORMAT FT2, VIVITAR SERIES 1 90MM F/2.5, ILFORD XP2 RATED AT EI 320 AND PRINTED ON GRADE 3 PAPER. (FES)

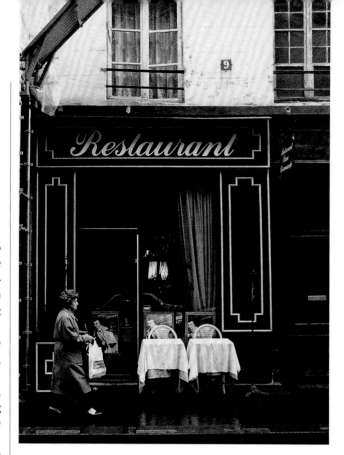

Shooting the test target

You now have a test target with a mid-tone and around a 5 stop contrast range (32:1, 1.5 log units). Under diffuse lighting (a cloudy day is good) or better still with copy-style lighting (one light each side, at 45 degrees to the target) take a spot reading of the grey card, or an incident light reading, and base your exposure on that.

Shoot at 20 focal lengths from the target; this reduces the exposure factor due to extra lens extension to insignificance, $\frac{1}{10}$ stop or less.

Bracket your exposures, in ½ stop or even ⅓ stop rests, from 2 or 3 stops under to 2 or 3 stops over. If you are using cut film, just shoot the one sheet; you can shoot the next one on the basis of your first test.

Next, develop the film in your usual way. The best negative is the one in which the three parts of the target are best differentiated from each other and from unexposed film base: the white paper should be detectably lighter than a piece

RUIN, PELOPPONESE

Sometimes, almost by accident, you come across a film/developer combination which seems almost perfect. Paterson Acupan 200 in Paterson FX39 is such a combination for us: from the first time we tried it, in 1997, it has been one of our favourites. Grain is merely average, but we find the tonality exquisite.

NIKKORMAT FTN, 35MM F/2.8 PC-NIKKOR, FILM RATED AT EI 160, INCIDENT LIGHT READING WITH SIXTOMAT DIGITAL. (FES)

of fogged and developed film, and the black velvet should be a good bit darker than film base plus fog. If you have a densitometer, you can take actual readings. The black velvet should be at least 0.10 log units darker than fb+f, and the white paper should have a density of around 1.1.

These figures are for normal, enlarging negatives: for contact prints (especially on printing-out paper) or for alternative processes, you may want the white paper to correspond to a maximum density of 2.1 or more.

If the black velvet is indistinguishable from film base plus fog, then you are under-exposing or under-developing or both. If the white paper is indistinguishable from fogged and developed film, you are over-exposing or over-developing or both.

If you do not have a densitometer or an analyser, the easiest thing is to print the test target so that the 18 per cent grey on the print matches the 18 per cent grey of the grey card. Use grade 2 paper. Remember to let the print dry before comparing it with the 18 per cent grey card, in order to allow for the inevitable darkening of the paper as it dries (dry-down). Again, the black patch should

WINDOW, MONTREUIL

Ilford XP2 is almost as forgiving as the colour negative films on which its technology is based: over-exposure causes a slight loss of sharpness, but that is all. Here, it retains detail in fairly deep shadow immediately above the window, with an exposure based on an incident light reading and an EI of 250.

NIKKORMAT FTN, 90MM F/2 VIVITAR SERIES 1, SIXTOMAT DIGITAL. (FES)

WALL AND VINE
Extreme contrast traditionally required high-contrast films and aggressive development, but the easiest approach today is to use a slightly contrasty film/developer combination such as was used here – Ilford Pan F over-developed by 10 to 20 per cent – and manipulate the image in Photoshop or a similar computer program. The negative remains printable on soft paper.
CAMERA AND LENS FORGOTTEN. (RWH)

improved and coated lenses became more usual (thereby reducing flare), it was stretched first to ten Zones (with additional shadow detail, thereby destroying the symmetry) and then to eleven Zones, restoring the symmetry but on Adams's own admission leading to a situation in which Zones IX and X could not always be differentiated by all photographers without special equipment.

The full eleven-Zone sequence is given in Appendix I; the original nine-Zone sequence, which will still give what most people regard as a superb print, is as follows:

read black, but not as black as a print made at the same exposure and aperture from the negative rebate (or from an unexposed film), and the white patch should have a tiny bit of tone in it.

Although this is not a particularly exhaustive or comprehensive test, it does allow you to get straight into the right ball-park with an unfamiliar film/developer combination, and it shows up faults quickly and easily. Used in combination with the kind of practical testing described in the first part of the chapter, it should enable you to establish 'normal' exposure indices and development times within three or four rolls of film.

Quite honestly, this is as much as you should ever need to do, but if you want to get really serious about film testing, there is further advice in Appendix I.

THE ZONE SYSTEM

The Zone System was invented in the early 1940s by the late Ansel Adams. He was without doubt one of the greatest photographers of the twentieth century, and those students who were fortunate enough to study under him report that he was also one of the greatest teachers of photography; but it is at the very least disputable whether his greatness either as a photographer or a teacher was much influenced by the Zone System.

The original Zone System used nine print Zones, symmetrical about Zone V, a mid-tone by definition. As films

DOG IN STREET
The Zone System cannot really be adapted to colour, despite the claims of some, but an understanding of the Zone System can make exposure in colour easier. A straight incident light reading leaves the lighter areas hovering on the edge of over-exposure, while a slightly flary lens (a 1970s Vivitar Series 1 35–85mm f/2.8) helped by flattening contrast, thereby opening up the shadows and giving detail in the dog; a Tiffen Ultra Contrast filter would have the same effect with a contrastier lens. Fuji Astia also helped; Velvia (for example) would have been too contrasty.
NIKON F. (RWH)

Zone I	The maximum black of which the paper is capable.
Zone II	The darkest tone distinguishable from Zone I.
Zone III	The darkest tone with detectable texture.
Zone IV	Dark mid-tones.
Zone V	The mid-tone: an 18 per cent grey.
Zone VI	Light mid-tones.
Zone VII	The lightest tone with detectable texture.
Zone VIII	The lightest tone distinguishable from Zone IX.
Zone IX	Pure, paper-base white.

Users of 35mm would be ill advised to try for anything more than the classical nine-Zone system, although they should (with modern materials) have a tiny bit of leeway. With 120, one can try for ten Zones: Zones I, II and III move down to become Zones 0, I and II, and a new Zone III is added comprising very dark tones with detail. Only with large-format cut film is it advisable even to try for the eleven-Zone system.

The most important thing to remember is that Ansel Adams was a teacher of photography, and that teachers inevitably try to supply a theoretical background to their subjects. Sensitometry is a difficult subject, and one which can lack charm for keen young photographers who just want to get out and take pictures. The Zone System was, therefore, a way of getting the attention of students, and of simplifying sensitometry so that they could understand it.

TREE ROOT, BERMUDA
Cynics sometimes point out that Ansel Adams was an excellent photographer before he ever invented the Zone System, and it is certainly true that (relative) ignorance does not preclude the possibility of good pictures; Roger shot this with a Pentax SV and a 50mm f/1.8 Super-Takumar on outdated FP3 in the 1960s, rating the film at EI 125 and relying on the clip-on Pentax meter.

Regardless of these reservations, it is a foolish photographer who does not borrow a number of useful ideas and terms from the Zone System. The naming of the Zones themselves is the most obvious, as is the concept of 'normal' and 'N minus' or 'N plus' development (Appendix I). Another useful concept is the distinction between 'placing' tones, and letting them 'fall'. For example, suppose we meter a Caucasian skin tone. We can then choose an exposure which renders that skin tone as a mid-tone; or as a co-ventional Caucasian skin tone, 1 to 1½ stops lighter than a mid-tone; or even as a dark mid-tone, as might be the choice in a low-key portrait. In each case, we are 'placing' the skin tone on a particular Zone: Zone V as a mid-tone, Zone VI-½ as a conventional skin tone, and Zone IV as a dark mid-tone.

Now suppose that the owner of that skin tone is wearing a sweater which is 2 stops darker than the skin tone. If we 'place' the skin tone on Zone V, the sweater will 'fall' on Zone III; texture will be barely visible. 'Place' the skin tone on Zone VI-½, and the sweater 'falls' on Zone IV-½, just a

ROOFTOPS FROM CASTLE, MERTOLA
Interpretation is everything. Frances maintains that this picture is too contrasty
and too low key. Roger maintains that it is exactly as he visualised it.
NIKON F, 90–180MM F/4.5 VIVITAR SERIES 1, PATERSON ACUPAN 200 RATED AT EI 160 AND
DEVELOPED IN FX39, SPOT READINGS FROM ROOFS AND WHITE WALLS.

little darker than a mid-tone; but 'place' the skin tone on Zone IV, and the sweater 'falls' on Zone II, where it will normally show no texture whatsoever. By decreasing development, we can make sure that the sweater 'falls' a little closer to the skin tone, while by increasing it, we can push them farther apart. The applications are obvious.

There are a number of other points which are worth making about the origins and application of the Zone System. One is that the densitometers of the 1930s and 1940s were proportionately even more expensive than they are today, and that before the advent of solid-state electronics they were temperamental and prone to drifting, so they had to be recalibrated frequently. An ad hoc form of sensitometry was, therefore, proportionately more useful than it is today, when

anyone who is serious about the subject can buy a densitometer for the price of a mid-range SLR body.

It is also essential to remember that Ansel Adams's most famous work was almost all shot on large format. In order to explore the full panoply of the Zone System, not only do you need to be able to develop each exposure separately, you also need big negatives. The former is essential because development is always matched to exposure, instead of being the kind of compromise which is inevitable when there are mixed subjects on a single roll, and the latter is essential because one of the central tenets of the Zone System as espoused by most of its devotees is what would, in normal sensitometry, be regarded as over-exposure. The more exposure you give a conventional film, the bigger the grain, and the lower the sharpness. While this is irrelevant with large formats, it can significantly reduce the quality of images available on roll film, and it is likely to prove near-disastrous with 35mm.

Although a number of books purport to extend the Zone System to roll film and 35mm, they should be regarded with

the utmost suspicion. Once again, we repeat that the naming of Zones was a work of genius, and we would argue that without the vocabulary of Zones, it would be vastly more difficult to discuss the practical application of sensitometry to real-world photography; but much of the rest of the content of most of the books by followers of Ansel Adams is a restatement either of Ansel Adams's own work (in which case you might as well read the originals) or a rehash of basic sensitometry in a hopelessly jargon-ridden form, normally coupled with an advocacy of tedious and repetitive tests which are of considerably less use than getting out and taking real pictures in the real world.

Phil Davis's *Beyond The Zone System* is arguably the first book to provide a real supplement to Ansel Adams's own books, and is a very worthwhile work; it does exactly what its name suggests, and goes beyond the 1940s basics. His suggestions on adapting a spot meter to use as a densitometer are ingenious, though if you are that serious about your photography, a densitometer should perhaps be one of your first purchases.

Otherwise, the Zone System tends to get stuck in a time warp; or at least, some of its most vocal supporters do. Many techniques which were appropriate for the thick emulsions and uncoated lenses of the 1940s are quite simply not appropriate today. Ansel Adams cheerfully recognised this, and embraced new technologies as necessary. The three gospels of the Zone System, namely *The Camera*, *The Negative* and *The Print*, provide a useful framework for calibrating exposure indices and development times to suit each photographer's needs, and are far more down-to-earth than most subsequent books on the Zone System; but a depressing number of modern followers of the Zone System bemoan the passing of obsolete (and slow, and unsharp) films, and attempt to apply old-fashioned development techniques which do not work very well with modern materials.

DON'T PANIC

Admirers of the other Adams – Douglas, not Ansel – will recall that this message was inscribed 'in large, friendly letters' on the cover of *The Hitchhiker's Guide to the Galaxy*. A similar message is required now. The truth is that you can get excellent results, the sort of thing that most photographers will envy deeply, by a simple process of trial and error; and that the best possible starting point is the manufacturers' exposure and development recommendations. Even your early images, before you have established a precise EI and development time, should be eminently printable, and they will only get better.

One of the best printers we know has a very simple philosophy. He uses readily available developers – no exotic potions and brews for him – and he rates his films at the manufacturers' stated speeds and then develops them for the manufacturers' recommended times. If he does not have enough shadow detail with the first film he develops, he just re-rates it the next time; typically, he gives ⅔ stop more than the ISO speed, so that (for example) an ISO 125 film is re-rated at EI 80, or an ISO 25 film at EI 16. He keeps the development time constant, however. He regularly wins photographic competitions, and his prints are the envy of everyone at his local camera club, the Isle of Thanet Photographic Society.

After that, it is down to accurate exposure...

WEEDS AND WALL, MONTREUIL
This was shot to illustrate the possibility of cropping panoramic pictures from Linhof 56x72mm roll-film negatives, using the then-new Ilford SFX 120. The visualisation was three bands of tone: the dark wall, the variegated plants and the even-toned sky. Exposure determination was via spot readings (using a Spot Master 2) of the fluffy white seed-clusters, the dark part of the wall and the sky.
SUPER TECHNIKA IV, 180MM F/5.5 TELE ARTON. (RWH)

METERING EQUATIONS AND CALIBRATION DATA

If there is any chapter in this book which will scare off those who are faint of technical heart, this is it. Before you even attempt to read it, understand this: you do not need to take it all on board. You can learn a great deal about exposure, and about how to improve your technique, even if you ignore this chapter completely – which, quite frankly, we advise you to do until your curiosity drives you to make the effort to work through it. You may, however, find it interesting to skip through the chapter until you come to the last section.

The reason this chapter is in here is simple: it is because the information is not conveniently available to the lay reader anywhere else. We found it interesting, for the light it casts on

the pronouncements issued by other exposure gurus: once you understand the basics, you are in a much better position to analyse and criticise the arguments of others.

It is only fair to say that most of the information concerning modern meters is proprietary; that is, it is not even described in the patent literature, but is secret. We have already seen how the premises on which metering is based are empirical, and this has the almost inevitable consequence that if a meter manufacturer can steal a march by using better empirical data, he will do so. All this chapter can do, therefore, is to give you a basic understanding based on agreed criteria.

A second caveat is that (once again) there are a lot of simplifications and approximations in this chapter, and in the design of meters generally. To take the most obvious example, what is the spectral response of a meter cell? Meter cells are clearly affected to different degrees by different wavelengths of light, and all a manufacturer can do is to make a compromise which he believes is the best possible. We shall return to this and related questions in Chapter 7.

CANTERBURY
This is not a particularly dull day. Indeed, by British standards it might be accounted pleasant. But it would be remarkable if the overall brightness range of significant tones in the picture reached 64:1, let alone 128:1, and generous development would be extremely advisable in monochrome.
NIKKORMAT FTN, 35MM F/2.8 PC-NIKKOR, KODAK EKTACHROME ED3 ISO 200, INCIDENT LIGHT READING WITH SIXTOMAT DIGITAL. (FES)

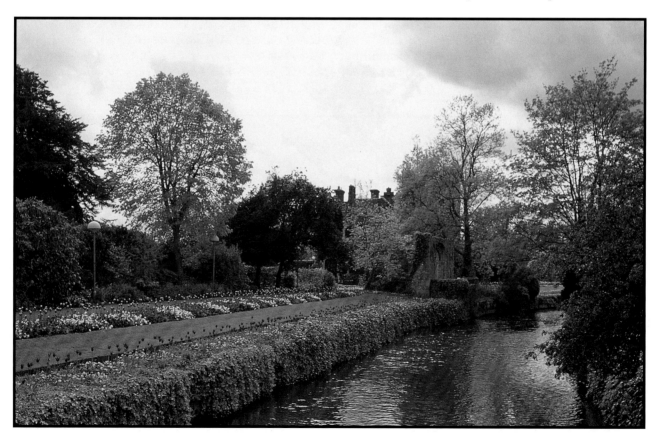

ORANGE
Flare levels in an elderly zoom (90–180mm f/4.5 Vivitar Series 1) desaturated this windfall orange; to retain the same sort of colour which his 90mm f/2 Summicron would have given, Roger should have used Velvia instead of Astia. Exposure was ½ stop less than indicated by an incident light reading with a Variosix F.
NIKON F.

SUBJECT AND IMAGE

The first thing to consider is the relationship between subject brightness, and illumination at the film plane. The basic formula for this is derived from work originally done by Kodak researchers L.A. Jones and H.R. Condit in the 1940s, and at first sight it is truly alarming:

$$I_0 = \frac{B(U\text{-}f)^2 tCH cos^4\theta}{4A^2U^2}$$

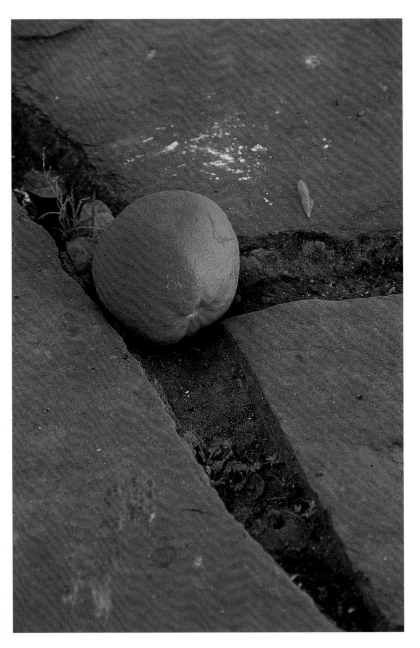

where I_0 is the image-forming illumination (in lux) at the focal plane; B is the subject brightness (lumens per sq m, as measured from the camera position); U is the object to lens distance; f is the focal length of the lens in use; t is the lens transmittance; C is the camera flare correction factor; H is the lens barrel vignetting factor; θ is the average angle of off-axis rays; and A is the geometric f/number of the lens. Upon closer examination, however, the whole thing does become slightly easier.

LENS CONSIDERATIONS

A good starting point is the aperture of the lens – the 'light stopping' effect. In practice, this is not quite as simple as the familiar f/number, as we also need to take into account the losses resulting from absorption and reflection in the glasses of the lens itself and the reduction in the effective f/number when the subject is closer than infinity (the effective lens speed decreases as the lens extension increases).

The first correction, t, takes into account the actual transmission of the lens. It is partially taken care of in the 'T/number', an idea which is more familiar in professional movie cameras than in still photography. The 'T/number' of a lens is equal to the equivalent f/number of a perfect lens with no such losses. Thus an f/2 lens might be described as T/2.2, the equivalent of a perfect f/2.2 lens. For the purposes of the exposure equations, transmittance is normally described in the form of the correction factor, t, above.

The original figure for t which was used by Jones and Condit was 0.85, though the ANSI standard of 1961 used 0.95 and the 1971 ANSI standard says that 'more recent information indicates' an average value of 0.90. It could easily go as low as 0.75 for a complex zoom, or a mirror lens, or closely approach 1.0 for a multi-coated triplet.

The exposure factor for a close subject is conveniently (if not immediately comprehensibly) expressed as $(U/U\text{-}f)^2$, where U is the lens – subject distance (strictly, the conjugate distance between the front nodal point and the object) and f is the focal length. The only catch lies in choosing a 'typical' subject distance.

Jones and Condit defined this as 40 focal lengths, presumably reckoning on a 105mm lens on an 8-on-120 roll-film camera. This equates to 4.2m (about 14ft). With the rise of the 35mm camera, this was revised to 80 focal lengths,

SEA AND RUIN, PELOPPONESE (OVERLEAF)
Painters tend to talk about 'quality of light' more than photographers, but there is no doubt that light and colour vary. This is ½ stop under-exposed, as compared with an incident light reading, to 'pop' the colours; but as the burned-out white of the house indicates, it is not in conventional terms significantly under-exposed.
NIKON F, 35MM F/2.8 PC-NIKKOR, KODAK ELITE 100, VARIOSIX F. (RWH)

EXPOSURE AND FILM SPEED

We know that the speed of an emulsion is defined in terms of that exposure (in lux-seconds) which gives a density of 0.10 above film base plus fog under the development conditions specified on page 36. This is expressed as

$$S_x = n/E_m$$

where S_x is the film speed, $n=0.8$, and E_m is the exposure required to give a density of 0.10 above film base plus fog; or more comprehensibly,

Arithmetic film speed=0.8 divided by the exposure required to give a density of 0.10 over film base plus fog, in lux-seconds.

The exposure meter recommends an exposure E_g which equals I_0T, where I_0 is the figure for image-forming illumination as arrived at above, and T is the exposure time in seconds; in equation form,

$$E_g = I_0T$$

The relationship between E_g, the recommended exposure, and E_m, the exposure required to give a density of 0.10 above film base plus fog, is assumed to be constant; if it is not, there is no fixed relationship between the film speed and the recommended exposure. This basic exposure meter constant, K_1, is normally expressed in the equation

$$E_g = K_1/S_x$$

or more comprehensibly,

Metered exposure (E_g)=constant (K_1) divided by film speed (S_x).

equating to 4m (about 13ft) for a 50mm 'standard' lens and 2.8m (about 9ft) for a 35mm wide-angle; but with a 210mm lens on a 4x5in camera, 80 focal lengths is an impressive 16.8m (about 55ft).

At 80 focal lengths, $(U/U-f)^2$ is 1.025, and the correction factor is negligible, but for a 210mm lens used on a 4x5in camera at around 1m (about 3ft) – which is a perfectly typical usage in the studio – it is about 1.25, which unless it is taken

HOUSE, RURAL GREECE
If you want texture and detail in bright white areas, a reflected reading is ideal precisely because it will recommend about 1 stop under-exposure; with an incident light reading, you will have to cut the recommended exposure by about 1 stop.

LEICA M2, 35MM F/1.4 SUMMILUX, FUJI ASTIA. (RWH)

into account will result in significant under-exposure.

Two less obvious correction factors are the losses H caused by lens barrel vignetting (strictly applicable only at full aperture), and the losses caused by off-axis rays. Jones and Condit took H as 0.80 and the off-axis angle θ as 15 degrees, which gives a value of $\cos^4\theta$ of 0.87. As so often, these were merely 'typical' values of the time, and the later ANSI standards took H to be 1.0 and the off-axis angle as 12 degrees which revised the $\cos^4\theta$ factor to 0.916.

Flare, represented by C, is a consequence of the way in which light is bounced around inside the lens and inside the camera, so that some of the light which reaches the film is non-image forming and serves only to lighten the shadows and degrade contrast. The original Jones and Condit flare factor was 4, which was fair enough in the days of uncoated lenses and box cameras but is far too high for modern coated lenses; the flare of a modern multiple-coated lens in a view camera with a well blacked bellows is close enough to 1.0 that the difference is not worth bothering about, and even a zoom

RUBBISH IN RUIN, MINAS SANTOS DOMINGOS
This would have been better shot on medium or large format; it depends for its effect on the numerous and varied textures. Paterson Acupan 200 gave excellent tonality, but 35mm is too small and the lens (our old 90–180mm f/4.5 Vivitar Series 1 from the 1970s) was simply not up to the job. With a larger format, of course, one could afford more generous exposure for improved tonality.

NIKON F, SPOT READINGS WITH A SPOT MASTER 2. (RWH)

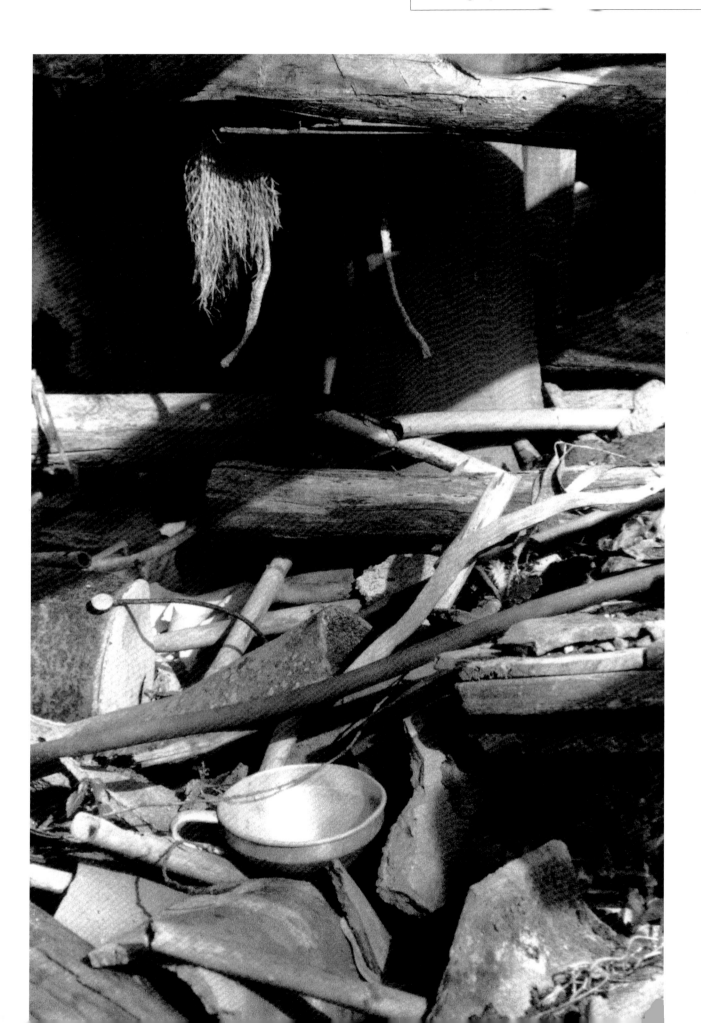

should not be worse than about 2.0. The assumed value in the 1971 ANSI standard was 1.03, and this is as good as any for our purposes.

In other words, we now have numerical values for transmittance t (0.90); for the correction factor for subject distance (1.025); for flare factor C (1.03); for vignetting H (1.0); and for $\cos^4\theta$ losses (0.916). We also know, though, that these are only 'typical' and that other figures could with a clear conscience be substituted. Even so, our variables are now

THE EXPOSURE METER CONSTANT

The value of the basic constant K_1 was determined experimentally by psychophysical testing, ie by popular acclaim, but it is only the starting point for other constants, K'_1, K_0 and the majestic K on its own, the last being the exposure meter constant. This wondrous constant appears in the basic exposure meter equation of

$$K = \frac{TS_x BK}{A^2}$$

where, by way of reminder, T is exposure time in seconds, S_x is the arithmetic film speed, B is the average field luminance and A is the geometric aperture or f/number. In words, rather than in algebraic symbols, K is equal to exposure time multiplied by film speed multiplied by field luminance, divided by the square of the aperture.

K and K_1

The value of K_1, on which K is partially based, depends on the spectral characteristics of the meter cell, the photographic effectiveness of the light on the scene, and the distribution of luminance levels in the scene as measured by the meter.

There is a three-cornered relationship between the light falling on (or reflected from) the scene, the response of the meter cell to that light and the response of the film to that light. Two constants are used to express this relationship.

The first constant, r, is the ratio of the luminance of the uniform surface source used in the original meter calibration to the luminance of the scene which produces the same response in the meter. If the calibration source has been wisely chosen, this should be 1.0, and it is assumed to be so, though in the old 1961 ANSI standard, it was taken as 1.05. The calibration source for the ANSI standard is diffuse blue light at 4,700K, achieved with separate non-diffusing blue filter (Corning blue daylight glass) and diffusing sandwich over a photometric lamp of 2,854K. In other words, it is not something which can readily be reproduced at home.

The second constant, p, is the ratio of the photographic effectiveness or 'actinity' of the scene illuminance to the photographic effectiveness of the illuminance used in determining film speed. Again, this should be 1.0, and is assumed to be so, though once again it was taken in the old 1961 ANSI standard to be something different, namely 1.1.

But as well as p and r, K_1 also takes account of the luminance distribution factor R, which is defined as B_a/B_d, where B_a is the field luminance as measured by the meter and B_d is the value of luminance which would give the best picture. The value of R for an average scene is (predictably) taken as 1.0, but it is a useful reminder that this is only an average value. When p, r and R are all unity, the constant K_1 is known as K'_1.

The basic value of K'_1 was established in the 1961 ANSI standard as 8.2, along with the following values for K; the reason for the choice is the proliferation of lighting units.

K for lumens/sq m (apostilbs) = 35.8
K for candelas/sq m (nit) = 11.4
K for lumens/sq ft (footlambert) = 3.33
K for candelas/sq ft = 1.06

Given that p and r can both change, according to film response and testing techniques, a further constant, K_0, was invoked in the 1971 standard, so that $K=K_0 r/t$. The values of K were revised as follows:

K for lumens/sq m (apostilbs) = 39.2
K for candelas/sq m (nit) = 12.4
K for lumens/sq ft (footlambert) = 3.64
K for candelas/sq ft = 1.16

and the following values of K_0 were used, which are the same as the old values of K:

K_0 for lumens/sq m (apostilbs) = 35.8
K_0 for candelas/sq m (nit) = 11.4
K_0 for lumens/sq ft (footlambert) = 3.33
K_0 for candelas/sq ft = 1.06

Then, just to make life more interesting, there is the rider in the 1971 ANSI standard that this value of K is valid for 16mm and larger films when projected. The lower screen luminance of 8mm films means that they need about ⅓ stop more exposure than larger formats, so K_0 (apostilbs) becomes 44.1. The relevance of this to a book on still photography – and indeed, to a world where 8mm film is mainly of historical interest – is merely to illustrate that the exposure meter equations are a highly sophisticated, codified and refined version of 'what works, works'.

reduced to B (the average field luminance) and to A, the lens aperture, with a 'fudge factor' which is achieved by multiplying all the above factors together.

THE IMPORTANCE (OR OTHERWISE) OF ALL THIS

The more fiercely critical reader will object that we have taken the above information from an obsolete ANSI standard, rather than the current ISO standard. The reason for this is no more, and no less, than the fact that the ANSI standard was conveniently available, and the ISO standard was not. Besides, the important thing was to show just how widely assumptions can vary, and how extraordinarily complex is the theoretical-cum-empirical basis for exposure determination.

BOAT, WESTON-SUPER-MARE
This was shot with a Leica A, with a fixed, uncoated 50mm f/3.5 Elmar, dating from about 1931; Roger took this picture on FP4 in the late 1970s, metering with a Weston Master V. For monochrome, even in 35mm, uncoated lenses can deliver attractive 'vintage' effects to this day, but with colour they are inclined to be very blue and slightly flat. With larger formats, some people actually prefer the look of ancient, uncoated lenses.

After all, you cannot do very much about how an exposure meter is calibrated. All you can do is to modify the readings you get, based on intelligent analysis of the scene and knowledge of the meter's behaviour, to get the results you

BACKLIT NETS, GOA
The exposure here conveys precisely the effect that was wanted – Roger was intrigued by the luminosity of the nets – but it is only one of a range of possible exposures. It was based on a straight reading of the sky, with the Variosix F tilted slightly upwards and no incident light dome in place.
LEICA M4P, 35MM F/1.4 SUMMILUX, FUJI ASTIA.

want. If everything is 'average' and you want an 'average' exposure, there is absolutely no need to depart from the settings recommended by the meter; but when you know just how many variables there are, you may be less inhibited about using other exposures than those recommended by the meter.

In the first draft of this chapter, we also explored the different equations for reflected light metering based on shadow brightness, and incident light exposure with receptors of different shapes (flat, hemispherical and cardioid); but somehow, the above seemed sufficient, or perhaps somewhat more than sufficient. We could explore theoretical considerations of this type for an entire book, but we have not the heart for it, and we suspect that most of our readers will feel the same. Ultimately, the question in understanding exposure determination must be, 'Yes, but what happens in the real world?' Now, it is time to return to that question.

RECULVER TOWERS

The image brightness equations are predicated on the assumption of certain off-axis angles: an assumption which collapses when confronted with a fish-eye image. Innumerable factors are fudged and approximated in photography, and the surprise is that most of the fudges cancel out, most of the time.

WRIGHT 5X4IN, ZODIAK FISH-EYE LENS, ILFORD FP4 PLUS RATED AT EI 100, READINGS OF SKY, SUNLIT AND SHADOW AREAS WITH MINOLTA SPOTMETER F. (RWH)

SIGNPOST, MINAS SANTOS DOMINGOS

The tonal range here is surprisingly narrow, the more so as a red (25A) filter was used to darken the sky and lighten the buildings. This concentrates attention on detail, rather than on broad shapes; small felicities like the intersection of the shadows and the signposts become apparent as you study the picture.

NIKON F, 35MM F/2.8 PC-NIKKOR, ILFORD SFX RATED AT EI 50 INCLUDING FILTER FACTOR, INCIDENT LIGHT READING WITH SIXTOMAT DIGITAL. (FES)

EXPOSURE METERS

Almost all modern 35mm cameras, and an increasing number of medium-format cameras, have built-in meters of varying degrees of sophistication. Users of large-format cameras, and of some medium-format cameras, have the additional option of through-lens metering using cassettes which are inserted into the film plane in much the same way as conventional film holders, or of metering off the ground glass.

Hand-held meters fall into two broad categories: general-purpose meters for reflected and incident light readings, and spot meters. Within these broad categories there are meters which will read only ambient light, ie not flash; only flash, though perhaps with the option of ambient light readings at a single shutter speed; and both ambient and flash. There are also differences in cell type, and for the sake of completeness, one should mention comparison photometers.

It makes sense to consider all this in reverse order, or close to reverse order, because this best reflects the evolution and application of meters, and this will be done later in the chapter. Regardless of the meter type, however, two fundamental considerations are speed of response and colour response. Speed of response can be dismissed fairly quickly, because few meters today still use the old cadmium sulphide (CdS) cells, which took some time to come to a final reading; the initial response was very rapid, but the reading would then 'creep' for several seconds – perhaps for a substantial fraction of a minute – across the last ⅓ stop or so. The older selenium barrier cells, and modern silicon cells, have pretty much an instantaneous response.

Colour response is a nightmarishly complicated subject, because you are looking at three completely different patterns of sensitivity. The human eye has one pattern, the film has another pattern, and the meter cell has yet a third. Before we look at the various types of meter, therefore, we need to look at this whole question of what should match what, and how.

COLOUR SENSITIVITY

It will come as no surprise to learn that the first thing we run into here is yet another 'fudge factor', namely the assumption that the overall colour of the light reflected from an average scene is about the same as the overall colour of the light that is falling on it. An additional problem, though, is that the light falling on a subject can vary widely in colour, according to whether it is daylight or artificial light.

The most convenient way to define daylight is by colour temperature. Colour temperature is the temperature to which a perfectly radiating black body must be heated to emit light of a particular colour. The basic principle is a matter of common experience: we have all seen metal heated to a glowing red, and we know how further heating brings first yellow and then eventually a dazzling blue-white. There are numerous theoretical considerations which differentiate a perfectly radiating black body from the real world, but for our purposes they can safely be ignored. We can also ignore the fact that daylight does not, in fact, comprise an even spread of all wavelengths and cannot in strict scientific terms be assigned a colour temperature. In practical terms, it is close enough.

Colour temperature is measured in Kelvins (formerly degrees Kelvin) which are the same size as degrees Celsius but start at absolute zero, approximately -373°C. A colour temperature of 5,000K, therefore, corresponds to a black body heated to 4,627°C.

The three most usual types of daylight are International White Light SB, also known as English daylight, at 4,800K; International White Light SC, or American daylight, at 6,500K; and International White Light SD, overcast American daylight, at 7,500K. Light from a blue sky can run from 10,000K to 20,000K; for the curious, International White Light SA, 2,854K, is a tungsten-source sensitometric standard which is not reliably found anywhere in nature.

Tungsten lighting also varies in colour temperature. Photofloods run at 3,400K; Argophot or Hundred Hour or Photopearl bulbs, and many other professional tungsten lamps, run at 3,200K; tungsten halogen lamps typically give out a light of around 3,100K; and domestic lamps run from about 3,000K downwards, with the most powerful lamps (200W) running hottest and the colour temperature decreasing as the wattage goes down, so that a 40W bulb

SOPHIE AS CHE

The light here was a Beard 800W focusing spot with a tungsten-halogen bulb having a colour temperature of about 3,100K. Exposure determination was with a Variosix F at the subject position with the incident light receptor pointed towards the light to introduce a bias towards under-exposure, though one wing of a Lastolite Tri-Flector was used to stop the unlit side of Sophie's face disappearing into shadow.

NIKON F, 90 – 180MM F/4.5 VIVITAR SERIES 1, FUJI SENSIA 2 RA ISO 100. (RWH)

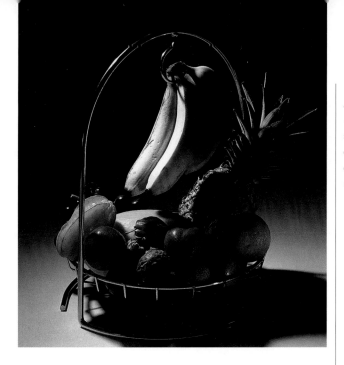

FRUIT BASKET

A spot reading off the bananas, taken with a Gossen Spot Master 2, formed the basis for this exposure. Two corrections totalling 3 stops had to be introduced: 1½ stops more to render the bananas as the right density, and another 1½ stops to compensate for the yellow colour. In practice, the latter correction proved excessive; after Polaroid testing, the final exposure was 2½ stops more than the reading.

LINHOF TECHNIKA 70, 100MM F/5.6 APO-SYMMAR, FUJI VELVIA RATED AT EI 40. (RWH)

the two curves shown below. One describes the sensitivity under normal lighting (photopic response) and the other under poor lighting (scotopic response). Because the two are not too different, and because (as we have seen) we are dealing with an awful lot of approximations anyway, it is not unreasonable to draw a single overall response curve, midway between the two.

The sensitivity of the film

With colour film, sensitivity is less of a problem than with monochrome, as the dimension of colour is incorporated in the film. As long as the film recreates the colours of the original subject reasonably faithfully – so that the picture does not look too unnatural when it is compared with the subject – then the response of the eye is, by definition, sufficiently the same to both.

There is, however, the question of colour temperature. 'Daylight' films are balanced to a colour temperature of around 5,500K, though quite wide variations are commonplace: we all know how some films record as 'warm' and others as 'cool'. Tungsten-balance films were originally balanced to the 3,400K of photofloods ('Type A' balance),

might run at as little as 2,500K. As an aside, 110 to 120V lamps typically run 50 to 100K higher than 220 to 240V lamps.

Fluorescent lighting cannot be assigned a colour temperature at all, but its faithfulness to daylight is typically measured as a CRI, an index of daylight matching. A CRI of below 90 will normally be inadequate for colour photography (the results are normally greenish, but may exhibit other biases depending on the phosphors used) and a CRI of 95 or above is often adequate for most purposes.

The sensitivity of the eye

The sensitivity of the human eye varies somewhat from individual to individual, but it can broadly be summed up by

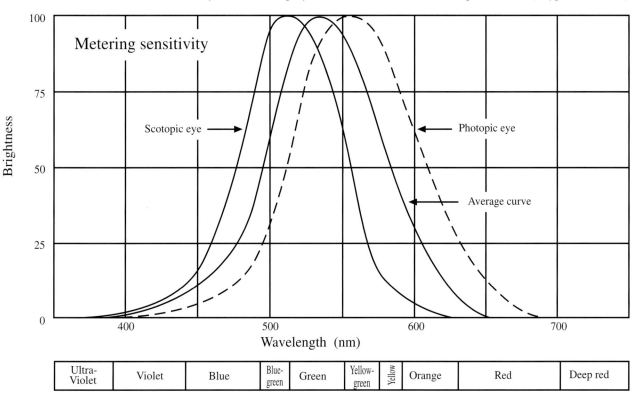

Metering sensitivity

Scotopic eye →

← Photopic eye

← Average curve

Wavelength (nm)

Ultra-Violet	Violet	Blue	Blue-green	Green	Yellow-green	Yellow	Orange	Red	Deep red

while today the normal balance is to 3,200K ('Type B'). At least one tungsten film has, however, been balanced to 3,100K.

With monochrome films, the question is much more vexed. The basic sensitivity of silver halide emulsions is to blue, violet and ultra-violet light, but with the use of sensitising dyes this can be extended into the green (orthochromatic or ortho), orange-red (panchromatic or pan), deep red (extended-red pan), and infra-red. The response to the different colours is not, however, entirely linear. This reflects the effect of the sensitising dyes, and in some cases the structure of the halide crystals: very thin crystals have less sensitivity to blue light than thick ones.

Precise linearity is not in any case desirable. There is an unusual Konica black and white film which is, in effect, a three-layer colour film with the colour taken out. In other words, instead of the usual red-, green- and blue-sensitive layers which when developed give cyan, magenta and yellow dye layers, all three layers give a monochrome image. The result suits some subjects quite well, but others are curiously dead and flat.

Anyway, each monochrome film has its own characteristic sensitivity pattern, and this is a significant component of its 'signature', the difference between it and other films (other components include grain, speed, contrast and the shape of the D/log E curve). The differences are, however, subtle, and they change from time to time as films are improved (or merely altered) by the manufacturers.

The sensitivity of the meter cell

Most modern meters use silicon cells which have a high sensitivity to infra-red and a low sensitivity to blue, violet and ultra-violet. This is, of course, the exact opposite of the sensitivity of film. Some meters can be grievously misled by warm light (ie light with a low colour temperature) or by red subjects, but the majority of the better meters on the market are filtered to give a more realistic response.

The only question is, what is 'a more realistic response'? Should the cell be filtered to match the response of the eye, or the response of the film? Among meter manufacturers, the general consensus seems to be that it should be filtered to match the eye, but a good case can be made for matching it to the sensitivity of film – though matching it to a particular black and white film, Kodak Tri-X, as is allegedly done with Zone VI modified Pentax meters, is another example of false precision, the more so because there are two kinds of Tri-X. Variations in sensitivity between different pan films are for the most part slight, and the matter of excess linearity which was canvassed a few paragraphs back also brings the value of such a modification into question.

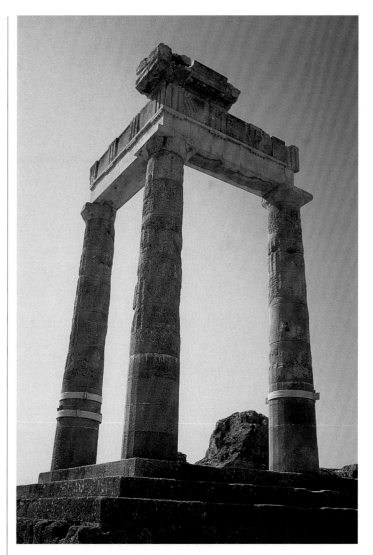

Does it matter?

From the above, it is clear that it is possible to get altogether too excited about precision in metering. After all, most meters work pretty well, and if things were as complicated as the last couple of pages suggest, they would not.

The first point, therefore, is clearly that – as with so many other aspects of photography – a lot of people are striving for a precision that simply isn't there. Of the numerous approximations which go into meter design, the colour temperature response of the meter cell is not the most significant, unless it is totally unfiltered and overly red sensitive as described above. In short, the approach taken by most manufacturers is pretty adequate.

PASOPTIC LENSES

Roger lit the subject softly in order to retain detail in both the black textured camera-body covering and the silver chrome lenses, and based his exposure on a spot reading (with a Spot Master 2) of the body covering of the M4-P, giving 2½ stops more than indicated.

GANDOLFI VARIANT LEVEL 3, 210MM F/5.6 SYMMAR CONVERTIBLE, FUJI PROVIA RDP2.

SARAH AND MIRROR

With colour negative film – this was shot on Fuji's astonishingly good ISO 1600 material – there is little need to worry about exposure accuracy; a quick incident light reading with the film rated at EI 1200 was all that was needed.

LEICA M2, 90MM F/2 SUMMICRON, VARIOSIX F. (RWH)

correction factors to get a useful meter reading. As far as we have been able to discover, the only manufacturer of spot meters who provides this information in the instruction books is Pentax, who recommend the following correction factors:

Red	Give ⅔ stop *more* exposure than indicated.
Orange	Give 1 to 1⅓ stop *more* exposure than indicated.
Yellow	Give 1⅔ stop *more* exposure than indicated.
Green	No correction factor.
Blue	Give ⅔ stop *less* exposure than indicated.
Indigo	Give 1 to 1⅓ stop *less* exposure than indicated.
Purple	Give 1 to 1⅓ stop *less* exposure than indicated.

The second point is that provided the excess infra-red sensitivity is filtered out, there should be very little problem; and that even if it is not, it may not matter very much in practice for most real-world applications.

The third point, however, is that if you are going to measure limited areas, you may need to apply colour

A great deal depends on colour purity and saturation, so the above figures are only a rough guide: Pentax specifies red as 'bright red', yellow as 'dark yellow' and green as 'dark leaf green'. Even so, they are a better guide than is generally available elsewhere.

METER CELLS

Almost all early meters used photogenerative cells, which generate a weak electric current in pro-portion to the light falling on the cell: the current drives the meter itself. The classic photogenerative cell is a thin layer of selenium on iron, and it needs to be quite large in order to get a decent amount of current in weak light. This not only makes for a big meter: it also makes for poor directionality. Recessing the cell is one possibility, and

covering it with embossed lenses or lenticles is another.

Almost all modern meters use photodiodes, though a few use photoresistive cells. The only real penalty, as compared with photogenerative meters, is battery dependency, though some photoresistive cells have a slow response time (they 'lag') and photodiodes generally have to be filtered to give an appropriate colour response. Either type of cell can be tiny, and still very sensitive, and making a flash meter is much easier because you do not have to rely on an almost instantaneous flicker of light to provide all the power needed to move a (relatively) big, heavy meter needle.

COMPARISON PHOTOMETERS

These, as their name suggests, rely on comparing a light source of known intensity with an area of subject brightness. They trace their ancestry back to the Bunsen grease-spot

SNOW SCENE, CALIFORNIA
The cold weather made the shutter of the 90mm Super Angulon on this Wright 617 sticky, so the exposure here is about ⅔ stop more than Roger intended. The highlights of the snow are therefore burned out. It is, however, probably a better exposure than the one he wanted: emotional factors play as large a part as technical ones in what 'works'. The surprisingly deep blue sky on the left is the result of light fall-off across the enormous 6x17cm format.
KODAK EPD 200, GOSSEN VARIOSIX.

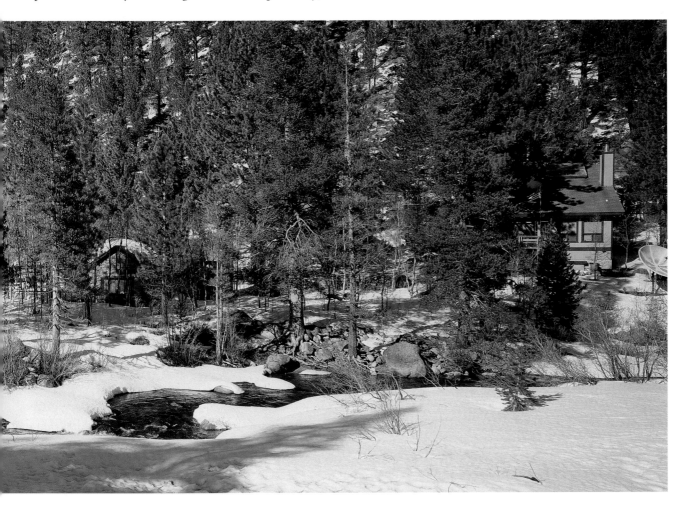

photometer of 1859. The now-legendary SEI photometer, the world's first production spot meter, was a comparison photometer, and there was a Russian spot meter which used an LED as the comparison source; but now that new bulbs for the SEI are no longer available, and given the somewhat eccentric construction of the Russian meter, together with the fact that it used a unique Russian mercury cell size, comparison photometers are at present only of historical interest in photography.

REFLECTED LIGHT AND INCIDENT LIGHT METERS

The techniques of using the different types of meter are covered in Chapter 9, but now is the time to look at their design and construction.

We have already seen the assumptions on which reflected light meters are based, and there is not a great deal to say about the theoretical background except that only the very cheapest meters are normally designed for reflected light only. Angles of acceptance vary from about 55–60 degrees to 30 degrees or less, and the acceptance pattern is typically circular: in other words, it measures a cone of light of the sort of angle described. A few older meters with recessed cells had an oval acceptance pattern, with the short axis vertically and the long axis horizontally; this minimised the influence of skies, which could be unduly bright, and foregrounds, which could be unduly dark. The penalty was however extra bulk and (unless the meter was unrealistically huge) reduced sensitivity.

Incident light meters use some sort of diffuser to create an 'artificial highlight' from which to take a reading. With most meters this is a slide-on or clip-on hemisphere, though the Weston Master Invercone (widely regarded as one of the finest incident light attachments ever made) is a dome with an inverted conical recess, which presumably explains the name, and some meters use flat receptors. Any curved diffuser takes considerably more account of side-lighting and even backlighting than any flat receptor, which does (or should) affect how you use the meter, as described in Chapter 9, but the Invercone is less sensitive to small changes in side lighting than a hemispherical diffuser (see page 114). Some flash meters are designed for

INVERCONE

The old Weston Invercone – a dome with an inverted cone in the centre – is without question the best designed incident light attachment for use in side- and backlighting, and it is surprising (at least to a lay observer) that a similar design has never been adapted for other incident light attachments.

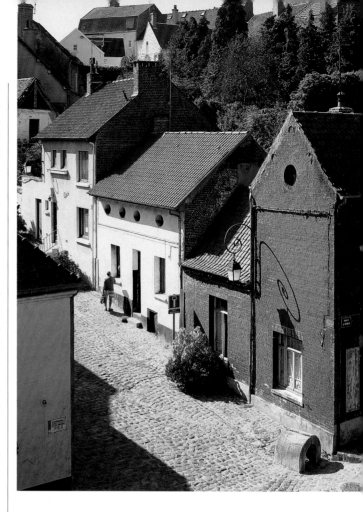

MONTREUIL

The exposure is spot on, but the flat, blue effect here is typical of the results obtained with lenses of an older generation, in this case a (Linhof-selected) 180mm f/5.5 Schneider Tele Arton. When we can afford it, we intend to replace the lens with a long-focus APO design.

LINHOF SUPER TECHNIKA IV, FUJI RAP, INCIDENT LIGHT READING WITH VARIOSIX F. (RWH)

incident light readings only, and at least one was made only with a flat receptor.

Flash and ambient readings

Cheaper flash meters are normally designed with a 'gate' that equates to a single shutter speed, typically $\frac{1}{60}$ second, $\frac{1}{100}$ second or $\frac{1}{125}$ second. This means that the reading they give is for the total light received in that period, comprising both ambient light and flash.

More sophisticated meters allow a choice of shutter speeds, which affects the influence of the ambient light: obviously, the shorter the shutter speed, the less the influence of the ambient light. Often, the differences between the flash-plus-ambient reading and the flash-only are quite small, but with bright ambient light and weak flash, they can be considerable. The best meters give both the overall reading (flash-plus-ambient) and the ambient-only reading. This feature can be very useful when you are mixing flash and continuous lighting.

Fill-in flash calculations are, however, slightly more difficult than you might at first expect, because they must be made using limited-area reflected light readings. A moment's

thought shows that flash-plus-ambient is always going to mean more light than ambient alone, and as the purpose of fill-in flash is to be weaker than the ambient light, you have to read the shadow area independently.

Suppose, for example, that your overall exposure is $\frac{1}{125}$ second at f/8, but that an important area of the subject – a person's face, perhaps – is 1 stop darker than you want it to be. You then need to set the flash to whatever power will make the face 1 stop lighter.

JOE
Automatic, on-camera flash can be a nightmare. This is the worst I have ever seen, with a brand-new, very expensive 'supercompact' from a leading maker. Obviously the camera was defective, but when you are looking at a compact in the $1,000 range, it should be tested before dispatch.

KODAK ELITE 100. (RWH)

BART
This is how on-camera flash should work. Keeping the subject well forward of the background removed the risk of awkward, tell-tale shadows and although the shot is no great compositional triumph, it succeeds at what it sets out to be: a plain record shot.

PENTAX 928, KODAK EKTACHROME 200. (RWH)

Depending on how the flash is distributed, you will then need to make some adjustment of the overall exposure: typically, anything from $\frac{1}{3}$ stop less to 1 stop less. Make this adjustment, of course, on the aperture and not the shutter speed, because the shutter speed affects only the ambient light and will therefore over-emphasise the effect of the flash. There is more about fill flash on page 154.

HAND-HELD METER DESIGN
A good hand-held meter should be reasonably compact, robust, easy to operate and easy to read. Unfortunately (as ever) some of these requirements are mutually incompatible.

The first control you need is a means of setting the ISO speed. Ideally, the setting should be lockable, so that it does not get knocked away from the intended setting, and the ISO speed should be constantly visible, so you do not suddenly find that you have been using a meter with the wrong ISO speed set. Needless to say, not all meters feature lockable settings, and not all ISO speeds are constantly displayed.

The second control you need is a means to take the reading: a button or rocker switch, though some meters avoided the need for this by being permanently switched on, so that they gave a reading for whatever they happened

GOSSEN LUNAPRO F

The null-scale Lunapro F represents an intermediate stage between swinging-needle meters, where scale gradations can be uncomfortably close together, and digital readouts. Note the Zone scale on the lower part of the calculator dial and the dangerous and unnecessary correction scale on the outer ring. After accidentally dislodging this from the zero position, Roger secured it with a dab of glue after resetting it.

to be pointing at. Ideally, though, you should have the choice of locking the reading once it has been taken, or of taking continuously varying readings.

The next thing you need is a readout. A digital readout can (or should) show the appropriate combination of aperture and shutter speeds as soon as you take the reading; but with analogue meters, the readout is likely to involve reading numbers off a scale, and (usually) transferring them to some sort of calculator.

Non-digital readouts

The usual choices are a needle which moves against a graduated scale, or a null system, or a system of LEDs (Light-Emitting Diodes).

Graduated scales are intuitively easy to use, but the separations between the gradations are typically very small and may not be fully linear. This can make it difficult to read the meter with a high degree of precision or repeatability. Also, the numbers on the scale have to be translated into

shutter speed/aperture combinations for a given ISO speed. This is normally achieved via a circular calculator, which shows all possible combinations of aperture and shutter speed. Although it is convenient to see at a glance that you can choose (say) ½₅₀ second at f/4 or ⅓₀ second at f/11, the numbers are inevitably fairly small and this can prove a strain for those with less than excellent eyesight.

Simple LED readouts use a sequence of LEDs in much the same way as a needle. The simplest models mark only whole stops, while more sophisticated models add another LED to indicate 'plus ½' or even two more to indicate 'plus ⅓' and 'plus ⅔'. Thus if the main LED reads f/11, you look at the subsidiary readouts to see if you need f/11 plus ½ (strictly, f/13.5 or so) or f/11 plus ⅓ (conventionally f/12.5) or f/11 plus ⅔ (conventionally f/14). This system is particularly popular with modestly priced flash meters.

Most null systems use a variable resistor to allow the needle to be set to a constant (null) position. Normally, this is incorporated in a rotating calculator dial like the one on graduated-scale meters. Others use LEDs as the null point, or even light up the entire scale: Zeiss did this in the 1950s or

POOL, PELOPPONESE

When you are shooting 4x5in, it makes sense to shoot Polaroid tests; or failing that (or in addition to that), to shoot two sheets and process one. The second sheet can then be 'pushed' or 'pulled' in development to give precisely the effect you want.

MPP MK VII, 150MM F/4.5 APO LANTHAR, FUJI PROVIA RDP2 ISO 100, INCIDENT LIGHT READING WITH VARIOSIX F. (RWH)

RAMSGATE HARBOUR

A Linhof 612 with a modern, multi-coated Schneider lens gives crisp, bright colours right across the frame. What is surprising is that fall-off is far from obtrusive, despite the fact that no centre-grad filter was used.

KODAK EKTACHROME HC ISO 100, INCIDENT LIGHT READING WITH LUNAPRO F. (RWH)

KREOPOLEION

Sometimes, all you can do is guess. Although print films are more tolerant, it is surprising how often you can guess an entirely adequate exposure even with slide film (this is Fuji Astia), if you practise. A spot reading would have been the only appropriate approach, but there was no time and Roger had no spot meter with him.

LEICA M2, 35MM F/1.4 SUMMILUX.

maybe early 1960s, but the resulting meter was let down by the need to use grain-of-wheat bulbs and crude electronics.

The advantage of a null readout is that the meter scale gradations can be made much bigger than for a graduated-scale meter, but the calculator scale gradations are similar in size to those on a graduated-scale meter.

Digital readouts

A digital readout allows much bigger, clearer numbers but can show only one speed/aperture combination at a time, so you need another control which allows you to scroll through the

possible combinations. It is also customary (though not strictly necessary) to offer a choice of aperture-priority or shutter-priority readings. In other words, you set the aperture you want to use and the meter indicates the necessary shutter speed, or you set the shutter speed and it indicates the necessary aperture.

The best digital meters have, in addition to the digital

readout, a simple scale with ½ stop resolution which shows the aperture needed at the set speed. This can also be used with the shutter-priority mode to indicate the range of exposures required by different parts of the subject: you 'hosepipe' the subject to see what the range of readings is. Thus while the main readout indicates (say) ¹⁄₆₀ second at f/11, the scale might indicate f/8 to f/22, showing that the darkest areas are only

ACROSS THE BOSPHORUS

Weak sun and a substantially white sky meant that this was never going to be a very interesting picture. Exposure was based on a straight incident light reading; reducing the exposure would have made the European side of the picture grey and flat without increasing colour saturation, so the only hope was to keep the Asian side reasonably bright and cheerful.

LEICA M4P, 90MM F/2 SUMMICRON, FUJI ASTIA. (RWH)

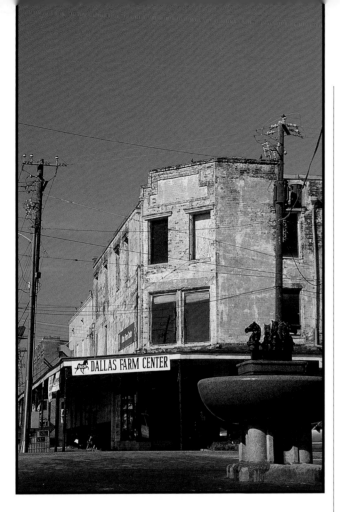

DALLAS FARM CENTER, SELMA, ALABAMA

Roger set himself the task of shooting 36 entirely different pictures with no brackets, on a single roll of slide film. This concentrates the mind wonderfully. The base exposure was a spot reading (with a Spot Master 2) of the blue sky, but numerous other spot readings were taken to confirm the brightness range.

NIKON F, 35–85MM F/2.8 VIVITAR SERIES 1, FUJI ASTIA.

CATWALK OF FLY LOFT, THEATRE ROYAL, MARGATE

Spot readings of the wood and the ropes formed the basis for exposure determination. Ilford 100 Delta was chosen for its tonality and sharpness, which well complement the 105mm f/3.5 Linhof-selected Xenar on the Super Technika IV. Light came from a Courtenay Sola-Pro 1200 to camera left. The original print is on Ilford Multigrade Warmtone, which gives a wonderfully 'woody' feel to the image.

SPOT MASTER 2. (FES)

1 stop darker than the overall reading while the lightest areas are 2 stops lighter.

Other controls and features

If the meter can read both flash and ambient, you need a means of switching between the two, and a meter which can be used with a synch cord requires yet another control to fire the flash. After this, it is (for most people) a matter of bells and whistles. Some meters indicate cine speeds, some allow readings in EVs, and some allow you to dial in correction factors to compensate for filters, or processing variations, or personal preferences. Cine speeds require little comment – only professional cinematographers are likely to care nowadays – and most photographers find it easier to adjust the

ISO speed than to dial in a correction factor. For example, if you are using a filter with a 3x factor, you might as well divide the arithmetic ISO speed by three, rating an ISO 125 film at EI 40 or an ISO 1000 film at EI 320; and if you are going to push the film 1 stop, set EI 250 for ISO 125 and EI 800 for ISO 400.

EVs are, however, worthy of comment (if of little else). Contrary to widespread belief, they were not originally invented by the devil, but were the brain-child of the Prontor shutter company who sprang Light Values (LVs), later retitled Exposure Values (EVs), on the world at *photokina* 1954.

A given EV summarises all equivalent combinations of shutter speed and aperture. Thus EV 1 is 1 second at f/1.4, 2 seconds at f/2, 4 seconds at f/2.8, and so on through to 64 seconds at f/11, while EV 7 is ⅟₆₀ second at f/1.4, ⅟₃₀ second at f/2 and so forth through to 8 seconds at f/32. The advantage of EVs is that you can transfer a single number from your exposure meter to your camera; but as you then have to decide which shutter speed/aperture combination to use, there seems singularly little advantage in this.

With a meter using a dial-type scale, EVs and cine speeds can be incorporated on the main scale with minimal effort; and by adding another concentric scale, correction factors can also be dialed in. With digital meters, a single control (or a pair of buttons, for left/right or up/down) is normally used to step through the various options: shutter-priority ambient, aperture-priority ambient, flash, EV, correction factor, and ISO setting.

SPOT METERS

The simplest and crudest limited-area meters are add-on attachments for some Gossen meters which restrict the

METERS AND GREY CARD

The Spot Master 2 is bulky and idiosyncratic but easy to use once you have accepted the designer's world-picture. The Sixtomat Flash is extremely easy to use, as well as being admirably compact; it is an enhanced version of the Sixtomat Digital which Frances used for so many shots in this book. The 'pub menu' style grey card is from Paterson and is remarkably convenient.

measuring angle from 30 degrees to 15 degrees or 7.5 degrees, but a true spot meter usually has a measuring angle of 1 degree and the SEI was 0.5 degree, which was arguably even more useful. A few offer choices of 1 degree and 3 degrees or 5 degrees, but there is no real advantage in this: if you know what to measure, you will measure it as well with 1 degree as with anything bigger, and if you don't, there is little to be said for a spot meter anyway.

Basic spot meters such as the Pentax use much the same system of swinging needles as a conventional meter: the exposure calculator may be circular, on the side of the meter, or cylindrical, concentric with the meter's lens. Some 'digital' meters do not give what most people would regard as a true digital reading, but rather a number which is transferred to a calculator dial in the same way as a swinging-needle reading.

The big advantage of any digital meter is (or should be) robustness, as the needle movement is inevitably mechanically delicate.

True digital spot meters give aperture and shutter speed readouts in the same way as any other true digital meter, but the principal objection to all of them is that they take some getting used to. Some have a dozen or more controls, and the one with the simplest controls (just five buttons, on the Gossen) requires a certain willingness to accept the designer's mind-set.

The techniques of using spot meters are covered in Chapter 9.

VEIL

Where do you begin to meter something like this rather disturbing picture? Roger took an incident light reading from the subject position, using a Variosix F, then added 1 stop to allow for the considerable extra extension on the MPP Mk VII with a 150mm f/4.5 Apo Lanthar; the large format explains the negligible depth of field.

ILFORD FP4 PLUS RATED AT EI 80.

CASSETTE AND GROUND-GLASS METERS

Cassette meters are an even more specialised variety of spot meter, in that they are designed to be used in the focal plane of a large-format camera. A movable probe can be used to take readings from a number of different parts of the image. Some are sold as stand-alone systems, while others are sold as accessories to 'system' meters. What they all have in common is that they are alarmingly expensive. Ground-glass metering, using a fibre-optic probe, is a less sophisticated approach to the same thing, but unfortunately it is very nearly as expensive and the reading can be affected by ambient light.

IN-CAMERA METERS

The simplest in-camera meters are no more than broad-area reflected light meters, as discussed above. At the time of writing, incident light meters for cameras were something of a rarity, though one of the Hasselblad heads incorporated an incident light option and the Wallace ExpoDisc converts most in-camera, through-lens meters to a usable incident light meter.

Because of the known limitations of broad-area reflected light meters, most especially the unwillingness or inability of most photographers to learn to use them intelligently, designers of early through-lens meters flirted with spot metering as the sole option. Unfortunately, this requires even more skill and intelligence than a broad-area meter, and it was therefore swiftly dropped except as an option on some cameras. Using a through-lens spot meter built into a camera is very like using a stand-alone spot meter.

Centre-weighted meters

The 'centre-weighted' through-lens meter was the first complication which was added to most cameras, and many cameras with this sort of meter remain in service today. As the name suggests, the meter accords more importance to the centre of the image than to the edges. For the snapshot photographer, especially the snapshot photographer using colour negative film, it will give better results than either a broad-area meter or a spot meter, but it is still very easily fooled by atypical subjects, where you have a bright subject against a dark background or a dark subject against a bright background.

The enormous disadvantage of a plain centre-weighted meter is that it takes a long time before you can become intuitively familiar with the metering pattern of the camera, and until you do, you are never entirely sure what you are metering. Although we have cameras with centre-weighted meters, we prefer to use separate hand-held meters for anything but the simplest exposure problems.

Multiple-sector meters

In order to overcome the drawbacks of centre-weighted meters, more and more manufacturers have introduced cameras where multiple areas or sectors of the image are metered simultaneously: names include multi-segment, multi-sector and matrix metering. Some cameras even incorporate automatic switches to change the metering pattern according to how the camera is held, whether horizontally or vertically.

The actual exposure is calculated by a microprocessor in accordance with proprietary algorithms programmed into the camera. Unfortunately, next to no information is available on the research which produced these algorithms, or on the weight which is attached to different areas of the image by the algorithms themselves. This is a major, but unavoidable, shortcoming of this book.

It has to be said that meters of this type are extraordinarily good, especially for colour slide films and for subjects against a bright background. With subjects against a dark background

their performance is however considerably more variable, and they will never give the best possible exposure on monochrome negative films which are rated at their nominal ISO speed. This is because they are designed to meter for the highlights, as is required for colour slide films, and not for the shadows, as is required for negative films.

Most of the time, these meters will give good to excellent results with slide films, and if you set the film speed of a monochrome negative film to one half of the nominal ISO speed they will give good to excellent results with black and white. With colour negative films, you can usually leave them on automatic exposure, although you may do well to rate the film at ⅓ to ⅔ stop slower than its nominal ISO speed. But if you want real control over your exposures, switch to the spot mode – or use a separate meter.

Most in-camera meters are of the null type, where setting the shutter speed and aperture on the camera itself produces a null reading in the viewfinder; this is true in whatever mode you choose. The same caveats apply concerning the colour sensitivity of meter cells as have already been canvassed earlier in the chapter.

Automatic cameras simply set the recommended exposure automatically, whether aperture priority (where the photographer chooses the aperture and the camera sets the shutter speed) or the mechanically more demanding but arguably more useful shutter priority, where the photographer sets the shutter speed and the camera sets the aperture. In 'program' mode, the camera steps through a predetermined sequence of apertures and shutter speeds, in the more advanced models taking account of focal length to avoid camera shake. Modern automatic cameras not only have much better meters than their older counterparts: the automation is a lot faster, too. The old mechanical systems could introduce a delay of as much as ¹⁄₁₀ second between pressing the shutter release and taking the picture.

INDIA GATE

Once you have your 'correctly' exposed negative, printing is still a matter of interpretation. Some prefer the hint of shadow detail in the lighter, less contrasty picture; others prefer the drama of the framed image in the other picture. Frances determined exposure with an incident light reading in full sun using her trusty Sixtomat Digital, adding 1 stop to retain the option of shadow detail. Film was Ilford SFX with a tri-cut red filter, rated at EI 50 with the filter.

NIKKORMAT FT2, 35MM F/2.8 PC-NIKKOR.

FILTERS AND METERING

Most filters – the principal exception is polarisers – are sold with a stated 'filter factor', the increase in exposure that is needed when the filter is used. This is normally expressed as an arithmetic factor: 1.5x, 2x, whatever. For convenience, these factors are sometimes listed as stop equivalents, normally rounded to the nearest ½ stop. Thus 1.5x is ½ stop, 2x is 1 stop, 3x is 1½ stops, 4x is 2 stops, 6x is 2½ stops and 8x is 3 stops. The only common filters with higher factors than 8x are neutral density filters and infra-red filters. With the former, you can normally take the manufacturer's word for the filter factor, be it 100x (D=2.0, 6⅔ stops) or 1,000,000x (D=6.0, 20 stops). Infra-red filters, however, rather neatly illustrate the variability of filter factors, as will be demonstrated shortly.

The truth is that like so much else in exposure, filter factors are a good approximation; but a great deal depends on the colour of the light, the colour of the subject and the sensitivity of the film.

Fairly obviously, if the light is very red to begin with, then a yellow or red filter will have less effect than it will if the light is very blue. By overcast daylight, the normal 8x filter factor for a tri-cut red (25A) filter on normal panchromatic film is if anything an underestimate – 10x would not be excessive – but by tungsten light it may well be 4x and by candlelight it could fall to 3x or less. Likewise, a very weak blue 'portrait' filter may be a negligible ⅓ stop by overcast daylight, but ½ stop by tungsten light and as much as 1 stop by candlelight. The more honest and diligent filter manufacturers give different filter factors for daylight and artificial light, but not all manufacturers are honest and diligent.

Likewise, if you photograph red brick through a tri-cut red filter, the filter factor may be 2x or less: that is why the brick reads as almost white in the final picture, because (in comparison with the rest of the subject) it has been greatly over-exposed; but photograph the same brick through a weak blue 'portrait' filter, and if you want to maintain the tone of the wall, the filter factor will be 2x or more.

FILM SENSITISATION

The blue–light sensitivity of an 'ordinary' emulsion is up to about 500nm: ultra-violet, violet and blue. Ortho films extend this into the green, to maybe 550nm. Conventional

HOLLYWOOD

A highly specialised filter is the centre grad, which is used to even up the illumination between the centre and the edges of the image cast by an extreme wide-angle lens, in this case a 90mm f/8 Schneider Super Angulon on a Wright 6x17cm camera. In practice, we seldom use them, as we find that the composition is often enhanced by modest vignetting.

KODAK EKTACHROME 200 EPD, INCIDENT LIGHT READING WITH LUNAPRO F. (RWH)

CHURCHYARD OF ALL SAINTS, BIRCHINGTON
An 81 series warming filter can provide a useful 'lift' to make a scene more attractive, though today more and more films are deliberately made warm which reduces the need for these filters. As you can see from the sky, the day was dull and blue, but an 81C on Fuji Provia RDPII made it a little more attractive.
MPP MK VII WITH HORSEMAN 6X12CM BACK, 150MM F/4.5 APO LANTHAR, INCIDENT LIGHT READING WITH LUNAPRO F. (RWH)

pan films are sensitised into the red to varying degrees, typically out to 680nm to 700nm, though sensitivity is likely to fall off fairly sharply after 650nm to 680nm. Extended-red sensitivity films can be sensitised still further out, to 740nm or

even 750nm, though once again, the red and infra-red sensitivity will peak a little sooner than this.

True infra-red films are sensitised out to 900nm and beyond, and they are sensitised only for red and infra-red light; in other words, they are sensitive only to this and to the same blue as an 'ordinary' emulsion. They are completely insensitive to green – the so-called 'green gap' – and can be handled perfectly safely under an appropriate green safelight.

The human eye still has a surprising amount of sensitivity beyond 700nm, even up to 750nm or so, and if you allow a minute or two to acclimatise and carefully block all the light around the edges of the filter, you can see fairly distinctly

WEDGE SPECTROGRAMS
These spectrograms show the spectral response of three films: Ortho Plus, HP5 Plus (panchromatic) and SFX 200 (extended-red/near infra-red). The basic sensitivity of the silver halide is clearly visible, as are the peaks of the dye sensitisation, and you can see how the sensitivity dies away rapidly after the last dye peak. You can also see how a wedge spectrogram, as conventionally drawn, is open to interpretation. (Courtesy Ilford Ltd)

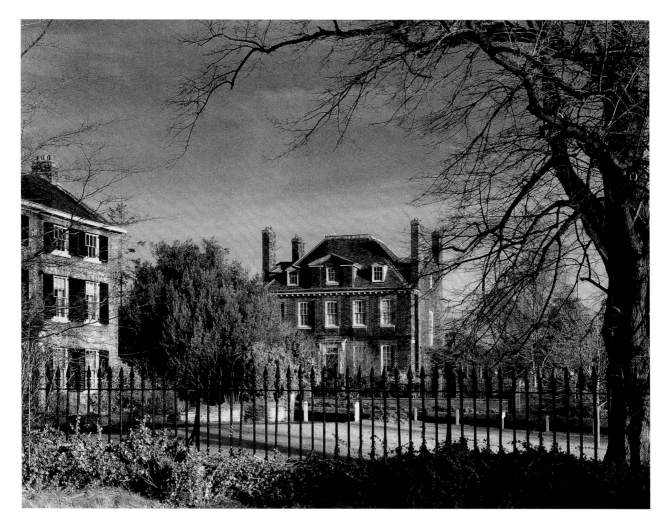

through a filter which transmits little or no light at all below 700nm. It is a rather eerie experience. Even so, in photography, 'infra-red' is still reckoned to begin at around 700nm.

Now consider the tri-cut red filter again. An 'ordinary' (blue-sensitive) emulsion will effectively have no sensitivity through such a filter; an ortho film will have very little; a pan film is likely to be cut by something between 9x (sensitised to 650nm) and 7x (sensitised to 700nm); and an extended-red film such as Ilford SFX, sensitised to around 740nm with a peak at around 720nm, may be cut as little as 4x.

Infra-red filtration and metering

The effect of an infra-red filter on film speed is even more pronounced than that of a red tri-cut. Take a typical IR filter with a T_{50} (50 per cent transmission) of 715nm. With a typical panchromatic film, film speed will fall to almost nothing; but with Ilford SFX, the filter factor is 8x to 16x, so EI 200 falls to something between EI 25 and EI 6. The precise filter factor will depend on the weather: on a sunny day, EI 25 is perfectly realistic, but on an overcast day, even EI 6 may be pushing your luck.

Because of the 'green gap' already described, an IR film such as Kodak High-Speed Infra-red is sensitised only to red

WICKHAMBREAUX

Ilford SFX with a deep red (25A) filter gives effects which are somewhere between those of a conventional film and those of a true infra-red; note the lightening of the grass in front of the railings. It gives these effects because it is a continuously sensitised film without a 'green gap'.

LINHOF SUPER TECHNIKA IV, 105MM F/3.5 XENAR, ILFORD SFX RATED AT EI 50 INCLUDING FILTER FACTOR, SPOT READINGS WITH SPOT MASTER 2. (RWH)

and infra-red, from about 550nm to 950nm, plus the residual blue sensitivity. The difference between a medium yellow filter, an orange filter and even a red filter will therefore be comparatively small. A B+W 023 (deep yellow) transmits effectively no light below 480nm, and exceeds 95 per cent at 550nm, which makes maximum use of the red/infra-red sensitisation of the film; switching to an 040 (yellow-orange), which still passes 50 per cent of the light at 550nm and over 95 per cent at 580nm, will make a fairly modest difference to exposure, while an 090 (light red) transmits 50 per cent of the light at about 595nm and over 95 per cent at 630nm.

Although Konica's infra-red film again exhibits the green gap, it is sensitised only to about 750nm and therefore will show a similar response to a deep infra-red filter as that of Ilford SFX; but unlike SFX, where visible light makes a significant contribution when ordinary red, yellow or orange

filters are used, Konica IR will still exhibit strong IR effects with these filters. The filter factor for a deep yellow filter with Konica IR will therefore be greater than it would be for SFX.

The real problem with metering for infra-red is that you do not know how sensitive your meter's cell is to IR light, and you do not know the balance between IR and visible light. The only possibility, therefore, is to follow the manufacturer's recommendations; but at least you now know the basis of those recommendations, and why they may vary.

Other sensitisation considerations

Infra-red is obviously an extreme case, but there is no doubt that the different spectral responses of different films can make detectable differences to filter factors. For example, the very thin crystals of Kodak's T-Max series are less sensitive than you might expect to blue light, simply because the light actually passes through some of the crystals. To maintain film speed, the sensitivity is made up with increased orange dye sensitivity. A yellow filter will therefore have a smaller filter factor on TMX or TMY than on Plus-X Pan or Tri-X.

The differences will be subtle, but they will not be too subtle for the human eye to notice: this is a part of the 'signature' of a black and white film. Anyone who really wants to explore the versatility of monochrome films may

therefore be well advised to spend at least as much time in searching for a tonality which they like, as in comparing grain and trying to pin down precise film speeds. Sometimes, a film which is quite poor by many objective measures will have a certain magic which is due principally to its sensitisation; and another film which apparently scores highly in grain and the shape of the D/log E curve will have a curious dullness, for the same reason.

Another point is that an emulsion which bears the same name may well vary in red sensitivity in different formats. For example, Paterson Acupan 200 in 35mm has a red peak of around 640nm and runs out of sensitivity at around 660nm; but Paterson Acupan 200 in 120 uses a different red sensitising dye, so it peaks at around 690nm, at which point the 35mm film is already completely out of sensitivity, though the 120 does not run out of sensitivity until about 705nm. Use a deep red filter such as a B+W 091 (T_{50}, about 625nm) and you will

CHURCH, MINAS SANTOS DOMINGOS

With a filter having a sufficiently high T_{50} – this is an Ilford gel, with a T_{50} of 715nm – Ilford SFX behaves much like a true IR film with very dark, almost black skies and very light foliage.

NIKKORMAT FTN, 35MM F/2.8 PC-NIKKOR, ILFORD SFX RATED AT EI 20 INCLUDING FILTER FACTOR, INCIDENT LIGHT READING WITH SIXTOMAT DIGITAL. (FES)

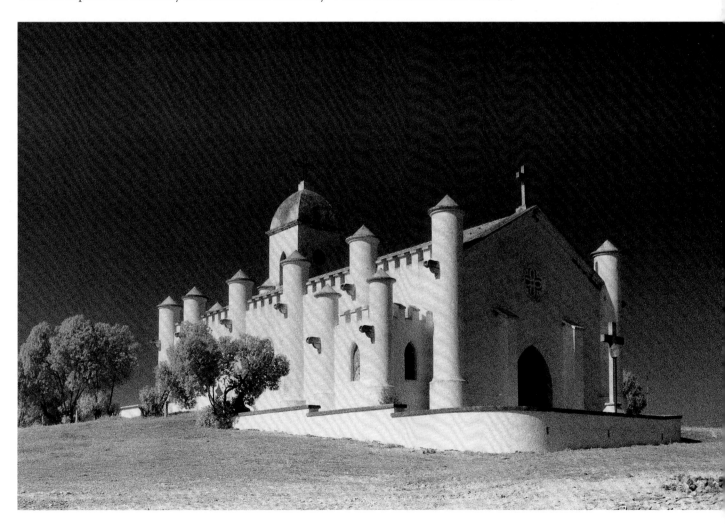

cut the sensitivity of the 35mm material by rather over the nominal 8x, while the 120 film will be affected by a factor rather below 8x.

INFRA-RED COLOUR

The most usual 'false colour' films come from Kodak, though a number of other manufacturers either make them or have made them, especially Niikhimproiect in Moscow. The *raison d'être* of these films is mostly military, principally for seeing through camouflage; it is unlikely that civilian sales could justify their existence.

Like Ilford SFX, they are sensitive to visible light as well as to infra-red. In fact, the three layers of the film are sensitised to yellow (forms green dye), red (forms magenta) and infra-red (forms cyan). All three layers have the usual residual blue sensitivity, and the film must be used with a yellow filter; orange or red filtration will cause colour shifts.

Because the film is sensitive to infra-red as well as to visible light, ISO ratings are meaningless and accurate metering is impossible, but a very good approximation can be obtained after shooting a roll or two for practice. Our own results with Kodak E6 IR (EIR) indicate a speed of EI 250 or even EI 320

in full sun, falling to EI 200 on an overcast day and EI 160 to EI 125 in shadow; Kodak's recommended EI was 200. With these films, a great deal depends on the filter you use, and the sensitivity of your meter. Exposure is extremely critical: where one exposure is about right, 1 stop extra will be 'blown' and 1 stop less will be distinctly murky, so bracketing with ½ stop rests based on the above EIs, or on the ones which you establish, is essential.

POLARISING FILTERS

The reason why a polarising filter cannot be accorded a single, fixed filter factor is because it cuts out different amounts of light according to the degree of polarisation of the light and the angle to which it is rotated. It will always have a minimum

PARIS

For filtering infra-red colour, a medium or deep yellow filter will retain some colours (in particular, blue skies) as natural, while turning anything with high IR reflectivity bright red. Orange or red filters will distort other colours; weak yellow filters will give an excessively blue image.

KONICA IIIA, 45MM F/1.9 HEXANON, KODAK EIR AT EI 200, INCIDENT LIGHT READING WITH VARIOSIX F. (RWH)

BIREFRINGENCE
Birefringence is the phenomenon whereby light is differentially polarised by a transparent medium, creating a veritable rainbow of colours which can be seen through a polarising screen. Many plastics exhibit this effect, which is most easily seen by viewing them between crossed polarisers.
(MARIE MUSCAT-KING)

or densitometric factor, which is typically around 1 stop (2x, D=0.30), but the maximum effective factor is typically 50 to 100 per cent greater than this (3x to 4x) and under conditions of strongly polarised light it can be a good deal higher.

TESTING FILTER FACTORS

Whenever you try an unfamiliar combination of film and filters, it is worth 'wasting' a few frames on a couple of films to check the effect. Shoot four pictures: one at the 'correct' exposure without the filter (interpreting the metered exposure as necessary), one with the filter in place, based on the previous exposure but using the manufacturer's filter factor, and two more at ½ stop more and less than the adjusted exposure. After a few such tests, you should be able to see whether the manufacturer's filter factor suits your style of photography and your films and your subjects. It would not be unusual to find that a given filter gives you a range of filter factors: a green filter with a manufacturer's factor of 3x, for example, might well range from 2x to 4x, depending on subject matter and film stock.

Anything more formal is a fairly tedious undertaking which is best attempted with the help of a densitometer. You need a subject with a fixed colour; light of a fixed colour temperature; and, of course, considerable precision in your

development technique. The easiest way to do it is with a Macbeth colour chart and electronic flash, but you have to remember that the results you get will only apply, strictly, to the flash you used and to those pure colours. These should prove a good guide to what will happen in daylight, but will not be infallible.

What you do is to take an incident light reading (or a reflected light reading from a grey card) and use that as your base exposure. Then, using the manufacturer's filter factor as a basis, you make a series of exposures with the filter in place.

Suppose, for example, that the base exposure is ¼ second at f/32 – the base (unfiltered) exposure in Ansel Adams's celebrated *Moonrise, Hernandez, New Mexico*. Suppose also that you are using a green filter with a factor of 3x: again, as Ansel Adams did for the picture in question. You then need to run a series of tests, with ½ stop rests, to determine the filter

POLARISING FILTERS
While polarising filters can saturate colours and deepen blue skies, they need to be used with caution. The purpose of these pictures was to illustrate how the filters can turn a blue sea to green, but the plastic windows of the shelter also introduced their own colours because of birefringence.
NIKON F, 35MM F/2.8 PC-NIKKOR, KODAK EKTACHROME 200, INCIDENT LIGHT READING WITH SIXTOMAT FLASH. (RWH)

PALMS, GOA

Although a polariser may seem tempting for pictures like this, if you are using a contrasty prime lens such as Roger's 90mm f/2 Summicron, you may find that the picture looks over-saturated and unnatural, especially if you also reduce exposure to 'pop' colours. With a zoom, it can be quite another matter.

LEICA M4-P, FUJI ASTIA, INCIDENT LIGHT READING WITH VARIOSIX F REDUCED BY ½ STOP TO AVOID BURNING OUT THE SAND. (RWH)

LEMONS, MERTOLA

For pictures like this, especially at high altitudes, an ultra-violet filter acts as more than just an 'optical lens cap': it also reduces the blue cast which can be introduced by excess UV. At very high altitudes, a UV filter will darken the sky much more than you would expect.

NIKON F, 90–180MM F/4.5 VIVITAR SERIES 1, KODAK EKTACHROME 200, SPOT READINGS WITH SPOT MASTER 2. (RWH)

factor. You might expose at ½ second at f/32 (1 stop, 2x), ½ second at f/22½ (f/27, 1½ stops, 3x) and 1 second at f/32 (2 stops, 4x). You might then, using a densitometer, measure the density of the moon, of the sky, and of the foreground.

Inevitably, the filter factor is an average; it would be very surprising if the filter factor were the same for the white

moon, the blue sky and a green shrub. You might well find that the filter factor for the moon was indeed about 3x, while for the sky it was 2x and for the shrub it was 1.5x. If by any chance there had been a decent-sized red-brick building in the picture, the filter factor for that could well have been 4x.

INTERNALISATION – AND A SENSE OF PROPORTION

To be quite honest, it would also be fairly surprising if the differences between the filter factors for different subject colours mattered very much in the final picture: so why have we dedicated an (admittedly short) chapter to this subject? The answer is simple, though twofold.

First, it is to demonstrate that eventually, the seemingly endless complexities of photography have to be internalised so that you can make tiny corrections either without thinking, or with only a moment's thought. These corrections are small, but they are not un-detectable; and if you want the finest possible results, then you have to have them in mind.

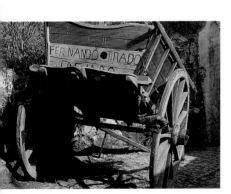

TREES AND SKY, MARSHSIDE

Although the classical advice is that a yellow, orange or red filter will only darken a blue sky, a 'bruised' cloudy sky has quite a lot of blue in some areas and will often respond well to very heavy red filtration, in this case a tri-cut red 25A.

LINHOF SUPER TECHNIKA IV, 105MM F/3.5 XENAR, ILFORD SFX RATED AT EI 25 INCLUDING FILTER FACTOR, INCIDENT LIGHT READING WITH SIXTOMAT DIGITAL. (FES)

FERNANDO TIRADO WAGON

Tiffen's Ultra Contrast filters are somewhat misleadingly named, as they actually reduce contrast in rather a magical way, allowing such tricks as recording the underside of this wagon in Mertola, Portugal. With a contrastier film or lens, this could have blocked up solid.

NIKON F, 35–85MM F/2.8 VIVITAR SERIES 1, KODAK E200, SPOT READINGS WITH SPOT MASTER 2 TO SET UNDERSIDE OF WAGON 2½ STOPS DARKER THAN A MID-TONE. (RWH)

In fact, *Moonrise* demonstrates internalisation very well. Ansel Adams had mislaid his exposure meter, so he based his exposure on his recollection that the brightness of the moon at that elevation was 250 candles per sq ft, from which he 'made a quick calculation' and made the exposure. The 'quick calculation' in question was that 'the correct shutter speed in seconds to expose a given luminance on Zone V [the 18 per cent grey mid-tone] is the reciprocal of the luminance expressed in candles per square foot' at the 'key stop' for a given film speed.

The 'key stop' is the square root of the ASA (or ISO

arithmetic) film speed. With ASA 64 film, the 'key stop' is the square root of 64, or f/8, and the exposure is therefore ½₅₀ second if you want the moon on Zone V. This translates to ½₂₅ second at f/11, ½₀ second at f/16, ½₀ second at f/22 and ½₅ second at f/32.

But all that was needed was for the moon to 'read' without burning out to a featureless white, so it was quite safe to give 2 stops more exposure than this: in other words, ¼ second at f/32. Finally, figure in the 3x green filter, and you have just over 1 second at f/32; and 1 second at f/32 was the exposure given.

An entirely separate way to come to very much the same conclusion is via the 'sunny f/16 rule'. The moon is illuminated by the sun: at ASA 64, the correct exposure is therefore about ½₀ second (1/ASA) at f/16, or ½₀ second at f/22 and ½₅ second at f/32. This is exactly the same figure as Ansel Adams arrived at with his convoluted calculations, and you now make the same allowances for over-exposing the moon while retaining texture – 2 stops (¼ second at f/32) – and finally 3x for the filter (1 second at f/32).

The second way sounds less scientific, because it doesn't use square roots and candles per sq ft and luminances and key stops, but it is just as valid and just as good an approximation – as witness the fact that it came out at the same answer. Quite honestly, you would have got exactly the same result if you

had rated the film ½ stop slower than its given ISO speed (as so many photographers do) and allowed for over-exposing the moon by 2½ stops, which still gives texture if you down-rate the film slightly. In fact, you might well get an acceptable exposure at as much as 1 stop either way: it is the moment, and the composition, which transfixes us with this picture, and as long as the technical quality is better than adequate, it is distinctly secondary.

The picture is what matters

This is the second point which this chapter is intended to make: the point that in the long run, what matters is the picture – which, more often than not, means the subject matter and the composition. Get those right, and there is little to be gained by striving for a precision of exposure or filter factor which does not exist.

MINAS SANTOS DOMINGOS
These two shots on Kodak T400CN show the different effects of yellow (left) and orange (right) filtration, though the unusually high orange sensitivity of Kodak's T-grain films makes the difference less apparent than it might be with (say) Tri-X or another cubic-crystal emulsion. The density of the shutter in the building on the left was held constant in the two enlargements; the differences in the sky, the path and the foliage are subtle but clear enough.

NIKKORMAT FTN, 35MM F/2.8 PC-NIKKOR, INCIDENT LIGHT READING WITH SIXTOMAT DIGITAL. (FES)

METERING TECHNIQUE

'Metering technique' is a rather grandiose term for 'whatever works'. We have already seen how there are numerous variables and approximations in the whole metering sequence, and the way in which an individual uses a meter is yet another variable; and we need to look at this before we look at specific subjects.

It is a curious but undeniable fact that different photographers using the same meter to determine the exposure for the same subject can get different readings. The two main variables are almost certainly the angle at which the meter is held, and the degree of optimism (or pessimism) with which the scales are read.

METERING ANGLE

Many people are surprisingly vague about their metering. They just point the meter in the general direction of the subject, and hope. But the angle at which you hold the meter can make quite a difference to your readings: easily ⅓ stop in most cases, and commonly as much as 1 stop. With a reflected light reading, you have mainly to consider the up/down

SUNSET, GOA
To make this reading, Roger removed the incident light receptor from his Variosix F and pointed the bare meter cell straight at the sky, tilting it upwards slightly to bias the exposure still further. He knew that the figures in the foreground would be reduced to silhouettes, but that is what he wanted.
LEICA M4P, 35MM F/1.4 SUMMILUX, FUJI ASTIA.

angle; with an incident light reading, you have to consider the left/right angle as well.

Reflected light readings

For a typical outdoor subject, we have found that the best reflected light readings are obtained by tilting the meter slightly downwards. For us, something between 5 and 10 degrees works well.

A lot depends both on the sky and on the foreground. Both green grass and clear blue sky are remarkably good mid-tones, so the variation as compared with a horizontal reading will be small: ⅓ to ½ stop. Black asphalt and white overcast will give considerably greater variations: 1 stop or more. Regardless of the size of the variations, however, you will get the best possible consistency if you always work at the same slight downward angle.

Incident light readings

Again for a typical outdoor subject, especially on a sunny day, we have found that the best incident light readings are obtained by tilting the meter slightly upwards. The angle is less critical than for reflected light readings, but 10 to 20 degrees is generally best. Holding the meter parallel with the ground is likely to result in readings which recommend about ¼ stop more exposure.

Left/right angles can have a far greater effect on incident light readings, especially with side-lit subjects. On a sunny day, with the sun 30 degrees or more above the horizon, you are quite likely to find a 2 stop variation between a reading taken with the sun full on the incident light receptor, and one taken with the receptor pointed away from the sun and shaded by the body of the meter. The figures that follow are for a typical hemispherical receptor; the cardioid response of an Invercone (see page 94) is rather more reliable, but it is certainly still not perfect.

At 45 degrees on either side of the sun, variations are likely to be less than ¼ stop, and even at 60 degrees, they are likely to amount only to ⅓ stop. In other words, with classic 'sun over your shoulder' lighting, problems are not great.

As soon as you are reading a subject which is side-lit, though, you have to be

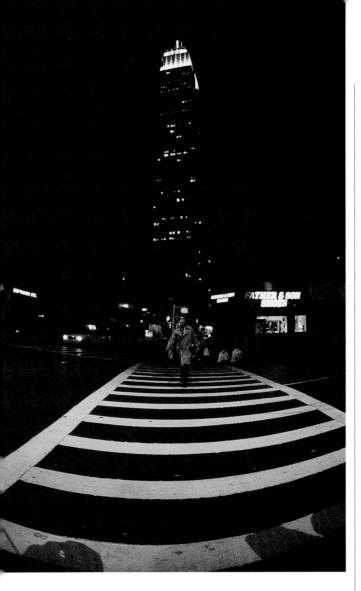

considerably more careful. If the sun is at right angles to the camera/subject axis, quite tiny variations can affect the reading by up to ¼ stop either way – or ½ stop overall. These are variations of as little as 10 degrees from perfect meter positioning, and the nearest 5 to 10 degrees is about as accurately as most people can judge the angle at which they take readings.

Then we come into the realms of backlighting, and although variations with metering angle decline again, you are faced with the question of how you want to represent the subject. We shall return to this later in the chapter.

Using variations in meter angle

In general, it is as well to try to be as consistent as possible in choosing your angle of metering, though you can make a conscious effort to use the angle of the meter to bias your exposures, especially with reflected light readings. If you want

WRECKED CAR

Well over half the area of this image is lighter than 'average' and a centre-weighted reading would almost certainly have led to slight (though probably acceptable) under-exposure. An incident light reading with a Variosix F, from a position which was identically lit, required no interpretation whatsoever.

NIKON F, 200MM F/3 VIVITAR SERIES 1, KODAK EKTACHROME 200. (RWH)

CROSSING, NEW YORK

Contrast ranges in pictures like this are enormous, and most in-camera metering systems give much better results with backlit subjects than with light subjects against a dark background. The best bet is incident light readings from the subject position, or from positions which are similarly lit.

NIKKORMAT FT2, 15MM F/2.8 SIGMA, FUJI RSP RATED AT EI 2500 AND PROCESSED AS FOR 3200, SIXTOMAT DIGITAL. (FES)

colour (or tone) in the sky with a reflected light reading, angle the meter upwards; if detail in the land is more important, angle the meter downwards.

Similar considerations apply in most other situations. Inside a church, for example, you might choose to angle the meter towards a wall, to favour internal detail, or towards a window, to favour the stained glass. If you favour internal detail, you will normally find that the window burns out so that there is little or no detail, while if you favour the stained glass, you will have to put up with the interior blocking up. The only way around this is to attempt to balance the indoor and outdoor lighting, adding supplementary light (usually flash) to illuminate the interior while exposing the window correctly. There is more about this later in the chapter. Before then, we need to look at the other major source of variation in meter readings.

READING THE SCALES

With a traditional meter such as the Weston Master, you have to decide exactly where the needle is pointing. Is it half-way between two numbers, or two-thirds of the way from one to the next, or three-quarters of the way? Then, you have to transfer that reading to the calculator dial. And finally, you have to read the recommended aperture and shutter speed off the calculator dial.

At each stage, there is scope for either optimism or pessimism; in other words, for saying that it is near enough pointing to 8 on the scale, which lines up pretty much like *this*, so the reading is ⅟₆₀ second at f/2.8-and-a-half. Another photographer might say, well, no, it's more like 7⅔ on the scale, so it lines up like *this*, and ⅟₆₀ second at f/2.8 is nearer the

MONASTERY OVEN, RHODES

This picture has a surprisingly long tonal range, from the white stick across the oven door to the inky shadows. Fortunately, the shadow areas are quite small and can be sacrificed in order to increase colour saturation in the rest of the picture and give detail in the white stick; the exposure given was ½ stop less than indicated by an incident light reading with a Variosix F.

LEICA M2, 90MM F/2 SUMMICRON, FUJI ASTIA. (RWH)

mark. It's only ½ stop different, but add that to a difference in the angle at which you hold the meter and you can easily be looking at disagreements of 1 stop or more.

Also, photography often involves a degree of rounding.

Faced with a meter reading of ⅓₀ second at f/11⅔ (f/14), and a lens which allows only ½ stop settings, the choice is between ⅓₀ second at f/11½ (f/13.5) and f/16. The optimist will generally give f/16; the pessimist will give f/13.5. Combine this with the errors given in the last paragraph, and there are exposure variations of well over 1 stop between the exposures given by two photographers, using the same meter and metering the same subject.

CONSISTENCY

What is important is consistency, not accuracy. If your exposures are consistently less than what you consider the optimum, the remedy is simple. Don't change your metering technique: change your film speed, rating the film a little slower than the manufacturer's ISO speed – or even a great deal slower, if your pictures are grievously under-exposed. If your slides are always ⅓ stop dark, decrease your film speed by ⅓ stop; if your negatives have a full stop less shadow detail than you would like, decrease your film speed by a full stop. The same applies in the opposite direction: if your slides are consistently over-exposed, then increase your film speed.

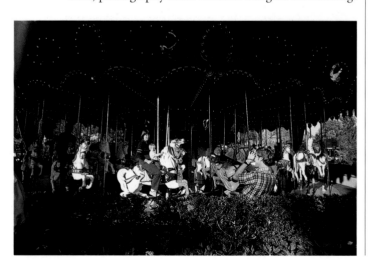

DISNEYLAND

Low, setting sun is extremely attractive and (as noted elsewhere) allows a surprisingly wide range of exposures. Exposure here was based on an incident light reading from the camera position, minus ⅓ stop to increase colour saturation and emphasise the sparkling lights and brass.

LEICA M4P, 90MM F/2 SUMMICRON, KODACHROME 64, WESTON MASTER V. (RWH)

Only if your exposures are inconsistent do you need to worry about changing your metering technique, paying more attention to the angle at which you hold the meter and the way in which you read the scales. And, of course, you may need to refine your metering technique when faced with out-of-the-ordinary subjects, which forms the basis of much of the rest of this chapter.

LIGHT AND DARK BACKGROUNDS

Reflected light meters are easily fooled by large areas which are either unusually bright or unusually dark. Normally, these large, deceptive areas are backgrounds, which means that the meter recommends an exposure for the background rather than for the principal subject. With a large bright area, the meter recommends under-exposure, so you end up with a background which is either correctly exposed or slightly over-exposed, and a main subject which is badly under-exposed; and with a large dark area, they recommend over-exposure, so you end up with a background which is either correctly exposed or slightly under-exposed, and a washed-out main subject.

A problem in both cases is that the correction is counter-intuitive. With a subject against a bright background, the light seems so bright (and the reading is so high) that the natural inclination is to stop down still further, which will of course make the problem worse and reduce the foreground subject to a silhouette; while with a dark subject, the reading is often so low that the temptation is to give a bit more exposure, which once again is likely to prove disastrous.

Going in the opposite direction, if you have someone standing in front of deep shade, you may well need to give 1 stop less exposure in order to have them exposed correctly; you will rarely need more than this, unless they occupy a very small part of the picture area.

Incident light metering reduces the above problems considerably, and the main compensations you need to make are for unusually light or unusually dark subjects; for backlighting; and for flare.

LIGHT AND DARK SUBJECTS

The classic examples of unusually light and unusually dark subjects are a girl in a white dress, and a black cat. If you want detail in the white dress, you will need to under-expose somewhat, in order to make it darker; and if you want texture

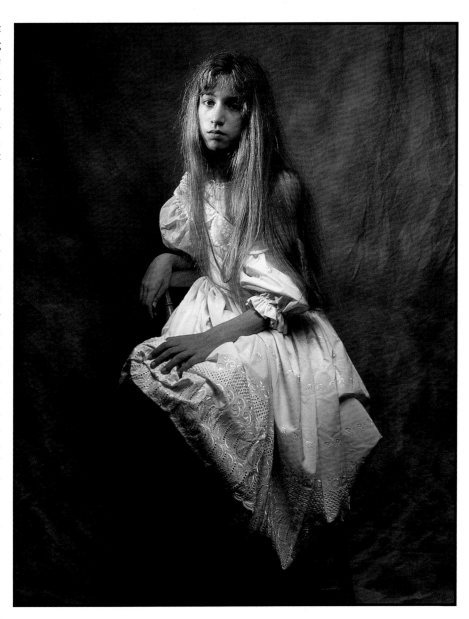

SOPHIE

In order to show the texture in the dress – it is actually her First Communion dress, although you would never guess it from the pose – the exposure was only 1⅔ stops more than indicated by a spot reading of the dress; a similar result would have been obtained by cutting an incident light reading by ⅔ stop. The skin tone is dark and rich, but not unnaturally so, and the strong side-lighting lightens the face.

NIKON F, 90–180MM F/4.5 VIVITAR SERIES 1, FUJI ASTIA, SPOT MASTER 2. (RWH)

in the cat's fur, you will need to over-expose somewhat, in order to make it lighter.

'Somewhat' is a vague term, and the precise degree of over- or under-exposure will depend on the circumstances. With a light-skinned blonde girl in a room with white-painted walls and white-upholstered furniture, you could probably get away with as much as 2 stops, although 1½ stops would probably look less unnatural and 1 stop would be best. If you under-expose too much, her skin tone will start to look

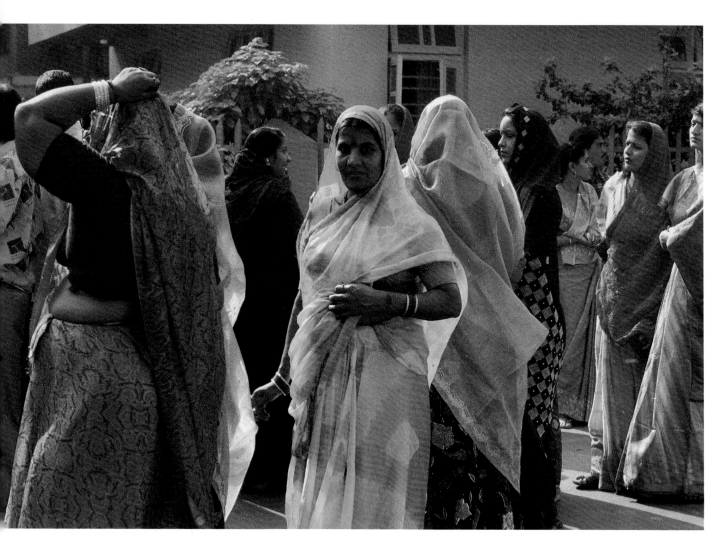

unnaturally dark, and if she is dark of complexion to begin with, ⅔ stop would be the maximum you would normally want to under-expose and ½ stop might be better. As a general rule of thumb, under-exposing by up to 1 stop will work best.

With the black cat, you could get away with 2 or even 3 stops if it was in a coal-cellar, but if it was lying on a pale-coloured sofa (preferably not having come straight from the coal cellar) you would need to limit yourself to around ⅔ stop again. Once again, the general rule of thumb is to over-expose by up to 1 stop.

These corrections would be for colour slides, and with black and white film you can often use still greater corrections, especially if the overall brightness range of the subject is not very great; but the corrections given are a good starting point.

Determining exposure

What, though, is your base line for these corrections? In the above examples – the girl in the white dress, and the black cat – an incident light reading would provide you with a good starting point. If you used a broad-area reflected light meter, however, you would have to make allowance for the subject and its surroundings as well as the subject.

SAREES, MULUND

Backlighting is always tricky to handle, but on this occasion Roger was using colour negative film (Fuji Reala) and rated it ⅔ stop slow to allow more latitude for under-exposure. A plain incident light reading with a Variosix F was more than adequate.

LEICA M2, 35MM F/1.4 SUMMILUX.

PALM WITH SUN BEHIND

You can take a reading from a blue sky, and cut it by as much as 2 stops to give silhouettes against a deep, saturated background. If there had been no cloud, 1 stop less than the metered exposure would have been better: this is going a little muddy, but was necessary in order to drop the palm to a maximum black.

LEICA M4P, 90MM F/2 SUMMICRON, FUJI ASTIA, VARIOSIX F. (RWH)

If the girl were in a white room, as already described, the meter would automatically recommend an exposure which would normally be regarded as under-exposure, but which in this particular circumstance would be about right. The same is true, *mutatis mutandis*, of the cat in the coal cellar: the recommended exposure would be regarded as over-exposure for a normal subject, but it should be about right for this particular very dark subject.

WALL AND FLOWERS, GREECE
This is about as far as you dare go in cutting exposure to give texture on the wall and increase saturation in the flowers. The wall is hovering on the edge of grey, at about 1 stop less than was indicated by an incident light reading using a Variosix F.
LEICA M4P, 90MM F/2 SUMMICRON, FUJI ASTIA. (RWH)

But if the girl were dark complexioned and standing in front of an area of shade, a reflected light meter would recommend more or less over-exposure, as already discussed, and you would need to apply a double correction factor, cutting exposure by maybe 1 stop for the dark background, and another stop in order to get detail in the dress. And if the cat were on a white sofa, you would again need to apply a double correction factor, maybe ⅔ stop for the light background and another ⅔ stop in order to get some detail in the cat's fur.

Once again, we have deliberately chosen extreme (though by no means uncommon) examples. You can see, though, that 'on the fly' corrections of ⅓ stop or more are by no means unrealistic. A state-of-the-art multi-segment, through-lens meter can cope surprisingly well with some of these situations, though a given camera can rarely cope with all of them. Normally, they are much better for dark subjects against a light background than for light subjects against a dark background.

Subjects with a very long tonal range
Suppose now that the girl in the white dress is holding the black cat. What do you do?

The only thing you normally can do is to use a film with as little contrast as possible. In colour, this means avoiding the high-contrast, high-saturation films which are so popular for many subjects, and seeking out a low-contrast film which may have a slight hope of 'holding' both the cat and the dress. In monochrome, you can increase exposure by about 1 stop, and cut development time by about 15 per cent, to reduce the overall contrast of the film.

There is, of course, a common situation where you have to accommodate both a white dress and very dark clothes simultaneously: a wedding. This is why the ISO 160 films so widely favoured by wedding photographers are designed with a low inherent contrast, and with a particular eye to good skin-tone rendition.

BACKLIGHTING
The basic problem of backlighting is obvious as soon as you look at a sunlit building in the middle of a large, green lawn, with a blue sky above. The basic exposure for the lawn is pretty much the same regardless of the direction of the light, but the optimum exposure for the building will vary according to whether you are photographing the sunlit face or the shaded face; and the matter will be further confused by whether the building is light coloured (such as white stucco) or dark coloured (such as red brick).

For the sunlit face of a light building, you may want to cut

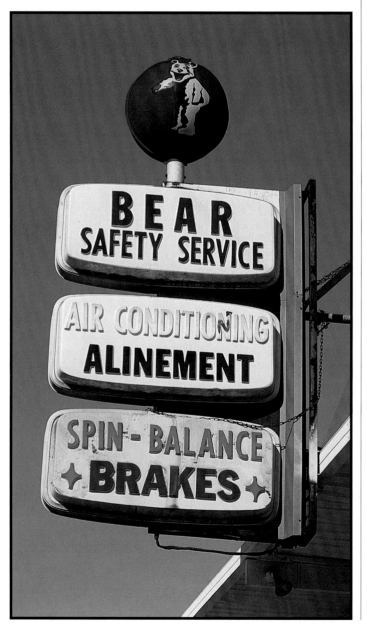

BEAR SAFETY SERVICE
A spot reading of the sky provided the basic exposure reading. A second spot reading of the sign confirmed that it would still read white, even if the exposure was cut by ⅔ stop to increase saturation, so that is what was done.
LEICA M2, 90MM F/2 SUMMICRON, FUJI RFP ISO 50, MINOLTA SPOTMETER F. (RWH)

an incident light reading by as much as 1 stop, to hold texture in the stucco, so the lawn (and the sky) will go dark. This is rarely a problem. But for the shaded face of a dark building, even if you are willing to let the red brick go 1 stop dark so that it only just reads, you are still likely to need 1 stop more exposure than is recommended by the incident light reading on the shaded side. The lawn and sky will therefore record as rather lighter than they are.

There is not much you can do about this in colour, though depending on the angle of the sun and the blueness of the sky, you may find a polarising filter helps a little, and in monochrome you can use coloured filters to even things out a bit. A green filter will lighten the grass and the sky without affecting white stucco, while a red filter will darken the grass and the sky as well as lighten the red brick.

Corrections for backlighting

Many modestly priced automatic cameras have a 'backlight' button, which (as its name suggests) adjusts the exposure for backlit subjects – typically, people against the sky, or against snow. The typical increase is 2 stops, though some cameras may give as little as 1½ stops, and others may give 2½ stops. This is quite adequate for colour negative film, and a step in the right direction for slide film.

If you are using a conventional broad-area reflected light meter, you can make the same correction manually, except that you can modify it intelligently. If the sky is a deep blue, the amount of backlight compensation you need will be minimal: ½ stop, or at most 1 stop. But if it is bright, sunlit cloud, 2½ stops will probably be about right and 3 stops will not be too much.

With an incident light meter, the easiest approach is often to take a reading at right angles to the subject/camera axis, so that the incident light receptor is half lit, half in shadow.

An even better approach is to take two incident readings from the subject position, one with the meter pointing straight at the camera, and the other with it pointing straight at the principal light source. Split the difference between these for the best possible compromise. If you have the choice, use a flat incident light receptor rather than a hemisphere, though a

SQUARE, MERTOLA
Quite often, Roger will take an incident light reading to establish the general light level, and then check the brightness of individual parts of the subject with a spot meter. In this case, he increased the incident light reading (from a Variosix F) by ⅓ stop on the strength of the spot reading (Spot Master 2), in order to open up the shadows.
NIKON F, 90–180MM F/4.5 VIVITAR SERIES 1, KODAK EKTACHROME 200. (RWH)

ARTICHOKES

Marie Muscat-King shot these, just before her mother cooked them. She has a knack of extracting excellent tonality from Paterson Phototec 400 rated at EI 200 and processed in Paterson Aculux: a clear proof of the truth that the only way to find out if something works in photography is to try it.

NIKKORMAT FT2, 135MM F/2.3 VIVITAR SERIES 1, REFLECTED LIGHT READING WITH IN-CAMERA METER.

CHURCH INTERIOR, PRESTON-NEXT-WINGHAM

Spot metering of highlights can be very useful when you have a very long tonal range and you cannot in any case get to the highlights. This was one of our first shots using a spot meter (a Spot Master 2) and we were just able to fit the tonal range onto Polaroid Type 55 P/N, though a conventional film would have been better.

WALKER TITAN SF, 121MM F/8 SUPER ANGULON. (RWH)

hemisphere will still work reasonably well. This technique is known as 'duplex' metering.

In either case, the reading will still be a compromise, so you may wish to decrease the exposure by up to 1 stop to give richer, deeper shadows and more saturated highlights, or to increase it by up to 1 stop to give more shadow detail at the expense of burning out the highlights.

FLARE

Flare is a problem which is commonly encountered with backlit subjects, particularly in colour. Regardless of the background, and even if fill-in flash is employed, the subject is flat, dull and desaturated. Reducing the exposure does not improve matters much: all that happens is that the subject looks dark, flat, dull and desaturated.

The cause is simple: excess light is bouncing around inside the lens, and some of it is ending up as a fog or veil on the film, degrading the shadows and reducing colour saturation and overall contrast. There are four things you can do about it.

The first is to switch to a lens with more contrast. This generally means switching to a simpler design. The more glass/air surfaces there are in a lens, other things being equal, the less contrasty it will be. Zooms have far more glass/air surfaces than most prime lenses (except ultra-fast or ultra-wide prime lenses) so prime lenses are generally contrastier. Multi-coating improves matters, but not all that much, despite the advertising hype; but dirt makes things very much worse, so keep your lenses clean. Leave filters off, too; the two extra glass/air surfaces will not make much difference if they are sparkling clean, but they will make some.

The second thing to do is to use as deep a lens shade as possible; in other words, one that is as deep as it can be without cutting into the image area. Most lens hoods, especially on zooms, are pretty vestigial, and you can get a lot more contrast in most cases by switching to a bellows lens hood and adjusting it carefully to suit the focal length in use: longer lenses can stand deeper hoods, obviously. Self-supporting bellows hoods are the quickest and most convenient to use, but unfortunately they are also the most expensive.

The third way to ameliorate matters, available only in monochrome, is to increase development time or print on a contrastier grade of paper, or both. This will not have the same effect as using a contrastier lens or using a lens shade, so both those options should be explored first; but it will effect some improvement.

The fourth and final possibility, open only to those who have computers with image manipulation software, is to adjust the colours and contrast using something like Adobe Photoshop. Although this is at present an option which is not available to many, it is worth remembering it as a possibility.

EXTRA DEEP LENS SHADE

Especially with older non-multicoated lenses, deep lens shades can dramatically improve contrast and colour saturation. Self-supporting shades, such as those from Cromatek, are easiest to use, or you can adapt second-hand shades: this is a Hasselblad shade on a 120mm f/6.8 Angulon, mounted on a Toho FC45X.

WHITE BLOUSE, DARK CLOAK
Compare the skin tones in these two pictures. In one, the whole picture is printed slightly light in order to preserve tone in the cloak; exposure determination was via a spot reading of the cloak, minus 2 stops so that the cloak would read dark but not quite black. In the other, the whole picture is printed slightly dark, to hold texture in the blouse; again, exposure determination was via a spot reading of the blouse, plus 1⅓ stops so it would retain some tone without burning out.
NIKON F, 90–180MM F/4.5 VIVITAR SERIES 1, PATERSON ACUPAN 200 RATED AT EI 125, SPOT MASTER 2. (RWH)

LIMITED-AREA METERING

At first sight, limited-area metering looks like a panacea. You know exactly what you are metering, so there is no uncertainty. As soon as you try it, though, you realise that there is an enormous, inherent drawback: it is very, very difficult to choose a 'mid-tone' to meter from.

There are two ways around this. One is to carry an artificial mid-tone – a grey card – around with you and to meter off that. The other is to think hard about how you want a given tone to 'read' in the final picture, and to adjust your metering technique accordingly.

Grey card metering

The first and most important consideration here is to point out once again that even spot meters are not necessarily calibrated to 18 per cent; around 12 per cent is the ISO standard, though plenty of meters are in fact calibrated to 18 per cent, either by the manufacturers or by repair men.

In other words, when you take your reading off the grey card, you do not necessarily want the card pointing straight at the camera. More often, you want it angled midway between the subject/camera axis and the subject/light axis. If the square-on approach works for you, fine; but if it does not, consider angling it as described, which is (after all) what it tells

you to do in the instructions which come with most grey cards.

After this, the main point is to make sure that the meter is reading only the grey card, and that the shadow of the meter is not falling on the grey card and affecting it. The light on the grey card must, of course, be identical to the light falling on the subject: if you cannot take a reading from the subject position, then make sure that the grey card is in the same kind of light, be it full sun, open shade, the same distance from the key light in a studio or whatever.

Perhaps surprisingly, a deep blue sky is extraordinarily close to a mid-tone, and makes an excellent 'grey card' in both colour and black and white. Another good mid-tone is grass, or any similar area of fresh greenery.

Highlight readings

Instead of reading a mid-tone, you may instead choose to read a highlight. Choose the brightest area in which you want to retain texture in the final picture, and meter that. Depending on the film in use, you then need to give up to 3 stops more exposure than the meter recommends. If you choose 2½ stops, you will get a very similar reading to what you would get with an incident light meter, as noted below.

With a colour slide film of average contrast, you can give about 2 to 2½ stops more exposure, though a high-contrast film may limit you to two stops.

With black and white film you can give up to 3 stops more exposure, depending on your chosen exposure index and development regime. If you rate the film at the ISO speed, and develop it normally, 2 to 2½ stops is the limit if you want texture in the metered area, but if you rate it at a lower speed and reduce the development time then you can safely go to 3 stops or even more.

If you get confused about the direction in which you need to correct your exposure, just remember this. If you gave the

metered exposure, the highlight would come out as a mid-tone. You want it to be lighter than that, so you need to give it extra exposure.

Shadow readings

If you take a reading of the darkest shadow in which you want texture, you can equally well base your exposure reading on that. For a conventional colour slide film, you want to give about 2⅓ stops less exposure than the meter indicates, while for monochrome negative films you can afford to give 3 or even 4 stops less (see page 182). Once again, remember that if you exposed the shadow area at the meter reading, it would come out as a mid-tone, so you want to give it less exposure to make it darker.

As with highlight readings, you can safely increase the degree of under-exposure, to 4 or even 5 stops, if you rate the film slower and cut your development time.

Other limited-area readings

A reading off the palm of the hand is a fine old tradition, and gives a useful light mid-tone; give 1 to 1½ stops more than the reading from the palm of the hand, which is apparently surprisingly consistent from race to race.

Reading other areas is perfectly feasible, but requires a good understanding of how much lighter (or darker) they are than a mid-tone. A useful way to judge this is to carry a small grey card around with you, and compare given subject tones with that.

Spot meters

A meter with a viewfinder is an extremely useful tool, as it allows you to see exactly what you are metering; normally, you have to guesstimate what is covered by the acceptance angle of the meter. Only a very few general-application meters incorporate viewfinders – the Russian Sverdlovsk-4 is one, though it is handicapped by the fact that it takes an obscure Russian battery size – and there is a clip-on accessory for some Gossen meters which allows 15 degrees and 7.5 degrees semi-spot metering, while the Profi-Spot for the Profisix gives a choice of 1 degree, 5 degrees and 10 degrees.

The 1-degree angle of the typical spot meter is the most useful, especially for lazy photographers, as it enables you to take a reading from the camera position, whether you want to read highlights or shadows or, of course, mid-tones or skin tones.

A further advantage of spot meters is that they

STORM LIGHT, ISTANBUL UNIVERSITY

Sometimes, the key to correct lighting and exposure is simply waiting, which is what Frances did here; but she gave the stormy light a hand by using a deep red 25A filter and Ilford SFX film rated at EI 50 including the filter factor.

NIKKORMAT FT2, 35MM F/2.8 PC-NIKKOR, INCIDENT LIGHT READING WITH SIXTOMAT DIGITAL.

automatically take account of the loss in contrast which becomes more and more evident as you get farther and farther from a subject. This is as true of the spot meters built into some cameras as it is of separate, hand-held meters. It is true that the angle of view of a camera spot meter depends on the focal length of the lens in use, which makes it less useful with wide-angles, but equally, perfect flare compensation is built in, as you are reading through the same lens as you will be using to take the picture. Although a separate spot meter provides a degree of flare compensation (in that it uses an optical system), it is not as good as the flare compensation that you get from a built-in spot meter.

There is rarely much point in using a spot meter to take highlight readings, as you will get almost exactly the same answer from an incident light meter which costs a great deal less and is considerably easier to use. Testing the two side by side, we found that the exposure as determined by a highlight reading and the exposure as determined with an incident light meter were always within 0.3 stop of one another, more often within 0.2 stop than not, and surprisingly often within

VE DAY ANNIVERSARY CELEBRATIONS, PRAGUE

Ilford XP2, with its considerable ability to tolerate over-exposure and its gentle contrast, is an ideal film for backlit subjects. Exposure was based on an incident light reading from the camera position, facing away from the band, and the negative printed perfectly on grade 2 paper instead of the grade 3 we normally use for XP2.

NIKKORMAT FT2, 35MM F/2.8 PC-NIKKOR, SIXTOMAT DIGITAL. (FES)

0.1 stop. On the other hand, for side-lit subjects it may be easier to achieve maximum consistency with the spot reading, because you are not troubled by the angle of the incident light reception.

There is, however, a great deal to be said for using a spot meter to take shadow readings, and indeed Ansel Adams praised them for this very reason; he also reckoned that his (monochrome) exposures increased, on average, by 1 stop when he first got a spot meter. For monochrome, spot readings of shadow areas are arguably the finest way to get perfect exposures.

The other great advantage of a spot meter is that it allows you to take multiple readings quickly and easily; and this is a sufficiently important technique to warrant a heading of its own.

MULTIPLE READINGS

The most usual form of multiple reading is to check both the shadows and the highlights. This can be done with most meters, if you can get close enough to the subject and if the areas you want to meter are large enough, but spot meters generally make it easier. Some spot meters even have shadow and highlight buttons built in. Designed for colour slide films, these normally assume that the highlights are 2⅔ stops lighter than the mid-tone, while shadows are 2⅓ stops darker. With monochrome, depending on your chosen EI and the film and development regime in use, you can meter shadows (with texture) as 3 to 4 stops darker than the mid-

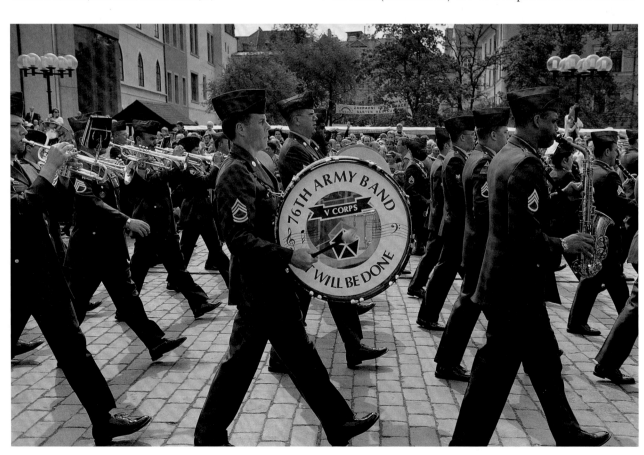

tones, and highlights (again with texture) as 2 to 3 stops lighter.

Any further readings, of tones other than the extremes, are mainly a matter of checking that things will turn out right in the final image: that skin tones are a little lighter than mid-tones (or wherever you want to place them) and so forth.

If the extremes are outside the recording range of the film in use, you can use your spot readings to decide which end of the tonal scale you are going to sacrifice, shadows or highlights. In colour, you normally have to sacrifice the shadows if there is any risk of large areas of burned-out highlights, but in black and white you may decide to sacrifice the highlights if the areas in question are very small.

Development regimes

You can use limited-area metering of multiple areas to determine your development regime for monochrome films. If your standard development regime is designed to accommodate a subject brightness range of (say) 128:1, and the actual subject range is only 64:1, you can increase your development time to increase the contrast and make full use of the printable contrast range of the film; or if the actual subject range is 256:1, you can cut your development time in order to record a longer subject brightness range on the printable contrast range of the film.

The precise amount of increased or decreased development will vary according to your preferred film contrast, your standard development regime, your normal film speed rating and so forth; the subject is discussed at greater length on pages 182–4.

'Hosepiping'

A specialist (but very easy) form of multiple reflected light reading is to wave your meter around so that it takes readings from many areas of the subject. Some digital meters will record the entire exposure range, as shown in the illustration, while with others you simply have to watch the movement of the meter needle and remember the range it covers.

This is not really limited-area metering, but it can give you a good idea of the overall contrast range of the major areas of light and shadow, and can provide realistic limits within which to bracket your exposures. For example, if your readings at ⅟₆₀ second run from f/2.8 to f/5.6, it makes sense to make three bracketed exposures of f/2.8, f/4 and f/5.6 – or if you want more choice, to make five bracketed exposures, using the ½ stop rests as well.

Another specialist, and easy, form of multiple reading is duplex incident light reading, as described on pages 121–123. It is quite possible to combine incident and reflected light metering, and this technique is also known as duplex metering, but combining different metering methods warrants a heading to itself.

COMBINING METERING METHODS

We have almost invariably found that a spot meter is most useful when it is combined with another metering method, most usually incident light metering, though broad-area reflected light metering can also be used. The incident or broad-area reflected reading gives you the approximate exposure, while the spot readings either confirm where specific tones lie relative to that reading or lead you to modify the exposure.

For example, suppose the incident reading in a cityscape is ⅟₂₅ second at f/8. You then read a patch of sunlight where you wanted texture, and find that it is ⅟₂₅ second at f/22. To be on the safe side, especially if you were shooting 35mm, you would probably reduce your overall exposure to ⅟₂₅ second at f/8½, to avoid burning out the light spot.

Even without a spot meter, combining incident and reflected light readings can be very useful when you are dealing with a light subject against a dark background, or vice versa. When metering a light subject against a dark background, a plain reflected light reading would recommend excessive over-exposure. But often, you want a compromise between the subject and the background, so you want some (but not too much) over-exposure, lightening the foreground subject enough to see it, but not so much that the background is burned out. Take an incident light reading, and split the difference between this and the reflected light reading, and you should have a good compromise.

READINGS AT NIGHT

On a bright, moonlit night, in a scene lit only by the full moon, the overall light distribution is very similar to that on a sunny day, but about one millionth as bright. The 'sunny f/16' rule (see page 189) can be modified appropriately: with ISO 1000 film, for example, the exposure on a sunny day would be ⅟₁₀₀₀ second at f/16, so by moonlight it would be 1,000 seconds (⅟₁₀₀₀x1,000,000) at f/16 – or 500 seconds at f/11, 250 at f/8, 125 at f/5.6, 60 at f/4, 30 at f/2.8, 15 at f/2 and 8 at f/1.4. With an f/1.2 lens you could even get away with 5 seconds; with something like Fuji RSP pushed to the limit at EI 4800, you could manage 1 second at f/1.2, ignoring reciprocity failure.

Normally, though, the moon is not the only light, and you have one or more bright, highly directional light sources and an enormous subject brightness range. As often as not, a wide

range of exposures will look 'right', from one where there are isolated, dark areas in a pool of darkness to one where there are burned-out areas in a general field of normal-seeming illumination.

Very low light levels

A small point worth making here, which really does not fit in very well anywhere else in the book, is that when light levels are so low that your meter runs out of sensitivity, you can remove the incident light receptor and take an incident light reading with the meter cell – in other words, so that the meter cell is pointed at the subject, as if you were taking an incident light reading, but without the incident light diffuser. Give one-fifth of the indicated exposure, and you should be all right.

This works because an incident light diffuser removes 80 per cent –

four-fifths – or so of the light falling on the meter cell. Remove the cell, and you have five times the amount of light, which may push your meter back over the sensitivity threshold. This is merely a starting point: with some meters, as much as eight times may be more appropriate, but with others, if there is a light source in shot, you may need to go down to 2x or 3x. It is, however, a trick worth remembering.

If even this approach does not work, then point the meter straight at the strongest light source, from the camera position, and estimate the difference between that reading (after the 5x correction factor, of course) and the light on the subject; most photographers can guess to within a stop or two, and this at least provides a good starting point for bracketing.

MIXING CONTINUOUS LIGHT AND FLASH

Quite often you either have to mix available light and flash, or you want to do so for a particular effect. Overwhelmingly the easiest approach is to make your ambient light reading first, and then adjust the flash to suit this. Because the techniques required for different situations such as interiors, portraits and still lifes are so varied, they are covered in the appropriate chapters.

POLAROID FILM AND EXPOSURE

Probably the quickest way to improve your metering technique – including your guessing technique – is with Polaroids. Because a Polaroid print is a direct positive, it has very little exposure latitude, and the great advantage

CHAPEL INTERIOR, GREECE
With a tricky side-lit subject like this, a useful technique is to take one incident light reading (from just in front of the altar step, in this case) and then one reflected light reading (from the camera position) and average them.
LEICA M4P, 21MM F/4.5 BIOGON, KODACHROME 25, VARIOSIX F. (RWH)

CHAMPS ELYSÉES
The exposure here was based on a guess as to what exposure would give a good reading for the Arc de Triomphe, based on a reading (with a Lunapro F) of a more-or-less similarly lit subject in the Place de la Concorde. The lens was then stopped down all the way, in order to allow the maximum possible exposure time to record the streaks of light from the cars; these are visible even in daylight, so there is no problem in exposing at f/16. Choose a slow film for pictures like this, or use an ND filter, to allow the longest possible exposure times.
LEICA M2, 35MM F/1.4 SUMMILUX, KODAK ELITE 50. (RWH)

is that you can see whether you were right in a couple of minutes or so.

You need a camera with controllable shutter speeds and apertures, which accepts peel-apart Polaroid materials (not the 'integral' materials which develop in front of your eyes). Unfortunately, no such general-application cameras were available from the Polaroid Corporation at the time of writing, so the principal options were as follows.

The Polaroid SE600 (illustrated) was discontinued in the mid-1990s but is still relatively common second-hand. It is available with a fixed 127mm lens or with interchangeable lenses of 75mm, 127mm and 150mm. It takes standard quarter-plate pack films.

POLAROID SE600E
Although this camera is now discontinued, it is still reasonably common on the used market and you can still get 4x5in single-sheet adapters for it from NPC of Newton, Massachusetts. This camera and NPC's own are ideal for learning about exposure.

LUBILOID

The Lubiloid is nothing more nor less than an old Lubitel TLR, bought for next to nothing at a garage sale, with a cheap Polaroid back glued onto it.

Many medium-format cameras accept Polaroid backs, though the price varies widely. Polaroid backs for cameras such as the Hasselblad, the Ukrainian-made Kiev 80 and the Mamiya RB67 are modestly priced and can be swiftly interchanged with standard roll-film backs; Polaroid backs for cameras such as the Pentax 67 and 645, which require a fibre-optic transfer plate, are expensive and really need to have a camera body dedicated to them. The same applies to Polaroid backs for 35mm cameras – and the very small images are in any case of limited value. Again, almost all backs accept the standard quarter-plate pack films.

Most 4x5in cameras accept Polaroid backs, although many accept only the single sheet backs (500/545/545i) which cost a great deal more to run than the quarter-plate pack-film backs: each exposure costs two or three times as much. Nor is the 4x5in pack back (550) much cheaper to run.

TEST SHOTS, POLAROID 35MM

Polaroid backs for 35mm cameras are horribly expensive, and you really need to dedicate a camera body to the back; but you can still learn a surprising amount from the tiny images, and better still, you get two images per Polaroid sheet. The only manufacturer of Polaroid backs for 35mm is NPC of Newton, Massachusetts.

The 405 quarter-plate back does not cost a fortune, even new, and can be fitted to a modestly priced old 4x5in camera. The image is smaller than 4x5in, and is offset to the side, but the ground glass can be marked accordingly and it is not hard to jury-rig an adequate viewfinder.

At the time of writing, too, NPC had just reintroduced a version of the old 'lazy-tongs' (or *doppel-klapp*) coupled-rangefinder pack-film Polaroid, with fully speeded shutter and manual diaphragm.

It is quite feasible to make your own Polaroid camera, using a modestly priced CF-103 back and an old roll-film folder or similar camera; the model shown above left is a Lubiloid, made from a Lubitel TLR. No particular skill is required: the Lubiloid was assembled using a Swiss Army knife, a small hacksaw, a sheet of emery cloth and some epoxy adhesive.

The most useful Polaroid films are arguably the ISO 100 emulsions in either colour or monochrome. Both have about the same latitude as colour slide films, though the monochrome film can capture a wider tonal range. It is also significantly cheaper than colour. Although the films are expensive – a single ten-exposure pack costs about 25 to 75 per cent more than a process-paid 35mm slide film – you can learn a great deal, very quickly, from four or five packs of film. Both time and temperature are critical. Always adjust processing times to take account of ambient temperature during processing: temperature during exposure is not important.

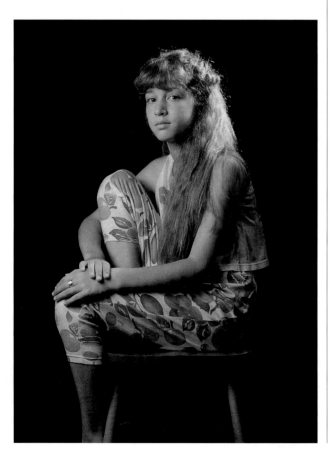

PORTRAIT

Monochrome Polaroids – this is Polapan Pro 100 – have to be interpreted according to the medium used for the final picture. The hair light here is slightly 'hot' for a colour transparency, and would need to be turned down, but it would just about work with black and white. The shot also shows that the pose, with a chopped-off ankle, is awkward.

GANDOLFI VARIANT, 210MM F/5.6 SYMMAR CONVERTIBLE, INCIDENT LIGHT AND SPOT READINGS WITH VARIOSIX F AND SPOT MASTER 2. (RWH)

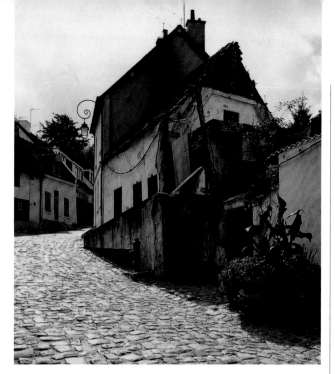

MONTREUIL

Even when you have plenty of experience and a spot meter, there is no substitute for actually seeing a Polaroid image. This shows that the proposed picture is right on the edge of technical feasibility: any lighter, and the sky burns out; any darker, and the building blocks up.

TOHO FC45A, 120MM F/6.8 SCHNEIDER ANGULON, POLACOLOR PRO 100, SPOT READINGS WITH SPOT MASTER 2. (RWH)

Learning exposure

Shoot the first pack or so using your usual metering technique. If you are not satisfied that a given exposure is the best obtainable, shoot another picture. Remember that this is a direct positive process, so extra exposure means a lighter picture, and less exposure means a darker picture. The only way to learn the effect of variations in exposure is to 'waste' a pack or so of Polaroid film; we put 'waste' in quotation marks because it will not be wasted at all if you learn from it. We thought of reproducing over- and under-exposed Polaroids here, but decided that the limitations of photomechanical reproduction were such that it was hardly worth it. If you want to learn to use Polaroids, you will do the tests yourself, and if you do not, there is little point in demonstrating the differences here.

Polaroid prints are an excellent guide to exposure with colour slide film, but the exposures cannot necessarily be transferred straight to monochrome negative, where you may prefer the tonality obtainable by rating the film at a lower exposure index than the ISO speed: Polaroid monochrome print films are always rated at their nominal ISO speed. What a Polaroid monochrome image can show you, however, is how to get the effect you want for a given ISO speed. If you then use (say) Ilford FP4 Plus rated at EI 80 for your 'real' monochrome photography, setting your meter for ISO 80 and using the same metering techniques as for the Polaroids will result in negatives which are similar in consistency to your Polaroids. What Polaroids teach, above all, is how to meter consistently.

The real value of learning with Polaroids comes when you change meters or metering technique. In particular, when you first start to use a spot meter, Polaroids are invaluable: you are likely to learn, very quickly, that you know a great deal less about tonal values than you thought you did. Only when you can get consistent results with Polaroids should you consider using your new meter or metering technique for general exposure determination.

Polaroid prints and films

Professionally, the main use for Polaroid backs is in exposure checking: they automatically take care of any individual variations in shutter accuracy, diaphragm calibration or metering technique. A separate Polaroid camera, such as the Lubiloid, cannot do this but it should still give you a pretty good idea.

Polaroid prints make perfectly good originals for book illustrations, and can be enlarged 2x to 3x without loss of detail; quality is better than you will get from any instant-capture digital camera on the market.

A wide range of films is available, in black and white, colour and even sepia. Note that colour films change tone as they dry: they are distinctly greenish when freshly peeled. With Polaroid P/N (positive-negative) monochrome films, you also get a recoverable negative, which must be cleared in sodium sulphite solution, then washed and dried before use: not 'instant', perhaps, but quicker than conventional photography and offering the option of checking both exposure and composition immediately, while the negative is still wet.

SELMA, ALABAMA

Polaroid Sepia (ISO 200) is available only in single-sheet 4x5in and from around EI 125 to around EI 250, so it will not necessarily teach you a lot about exposure on other media; but it can teach you a lot about mood, from a light, yellowish, Victorian appearance to a chocolate-brown, dark, 1920s appearance. This was at the rated speed with a Toho FC45A and a 120mm f/6.8 Angulon, from an incident light reading with a Variosix F. *(RWH)*

LANDSCAPES AND BUILDINGS

When considering metering techniques for specific applications, it makes sense to begin with landscapes because they most closely reflect the conditions on which the premises of film speed and meter design are based: the 128:1 brightness range and the average reflectivity of around 12 or 13 per cent.

While this should mean that landscapes are the easiest of all subjects to meter, as we have seen, the premises of film speed and meter design are at best compromises, and adjustments frequently need to be made. Along with landscapes, this chapter includes buildings, which are only slightly related to landscapes but do not really warrant a chapter to themselves.

METERING FOR COLOUR SLIDES

For general views, an incident light reading will normally be entirely adequate, and unless there are special factors such as snow or large expanses of light sand, a reflected light reading will probably agree with the incident light reading to within ⅓ stop, or often better.

The largest corrections that normally need to be made are ½ stop extra for pictures in which large areas of dark foliage are important, and ½ stop less for pictures where you want to intensify the yellow of sand or the blue of the sky. Still further under-exposure – as much as 1 stop – may be useful if you really want to 'pop' colours, though this can lead to problems if you have a long tonal range, such as you might have with the dark hull of a boat on light-coloured sand.

Film choice is influenced by much the same considerations: high-saturation films may work well on overcast days or for subjects with a limited tonal range, but on a bright, sunny day you will often do better to go for a film with less saturation – unless you particularly want inky black shadows.

It is when you start getting into more detailed shots, or when you photograph subjects with an unusual distribution of tones, that your metering technique needs to be refined.

MEADOW, PELOPPONESE
Exposure meters are designed to handle this sort of 'average' subject with green grass, a blue sky and a yellowish red main subject, so an incident light reading and a reflected light reading (the latter with the meter pointing slightly downwards, both taken with a Variosix F) proved to be identical.
MPP MK VII WITH HORSEMAN 6X12CM BACK, 150MM F/4.5 APO LANTHAR, KODAK EKTACHROME EC 100. (RWH)

Details

For most detail shots in full sun, a broad-area reflected light reading will prove surprisingly effective. Unusually light subjects will require a little exposure, and this is what a reflected light reading will recommend; the opposite will be true of an unusually dark subject, which again will tally with the meter reading. The point is that the departures from 'average' conditions are likely to be quite modest, so the corrections described on page 117 are unlikely to be needed.

If you want to take incident light readings instead, then by all means do so, but you may find that 'equivalent' readings – readings which are not taken at the subject position, but in light which looks to be the same – are deceptive.

This is especially true on a sunny day if there is much shadow in the shot. The temptation is to base your exposure on a sunlight reading, and to assume that the shadow will take care of itself; but surprisingly often, you need to give ½ stop or even 1 stop more if you are to avoid blocked-up shadows. The sunlit parts of the image will be correspondingly brighter, but unless they are whitewashed they should not burn out; even honey-coloured stone can stand a surprising amount of over-exposure.

You can also have problems, even on an overcast day, if you are photographing near cliffs or tall buildings. The reading from the middle of a street in the concrete canyons of New York can easily be ½ stop higher than one side of the street, and 1 stop brighter than the other. But because the light-coloured buildings are separated by black asphalt, it is difficult to see the differences and therefore all too easy to under-expose inadvertently.

JARDIN DU PALAIS ROYAL, PARIS

The widely varying reflectances here would be a trap for the unwary user of a limited-area meter, although the experienced user might choose the blue sky as a base exposure and check that the brightest part of the statue was not more than 2½ stops brighter while the dark, shadowed wall was not more than 2½ stops darker. Alternatively, an incident light reading (as here, with a Variosix F) is all that is needed.

TOHO FC45A WITH HORSEMAN 6X12CM BACK, 120MM F/6.8 SCHNEIDER ANGULON, KODAK EPN ISO 100. (RWH)

PELOPPONESE

Under-exposure – about ⅔ stop – has 'popped' the colours on Kodak Elite 100; the base exposure was determined with an incident light reading on a Variosix F. The very light undersides of the olive leaves still read light, creating even more apparent saturation than is really present.

NIKKORMAT FTN, 35MM F/2.8 PC-NIKKOR. (FES)

Unusual tonal distribution

Snow is the classic example of a tonal distribution which will fool most meters. Base your exposure on a straight reading, and you are likely to get a leaden grey (or blue-grey) image which is at least 2 stops under-exposed. Actually, it can easily be 3 stops under, but you want around 1 stop of under-exposure if you are to capture texture in the snow. With a reflected light reading, therefore, you will need to give about 1 stop more than the meter indicates, while with an

incident light reading, you will need to give about 1 stop less.

Similar considerations apply with freshly whitewashed buildings, such as are found throughout the Mediterranean, but whitewash that has been on the walls for a while is typically up to ½ stop darker than fresh whitewash, even though it is still bright white to the eye.

Photography from cave mouths, or out of the doors of buildings, or from any other location where there is a preponderance of dark tones, can be approached in three

SHOP, MULUND

Perhaps paradoxically, we use tripods more during the day than we do at night. At night, we tend to prefer ultra-fast films – this is Kodak TMZ P3200 rated at EI 12,500 – and fast lenses, here a 28mm f/1.9 Vivitar Series 1. Exposure is normally based (as here) on a sequence of incident light readings, plus guesswork.

NIKKORMAT FT2. (FES)

RIVER BED, PORTUGAL

Although the tonal range is small here, the colours are fairly dramatic – this is a badly polluted area in the Alentejo – and they have been further intensified by slight (½ stop) under-exposure as compared with an incident light reading from a Variosix F. Even so, Velvia would have given more dramatic results than the Fuji Astia used.

NIKON F, 90–180MM F/4.5 VIVITAR SERIES 1. (RWH)

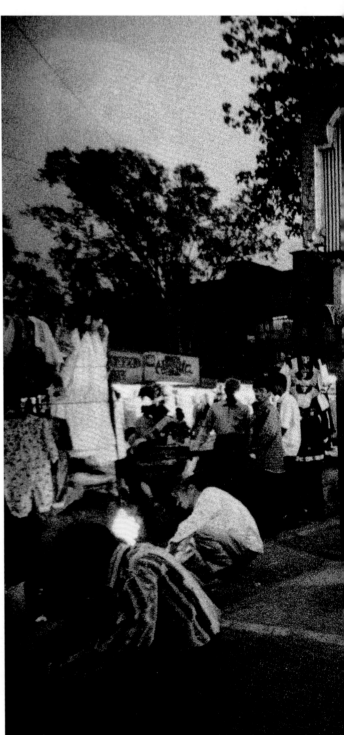

ways. You can simply meter the outside, and use the dark area as a silhouetted frame; you can use fill flash; or you can take at least two readings, one in the shadow and one in the light, and try to strike a compromise. Limited-area or even spot readings are likely to prove most useful, but you have to accept that with colour slides, anything which is more than about 2⅓ stops darker than your chosen exposure will block up to a featureless black, while anything that is more than about 2⅔ stops lighter will burn out, first to a rather nasty yellow and

then to a featureless white. With monochrome slides, you can normally capture around 1 stop extra in either direction. There is more about this on page 143.

Duplex metering
Both types of duplex metering (see page 127) may with advantage be applied for this sort of photography if you are dealing with backlit or side-lit subjects, especially around sunrise or sunset. Taking two incident light readings, one on

SHOP WINDOWS, RHODES OLD TOWN
It is difficult to retain detail both in shop windows and in the street, especially after twilight. Here, the bright window is on the edge of over-exposure, and the street on the edge of under-exposure, but you can still see what is going on in both, which was the intention.
LEICA M4P, 35MM F/1.4 SUMMILUX, FUJI RSP RATED AT EI 2500 BUT PROCESSED AS FOR EI 3200, LIMITED-AREA READINGS WITH VARIOSIX F. (RWH)

the subject/camera axis and the other on the axis between the subject and the sun, and then averaging the two, will almost invariably result in the best compromise, and the other technique (one incident light reading, one reflected light) will not be far behind.

The only question is whether you want a compromise. Often, it is better to let the foreground go to a silhouette (or at least very dark) and to concentrate on the sky in this sort of picture; but this is an artistic decision, not a technical matter.

Night shots

The best 'night' shots, especially in the city, are often taken when there is still some colour in the sky, and the best way to

meter such shots is usually with a broad-area reflected light meter, quite possibly 'hosepiping' the meter as described on page 127. Incident light readings will often result in over-exposure, because the meter is influenced mainly by the sky. If you take an incident light reading, unless you are standing directly under a street light or something similar, you may find it advisable to under-expose by a stop or even two.

Because night shots in the city typically embody huge brightness ranges, it is – as noted elsewhere – quite common for a wide range of exposures to be successful. At one extreme, you can take readings from shop windows and let the rest of the scene go dark, and at the other, you can expose the street pretty much normally and let the windows burn out; limited-area meter readings will give you the right

POWER SOCKET, SELMA, ALABAMA
The only depth in this comes from the strong, slanting sunlight. The colours are slightly exaggerated, but only slightly, by ⅓ stop under-exposure as compared with an incident light reading from a Variosix F.
NIKKORMAT FTN, 35–85MM F/2.8 VIVITAR SERIES 1, FUJI ASTIA. (RWH)

LINDOS, RHODES
As the sun set, we waited for almost an hour, shooting everything from the sunset to the twilight. This is a classic 'night' shot, with the lights on the edge of burning out but plenty of light still in the sky. Exposure was 1 stop less than indicated by a direct reading from the sky with a Variosix F. The 'starburst' is a consequence of reflections from the edge of the diaphragm: no filter was used.
LEICA M4P, 50MM F/1.2 CANON, AGFA RSX 100. (RWH)

RIVER IN THE PELOPPONESE
The combination of shadow detail and bright, sunlit whitewater was easier to capture than it might seem: there are few really dark shadows, and they are simply sacrificed. Exposure on Kodak Ektachrome 200 was as recommended by an incident light reading with a Variosix F.
LEICA M2, 35MM F/1.4 SUMMILUX. (RWH)

exposure for the shop windows, and incident readings for the overall scene, and of course you can split the difference between the two to varying degrees to achieve a compromise.

In very poor light, remember the trick of removing the incident light receptor and taking an incident light reading with the bare meter cell, then increasing the exposure by a factor of five (see page 129).

METERING FOR MONOCHROME NEGATIVES

Landscape photographers who work in black and white tend to fall into two camps. One camp uses the same metering techniques as for colour, which can deliver good results but will rarely deliver the best possible picture. The other camp uses the Zone System, which was devised principally for landscape photography.

The first camp tends to miss out on shadow detail, because they are normally using highlight metering techniques, and although the second normally gets much more shadow detail, they sometimes involve themselves in an unnecessary rigmarole in order to do so.

The basic approach is simple, and has been known since the earliest days of photography: it is to expose for the shadows, and develop for the highlights. The easiest approach is to take a limited-area reading of the darkest shadow area in which you want detail, and to give 2 or at most 3 stops less exposure than this. You do not normally need a spot meter, provided you can get reasonably close to the shadow area: an ordinary reflected light meter will do fine.

This will ensure that you have the detail you want in the shadows. You then adjust your development regime to suit the overall tonal range of the subject. For a 'normal' subject, you give 'normal' development. For a subject with a smaller

FATEPUR SIKRI

Balancing light on indoor/outdoor shots is most easily done on an overcast day, or at least, in the absence of harsh sunlight. In the days when Frances shot this we did not own a spot meter, so the exposure was based on a series of incident light readings indoors and out. The outdoor part is always going to be over-exposed; try to keep it less than 2 stops brighter than the exposure given, with the indoor part less than 1½ stops darker.

MAMIYA 645, 35MM F/3.5 LENS, KODAK EKTACHROME 64, WESTON MASTER V.

HOUSE, PRESTON-NEXT-WINGHAM

With panoramic pictures, you not only have the problem of vignetting at the corners, you also have the problem of getting the right exposure across the whole sweep of the picture. Here, spot readings were taken with a Minolta Spotmeter F of the sky; the lake; the house; the foliage; and the clouds. Some shadow detail was sacrificed, but not too much.

LINHOF 617, FUJI PROVIA RDP. (RWH)

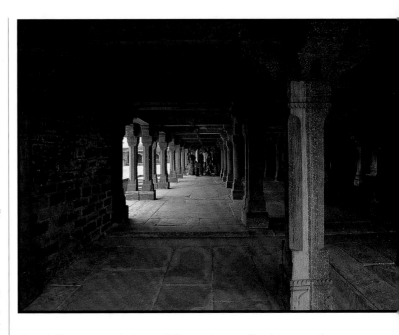

than 'normal' tonal range, you increase your development time, typically by up to 50 per cent, and for subjects with a greater than 'normal' tonal range, you decrease your development time; we would not normally decrease it by even 20 per cent, though there are those who halve their development times for subjects with a very long tonal range.

The reason why 'normal' is placed in quotation marks is that different people have different 'normal' subjects and development times. A great deal depends on where you live, and what you photograph. Suffice it to say that when we go to Greece or India, we typically cut the development times of

the black and white films which we shoot there by 10 to 15 per cent as compared with our 'normal' times for a sunny day in the south-eastern UK; while on a misty day in Scotland, we may increase our development times by around 30 per cent. By the same token, a Greek photographer might increase his 'normal' development times by 15 per cent or so if he shot in the southern UK on a sunny day, or 50 per cent for a misty day in Scotland.

You can if you wish take limited-area readings of both shadow and highlight areas, which will tell you the total tonal

ENTRANCE HALL OF THE EMPIRE STATE BUILDING

Adobe Photoshop is an excellent substitute for a shift lens. This was shot on Kodak TMZ rated at EI 12,500, using a 28mm f/1.9 Vivitar Series 1, and the wildly converging verticals were corrected in Photoshop. Exposure determination was by averaging incident and reflected light readings.

NIKKORMAT FT2, GOSSEN SIXTOMAT DIGITAL. (FES)

LAKE DISTRICT

One theory of exposure – for which we have considerable sympathy – argues that adjusting development to compensate for different subject brightnesses looks unnatural because it falsifies values. A misty day, this argument runs, should look misty, and a sunny day should look sunny. The argument certainly holds good for this misty evening shot in the Lake District, captured on Polaroid Type 55 P/N using an MPP with a 203mm f/7.7 Kodak Ektar. Exposure determination was by incident light reading with a Variosix F; the film was rated at EI 32.

(RWH)

THE PERFECTIONIST APPROACH

With a spot meter, you can measure the log brightness range of the subject; you know that you need a log density range of around 1.1 to make a contact print on grade 2 paper; and armed with the film manufacturer's gamma/time curves, plus a good guess at the flare factor for your lens, you can select the appropriate development time. If your brightness range is 7 stops, 128:1, 2.1 log units, and you assume a flare factor of 1.5 (a reasonable guess for a prime lens in a 35mm or medium-format camera), then your image brightness range will be approximately $6\frac{2}{3}$ stops, 85:1, 1.9 log units, and you need a G-bar of around 1.1/1.9=0.58. Drop the flare factor to 1 (an accurate estimate for many multicoated lenses in large-format cameras) and your image brightness range will be the same as your subject brightness range, so you need a G-bar of around 1.1/2.1=0.52.

Although it makes sense to have a good idea of this sort of strategy, we firmly believe that to apply all these calculations rigorously for all exposures is a dangerous waste of time. It is a fair complaint that 'average' development is a Procrustean bed; but so, in a sense, is precise matching of subject contrast to negative density range. After all, we expect a sunny day to look sunny and contrasty, and a misty day to look flat and dull. If we depart too far from these expectations, the pictures can all too easily look unnatural.

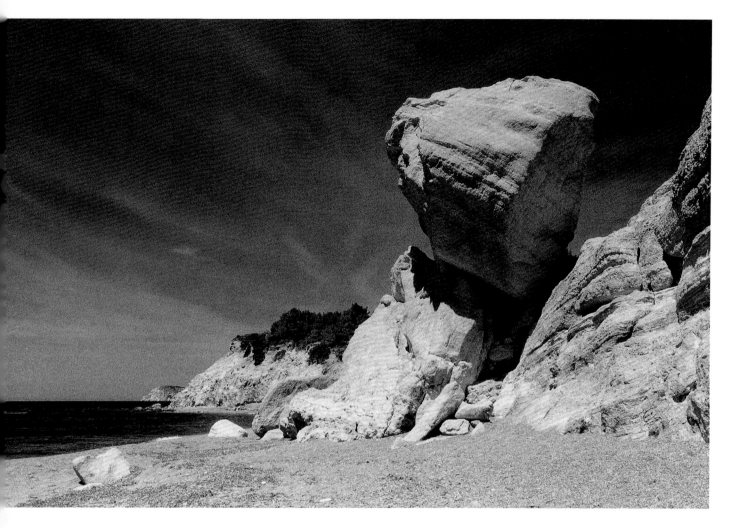

BALANCED ROCK
Compare this with the Lake District shot reproduced on page 141. No special development treatment was applied: this is a sunny day, and it looks sunny. A deep red (25A) filter darkened the sky and lightened the yellow sand and rock, however. Roger's 4x5in version of this appears in our *Black and White Handbook* (David & Charles, 1996).

NIKKORMAT FT2, 35MM F/2.8 PC-NIKKOR, ILFORD SFX RATED AT EI 50 INCLUDING THE FILTER FACTOR, INCIDENT LIGHT READING WITH SIXTOMAT DIGITAL. (FES)

range of the subject, and you can then adjust development times so that the subject brightness range in question is made to fit precisely on the range of printable densities of the negative; this is quite easily done by varying the slope of the characteristic curve, as described on pages 27 – 31.

Night shots
In the countryside, the only practical metering technique is normally as described earlier in the chapter, taking an incident light reading with the bare meter cell. In the city, limited-area or spot readings will allow a variety of compromises, as described for colour photography, but after twilight the overall brightness range is likely to be so great as to preclude useful representation of the entire range, even with greatly reduced development times.

INTERIORS
The main difficulty in metering interiors lies in deciding how much of a compromise you are willing to make between light areas and dark areas. A room which looks reasonably evenly lit to the casual eye will often, on closer examination, turn out to consist of pools of light in a sea of darkness. We do not normally notice this unless we train ourselves to do so, because the eye automatically adjusts for brightness as it scans a scene; but a still camera does not scan, and must take an entire scene at a single moment.

The only practical approach, in most cases, is to base your exposure on the highlights, either via limited-area readings or with an incident light meter. With a limited-area meter, you can read the important highlights and give 2 to 3 stops more exposure than the meter indicates, depending on the type of film in use and the nature of the highlights, while with an incident light meter you can generally get away with up to $\frac{2}{3}$ stop more exposure than the meter indicates and still get just-acceptable highlights without losing too much of the room in gloom.

Or, of course, you can use the gloom creatively, though this normally means coming in closer: one pool of light in gloom can have a Rembrandt-esque attraction, but two or more pools of light will normally just look confusing.

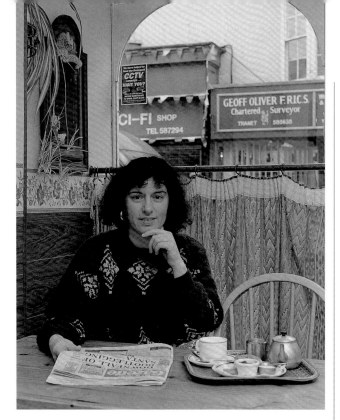

MARIE AT MR HIPPO'S, RAMSGATE
This looks like a pretty unremarkable shot – until you ask yourself how to get the right exposure for both indoors and outdoors. The key is a powerful (1200 W-s) Courtenay flash bounced off the ceiling to light the interior.
LINHOF SUPER TECHNIKA IV, 105MM F/3.5 XENAR, ILFORD XP2, INCIDENT LIGHT READINGS INDOORS AND IN THE STREET WITH A VARIOSIX F. (RWH)

Indoor/Outdoor

A problem which arises periodically is shooting an interior so that the scene outside the window also 'reads'. Normally, of course, you have a choice of recording the interior, and burning out the window, or recording the exterior, and leaving the room as a black hole. This is as much a lighting problem as it is a metering problem, but it can still be addressed here with advantage.

You have to begin by determining your exposure for outside. Let's say it is ⅟₆₀ second at f/8. You are unlikely to be able to use a wider aperture than this, simply because of depth of field: after all, you are trying to show the world outside as well as the interior of the room.

All you need to do now is to pump enough light into the room to allow (roughly) the same exposure. The easiest way to do this is normally with flash, not least because it matches daylight. You are likely to need quite powerful flash units, but you should be able to do it with around 800 W-s (Joules); that is, two middle-powered monobloc flash units, or one powerful one. Bounce it off the wall or ceiling to diffuse it, and take care to avoid reflections in the window. The effect will generally look most natural if you switch on internal room lights, though (once again) you may need to turn some off because of problems with reflections in the window.

If your flash units are not powerful enough, switch to a faster film. If you needed ⅟₆₀ second at f/8 with ISO 100 film, you could switch to ISO 400 film and shoot at the same

aperture with a shutter speed of ⅟₂₅₀ second (assuming your camera will synchronise at this speed), and you can now use a flash which is 2 stops less powerful. You might even be able to light the interior with a reasonably powerful on-camera flash such as the Metz 45-series, provided you could avoid flash-back from the window; you would need to angle and tilt the head to bounce the flash, as before, and in the absence of a modelling light you would experience considerable difficulty in ensuring even illumination and in avoiding unwanted reflections.

MERTOLA FROM ACROSS THE RIVER
We find that Ilford SFX with a true IR filter (here, the Ilford gel with a T_{50} of 715nm) gives pictures which are detectably different from the usual run of travel pictures without the sometimes bizarre effects of true IR films.
NIKKORMAT FT2, 35MM F/2.8 PC-NIKKOR, FILM RATED AT EI 20 INCLUDING FILTER FACTOR, INCIDENT LIGHT READING WITH SIXTOMAT DIGITAL. (FES)

PORTRAITS

The principal concern in metering for portraits is going to be skin tones, though it is also important to make sure that the clothes and background are rendered pleasingly. By convention, Caucasian skin tones are taken as being 1 to 1½ stops lighter than a mid-tone. According to at least one (Japanese) manufacturer of exposure meters, Japanese male skin tones are very close to a mid-tone; the difference between male and female skin tones is presumably explained by make-up.

In practice, even among Caucasians and Japanese, skin tones vary across a range of at least 1 stop, and among brown-skinned and black-skinned peoples the range can be considerably greater. Although any portraitist would be well advised to have a good idea of the average reflectivity of the skin of his particular subjects, the skin reflectivity of the subject is not necessarily a particularly good guide to the skin tone with which the subject of a portrait is likely to be happy.

In India, for example, a light complexion normally brings a higher dowry; and even in those layers of Indian society where such mediaeval considerations are of less than prime significance, fair or 'wheaten' skin is generally regarded as an attractive attribute. In Japan, the preference for a light-coloured skin is evidenced by the fact that make-up is almost invariably designed to give an impression of a lighter complexion rather than a darker one. In Scotland, the fair complexion with red hair is regarded as archetypally Scottish, and women will not thank you if you print their pictures too dark.

To be sure, there are individuals for whom a dark skin is a matter of pride (which is every bit as meaningless as a light skin being a matter of pride), but on a worldwide basis, fair skin is probably more popular. The sociobiological basis of this is probably that, again on a worldwide basis, very fair skins are rarer; and because humans have an innate weakness for exoticism, provided it does not tip over into freakishness, fair skins are therefore seen as attractive. There is also the point that except for those with very dark complexions indeed, a clean face is lighter than a dirty one; and most people tend to prefer clean faces.

GIRL, MULUND

As noted in the text, fair complexions are widely prized and make-up is often used to emphasise fairness. Generally, unless your subject is particularly proud of a dark skin, you will get results which please your sitters if you give an exposure 1⅔ or even 2 stops more than the limited-area reading from a light skin tone, or ⅓ to ½ stop more than is indicated by an incident light meter.

LEICA M4P, 35MM F/1.4 SUMMILUX, FUJI REALA, INCIDENT LIGHT READING WITH VARIOSIX F. (RWH)

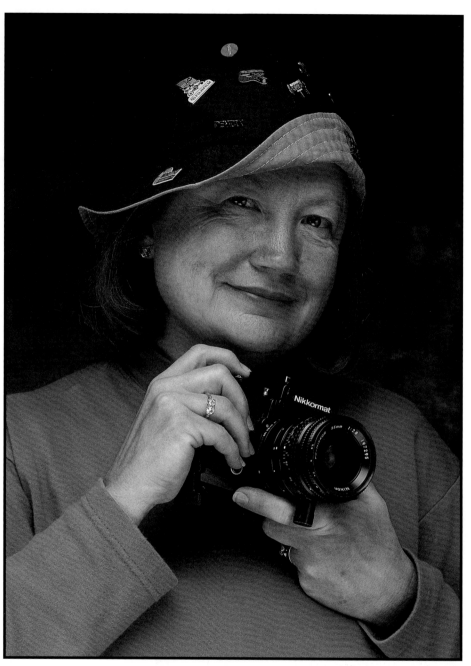

Another advantage of representing skin tones lighter than they actually are is that dark hair will be better differentiated. Some people have almost blue-black hair, and even with careful lighting it will block up into an almost solid mass (perhaps with some highlights) unless the skin tone is rendered a little light. With some people, and some hair-styles, an undifferentiated 'helmet' of hair can make for a very effective portrait; but with long, dark hair, at least some differentiation will normally be desirable.

Pictorially, on the other hand, portraits (especially of men) are often much more dramatic if the skin tone is represented somewhat darker than it actually is. The weather-beaten fisherman, the grizzled old soldier, the wrinkled grand-mother are all verging on clichés. The hair problem in these pictures is often solved by its having departed of its own accord, or at least by its having turned white, so there are no real disadvantages in representing it as darker than it is. This conflict between the photographer and the subject is unlikely ever to cause problems, provided the photographer is aware of it; but it does show that the representation of skin tone is very much a matter of choice and convention, rather than anything very objective.

Quite separately from the question of skin tone – and indeed, at something of a tangent from metering – there is the question of backgrounds. A besetting problem of backgrounds in amateur portraits is that they are too close to the subject, so that the subject casts shadows on them. In a professional portrait studio, the subject is normally at least

GOAN

Even dark skin tones are often best represented with significant highlights. This is partly a matter of lighting as well as exposure; a little over-exposure is unlikely to do any harm.

NIKKORMAT FT2, 90MM F/2.5 VIVITAR SERIES 1, ILFORD XP2 RATED AT EI 250, INCIDENT LIGHT READING WITH SIXTOMAT DIGITAL. (FES)

FRANCES

Our main concern here was not to 'lose' the black camera, which was carefully lit (and held) to reflect as much light as possible: black paint can be surprisingly reflective. In the event, we should also have looked more carefully at her hat, which is all but merging into the background.

LINHOF SUPER TECHNIKA IV, 180MM F/5.5 TELE ARTON, FUJI ASTIA, INCIDENT LIGHT READING WITH VARIOSIX F. (RWH)

1m (40in) from the background, and 2m (80in) allows more scope for lighting the background separately. For most portraits, the background is 1 or 2 stops darker than the skin tone; for high-key portraits, it is normally similar in tone to the skin tone, or up to a couple of stops lighter. Making it lighter still is an invitation to flare. Limited-area metering is the easiest approach here, but provided you do not shade the metered area with your hand, there is no need for a spot meter.

METERING FOR COLOUR SLIDES

Under any form of controlled lighting, overwhelmingly the easiest way to meter portraits is with an incident light meter. The only real question is how you orient the incident light meter in a multi-light set-up.

Most of the time, you will get a perfectly adequate reading by holding the meter in front of the subject's face, pointing straight at the camera. You may, however, wish to take two readings, one with the receptor pointed straight at the camera and the other with it pointed straight at the key light, and then average the two: this is the 'duplex' method described on page 121. It is best done with a flat-receptor incident light meter, though there may be a significant difference between the two readings even if the meter has a domed receptor. In practice, though, the problem tends to be self-solving, in that the averages for both domed and flat receptors end up fairly similar.

The resulting reading in both cases will recommend less exposure than a straight reading from the subject/camera axis, and this approach generally works best with middling lighting ratios. If the lighting ratio is tight, there will be little or no difference between the two readings, and if it is very wide, then it may accentuate bright edges; if the main part of the face is darkened and a bright edge is still very bright, the effect may not be pleasing.

Given the incident light reading, no matter how it is obtained, the exposure can then be adjusted in accordance with the wishes of the subject (typically up to 1 stop lighter, though ⅓ to ⅔ stop is likely to look more natural) or the photographer (typically anything up to 2 stops darker for Caucasian skin, or up to 1 stop darker for any but the darkest-skinned of other races).

DAVE AND MANDY BARBER

Wherever possible – clearly, it was not done here – avoid shadows from the subject on the background. It is also a good idea to 'garden out' unduly bright backgrounds such as some of the more vivid book spines; again, this clearly was not done here.

LINHOF TECHNIKARDAN, 210MM F/5.6 SYMMAR CONVERTIBLE, FUJI ASTIA, INCIDENT LIGHT READING WITH VARIOSIX F. (RWH)

SOPHIE

In order to emphasise the bright, metallic mask in the shot above, the negative (on XP2 Super) was slightly over-exposed. This lightened the overall skin tone, creating an atmosphere of innocence and dressing up. In the other print (right) from the same roll, about 1 stop of under-exposure was chosen to hold texture in the fabric. This darkened the skin tone, making Sophie look almost sallow. Exposure in both cases was determined with a Gossen Sixtomat Flash.

NIKKORMAT FTN, 85MM F/1.8 NIKKOR. (MARIE MUSCAT-KING)

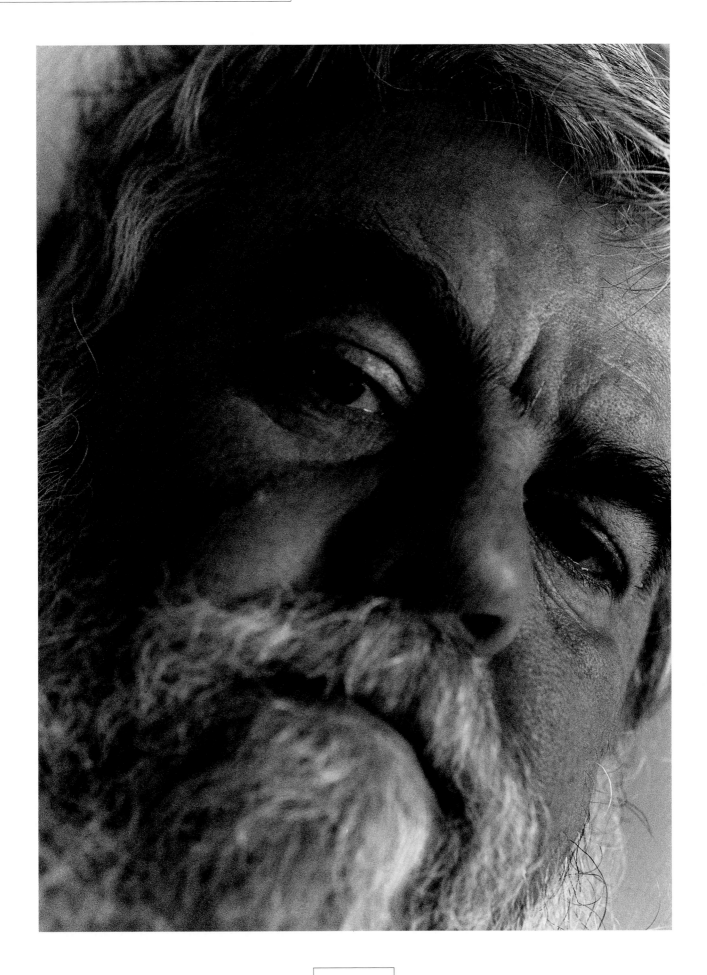

ROGER

You really need your subject's agreement before you print this sort of skin tone, which is hardly flattering. Ilford XP2 Super was rated at EI 800; metering was incident light with a Variosix in front of Roger's nose.

NIKKORMAT FT2, 90MM F/2.5 VIVITAR SERIES 1 MACRO. (FES)

SOPHIE

An important point with most portraits is to get enough light into the eyes, typically by using a reflector under the face. This was achieved here with a Lastolite Tri-Flector, which is one of our favourite tools for portraiture.

LINHOF SUPER TECHNIKA IV, 180MM F/5.5 TELE ARTON, FUJI ASTIA, INCIDENT LIGHT READING AT SOPHIE'S FACE WITH A VARIOSIX F. (RWH)

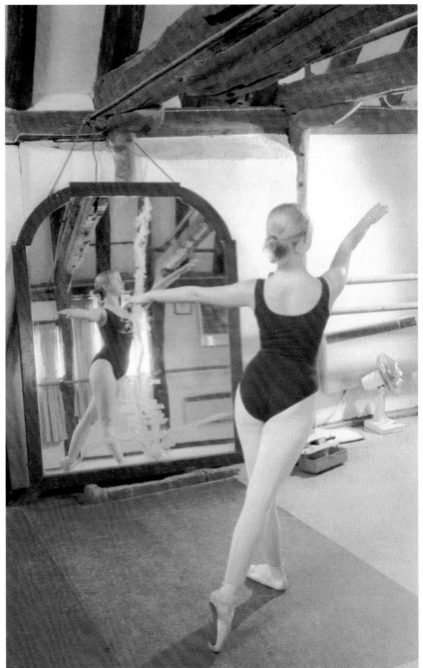

If you want to render the skin light, it is a good idea to ask the subject to wear fairly dark clothes, and to stick to colours which will not suffer if they are lightened. A conservative blue, for example, can turn positively electric if it is over-exposed, while a dark rose colour can become an extremely dull pink. The clothes should not, however, be true black, as this will either remain black and lead to excessive contrast, or will lighten to a charcoal grey. Either effect may, of course, be successful (as may the lightened colours), but it is essential to know what to expect, rather than being surprised by what you see on the film.

By the same token, if you want to render the skin dark, light clothing is usually a better bet: dark colours may block up to

EMMA AND THE MIRROR

The principal exposure constraint here was keeping acceptable skin tones in both the reflection and the dancer. The decision was to let the skin highlights go very light so that the reflection would still be on the light side of natural.

LEICA M2, 35MM F/1.4 SUMMILUX, FUJI ISO 1600 NEGATIVE MATERIAL RATED AT EI 1200, INCIDENT LIGHT READING WITH VARIOSIX F. (RWH, ART DIRECTED BY FES)

almost black, while some mid-tones can go quite nasty colours.

If you have lit the portrait properly, the background (if it is lit at all) can be lightened or darkened as necessary to give the right tone relative to the subject. If you are really serious about high-quality portraits, give serious thought to a camera which will accept a Polaroid back.

KAREN

Karen's sweater is right on the edge of under-exposure in this old photo of Roger's, which dates from the early to mid-1970s; but the contrasty style of photography, to say nothing of the attire, harks back to the influence of David Bailey in the 1960s. Each age has its own style and look.

PENTAX SV, 50MM F/1.8 SUPER TAKUMAR, OTHER DETAILS LONG FORGOTTEN.

METERING FOR MONOCHROME NEGATIVES

Once again, the incident light meter is a good starting point, but if you want to capture the textures of dark clothes, you may wish to set the film speed on the meter to as little as one-half the manufacturer's ISO speed. You can then make the same adjustments to the indicated exposure as you would for a colour shot.

Another possibility is a grey card, which you should ask your subject to point straight at the camera for the first reading, and then towards the key light for the second. Take limited-area readings in both cases – if you have a decent-sized grey card there should be no need for a spot meter – and split the difference between the two. There is no need to split them evenly: if they are (for example) ⅓₀ second at f/4 and ⅓₀ second at f/8, you may choose to give an exposure of ⅓₀ second at f/5.6½ (f/6.8) in order to get more shadow detail, or ⅓₀ second at f/4½ (f/4.8) in order to darken the subject's skin for a more dramatic portrait.

Otherwise, the best bet is probably a spot meter. Take several skin-tone readings, as they will vary quite widely according to the light falling on the skin. The brightest highlights are normally on the forehead, while the darkest tones will be on those areas which are at a steep angle to the light or to the camera. Armed with your range of spot readings (which will probably encompass a couple of stops at the most), you can decide how much lighter or darker than a mid-tone you want to represent the skin. There is, however, no real advantage in doing this instead of using a grey card – though if you take both skin-tone readings and grey card readings, it will help you to gauge the approximate tone of the subject's skin, which can be useful if their skin colour is widely different from what you are used to photographing.

Processing

Under controlled lighting, or with any normal indoor portrait except one which is lit by sunlight streaming through a window, the subject brightness range is likely to be comparatively low and it may not be a bad idea to increase development time – by anything from 20 per cent upwards – to compensate for this. Indeed, for high-key portraits it is quite usual to cut exposure time by 1 stop or more, and increase development time by 50 per cent or more. This

technique was espoused by a number of the masters of the 1930s, and the result was a luminosity and a differentiation of light skin tones which is unobtainable in any other way. It was also useful for creating a 'helmet' of black hair, which was very effective with the severe geometrical cuts of the time.

OUTDOOR PORTRAITS

Everything so far has been based on the assumption that you are shooting portraits under controlled light, or at least under

interior lighting. For outdoor portraits, the basic metering technique may either be as described above, or as described in the previous chapter for landscapes; it all depends on how much of your subject's surroundings you include, and on whether you want to emphasise the surroundings (in which there happens to be a person) or the person (who happens to be in a particular place). On an overcast day, in the right surroundings, you can even try the technique described above for high-key skin tones and dark hair.

JULIE AND HOLLY

Outdoor sun is seldom held to be promising lighting, but a relatively high-key picture of two blondes, mother and daughter, can be made to work quite well if exposure is kept to a minimum. Here, Paterson Acupan 200 was under-exposed by 1 stop, then developed normally in Paterson FX39, to get the requisite contrast and tonality.

PENTAX SV, 85MM F/1.9 SUPER TAKUMAR, INCIDENT LIGHT READING WITH VARIOSIX F. (FES)

STILL LIFE AND CLOSE-UP

Still life – or as the French rather alarmingly call it, *nature morte* – covers a multitude of different types of photography, from flowers, to food, to assemblages of man-made objects, to narratives which suggest an entire story.

What most still lifes have in common is that they are lit with some form of controlled lighting, simply because they take a while to put together. It is therefore impractical to rely on natural light, which is constantly changing. There is, however, a category of 'found' still life, which is, almost by definition, lit by available light. At one extreme, this shades into landscape photography, but there are still plenty of subjects which fall into this category and it is quite practical to

deal with them first, before considering studio shots.

Because many still lifes involve a degree of close-up photography, and because this makes metering demands of its own, close-ups are also covered later in this chapter.

FOUND STILL LIFES

The problem with any still life, found or otherwise, is that the individual components are often too small to be metered even with a spot meter, unless you have a close-up lens for it (see page 159), and they are certainly too small to be individually metered with anything else. The best approach in most cases is, therefore, an incident light reading plus an intelligent guess at the tonal range, though if a spot meter is available it can sometimes be put to good use.

In colour, the plain incident light reading is all that is needed, but in monochrome you may wish to give up to 1 stop more exposure in order to get extra detail in the shadows; or for very high-key subjects (such as patterns in wind-blown sand) you may wish to give 1 or even 2 stops less exposure,

BLUE STRING ON SAND

'Found' still lifes are often easier to spot than to photograph, but this one works reasonably well because of the colour contrasts. Exposure was ½ stop less than indicated by an incident light reading with a Sixtomat Digital, with the dome pointing straight up.

NIKKORMAT FTN, 35MM F/2.8 PC-NIKKOR, FUJI ASTIA. (FES)

and increase development by around 50 per cent, as described on page 150 for high-key portraiture.

With a spot meter, if appropriate, you can of course measure either the deepest shadow in which you want texture, or the brightest highlight, and base your exposure on either reading. In colour, if the readings are more than about 5 stops apart, you will have to decide whether to sacrifice shadow detail or highlights (normally shadows), and if they are less than 5 stops apart you will need to decide whether you want a darker transparency (basing the exposure on the shadows) or a lighter transparency (basing the exposure on the highlights). If you are shooting monochrome negative, you can adjust development in the light of the overall tonal range, in accordance with the principles discussed on page 27.

STUDIO STILL LIFES: COLOUR

For most applications, an incident light reading is perfectly satisfactory. For strongly backlit subjects, use a domed receptor and take two readings, one on the subject/camera axis and one at right angles to that axis, so that the dome is illuminated on one side. Split the difference between these two readings for a good compromise, or bias your exposure towards one or the other, in accordance with your inter-pretation of what will look best.

If you have one, a spot meter (with close-up lens if necessary) will make it much easier to manage still lifes under controlled light. Because the light is under your control, you can adjust it to cover precisely the range you wish. With the exception of specular or semi-specular highlights, you will not normally want any part of the image to be more than

CROSTINI
The anticipation is almost tangible: the warm sun, the newly arrived *crostini*, the wine about to be poured into the glass... The 'sun' is of course a tungsten light; a big soft box provides the fill. The exposure – 1 second at f/32 on Fuji Provia ISO 100 daylight film – is balanced to favour the tungsten, with the flash about 2 stops down.
LINHOF TECHNIKARDAN, 210MM F/5.6 SYMMAR CONVERTIBLE, INCIDENT LIGHT READINGS WITH LUNA-PRO F. (RWH)

ARTICHOKE
This withered artichoke, from the garden of a friend, called out to be photographed. The intention was to contrast all the textures, though it was less successful than Roger hoped; more striking lighting might have helped.
LINHOF SUPER TECHNIKA IV, 105MM F/4.5 APO LANTHAR, FUJI VELVIA RATED AT EI 40, INCIDENT LIGHT READING WITH LUNASIX.

about 2⅔ stops brighter than the mid-tone, and you can adjust the dark areas so that anywhere that you want texture is less than 2⅓ stops darker than the mid-tone. There may, of course, be areas which you want to disappear into shadow, and that is easy to arrange too.

Mixing continuous light and flash
A useful trick in many still lifes is using tungsten light to simulate sunlight and flash to simulate skylight. The colour temperature of studio tungsten lighting is very close to that of the setting sun at around 3,200K, while flash approximates daylight at 5,500K to 6,000K.

The tungsten light is normally the key light, so the best approach is to set that up first. Use a small reflector, to keep the light hard and sun-like, and position the light as far away as you can, in order to avoid excessively rapid fall-off. If the set is 1m (40in) wide, the difference between one end and the

BACKLIGHTING

Backlighting almost automatically creates a long tonal range, with the twin possibilities of specular reflections and deep shadows. The former can be controlled via polarisers, and the latter with reflectors or a fill light; but the problems are exacerbated when (as here) a contrasty film is used.

LINHOF TECHNIKA 70, 100MM F/5.6 APO-SYMMAR, VELVIA AT EI 32, INCIDENT LIGHT READING WITH COURTENAY FLASHMETER 3. (RWH)

other will be 2 stops (1:4) if the light is 1m (40in) from the edge of the set, but only about 1 stop (1:2) if the light is 2m (80in) away. If you have a focusing spot, or even if you use a slide projector as the light source, the inverse square law does not apply in quite the same way (because the beam is focused). The effect will be more convincing, and you will have more light.

Determine your tungsten exposure: 1 second at f/8, say. Then, set up your flash to act as a fill, using a soft box or a diffuser or a bounce to soften it. Turn off the tungsten light and set the flash to give whatever lighting ratio you like. Normally, about 1:4 is a realistic maximum if you want to

replicate dawn light, or 1:2 for sunset when the light is softer. With a key light at f/8, and a fill at 1:4, you need f/4 on the flash; with a fill at 1:2, you need f/5.6.

You may need a fairly powerful flash to achieve this over a large set, but if depth of field permits, you could go to ½ second at f/5.6 for your main exposure; you would then need f/2.8 (1:4) or f/4 (1:2).

These figures sound 'backwards' – surely, 1 stop less than f/5.6 is f/8 – but what you have to remember is that where the flash calls for f/5.6, you are exposing at f/8, so you are under-exposing by 1 stop.

Also, your combined flash-plus-tungsten lighting will (by definition) be more powerful than either flash or tungsten alone. If your lighting ratio is 1:2, you will need to give about ½ to ⅔ stop less exposure than with the tungsten alone, while if it is 1:4 you will need to give about ⅓ stop less exposure than with the tungsten alone. Make this adjustment on the aperture ring (which affects both flash and tungsten) and not on the shutter speed dial (which affects tungsten alone).

Subjects with a short brightness range

In theory, regardless of the reflectivities of the different parts of your subject, you can increase the lighting contrast until you have the sort of subject brightness range that you want.

In practice, such lighting will often be far too harsh. If it is, then you may end up with a very short subject brightness range – far shorter than the range which looks natural in a picture.

If the colour contrasts are sufficient, this may not matter at all: a subject can be absolutely 'flat' from a tonal viewpoint, and still be perfectly well differentiated in colour.

If the colour contrasts are insufficient, you normally have to make an aesthetic choice between a picture with no real shadows, and a picture with no real highlights. As a rule of thumb, the latter is more effective, with rich colours and true blacks; but inevitably, there are times when ethereal, desaturated colours are more effective.

Although it is possible to push both colour slide and colour negative films for more contrast, the effects are unpredictable, and the only way to find out if you get a worthwhile increase in contrast from a particular film is to try it. Another possibility is computer manipulation of the image to increase its contrast, but this is more properly discussed in Chapter 14.

STUDIO STILL LIFES: MONOCHROME

Metering monochrome still lifes is much the same as monitoring colour still lifes, except that you can capture a longer tonal range. Rather than incident light readings, it may be better to take grey card readings, or (as for colour) spot meter readings. Shadows where texture is required should be no more than 3 to 3½ stops down from the grey card reading, and highlights where texture is required should be no more than 2 to 2½ stops up; the lower limits are more suitable for 35mm, the higher limits for roll film or cut film.

Subjects with a short brightness range

The same reservations about overly contrasty lighting may apply in monochrome still lifes as in colour; and, of course, you do not have the dimension of colour to help you out.

An option which is considerably more attractive in monochrome than in colour is to develop more aggressively

MASK AND PEPPERS

This shot does not work in black and white, because the contrast range is too low and the picture components are insufficiently differentiated. Add the dimension of colour, however, and it fairly leaps out at you.

LINHOF TECHNIKARDAN, 210MM F/5.6 SYMMAR CONVERTIBLE, FUJI ASTIA, INCIDENT LIGHT READING WITH COURTENAY FLASHMETER 3. (FES)

to expand the tonal range of the image. A subject with a very modest brightness range, perhaps as little as 16:1, can be 'punched up' very effectively by increasing development time by between 50 and 100 per cent; or by increasing development temperature from 20°C (68°F) to 24°C (75°F); or by choosing a more active developer.

You can also increase tonal differentiation through filtration, remembering that a filter lightens its own colour and darkens its complementary colour. A useful way to remember colours and complementaries is via a colour 'Star of David' as shown on the right. The straight lines of the additive colour triangle (red-green, green-blue, blue-red) are broken by the points of the subtractive colour triangle (cyan, magenta, yellow); opposite points represent complementary colours.

CLOSE-UPS

Most lenses in conventional helical focusing mounts will focus to about ten times their own focal length. For example, a 50mm lens will focus to 500mm (about 20in); a 35mm lens to 350mm (about 14in); and a 135mm lens to about 1,350mm (about 4ft 5in).

This is partly because of the bulk, weight and expense of focusing mounts which allow closer focusing; partly because image quality may deteriorate if the lens is focused very close

Colour 'Star of David'

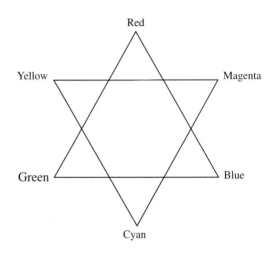

ASPARAGUS AND ARTICHOKES

Shooting big close-ups on 8x10in – this was a Gandolfi Precision with a 14in Cooke Apotal from Taylor, Taylor Hobson – requires a good deal of extension, and therefore a good deal of extra exposure. This is about half life size, necessitating an extra stop or so of exposure. As it was for contact printing, and as the film was Ilford Ortho Plus which has tremendous over-exposure latitude, Roger simply gave a couple of stops more than the Variosix incident light reading indicated.

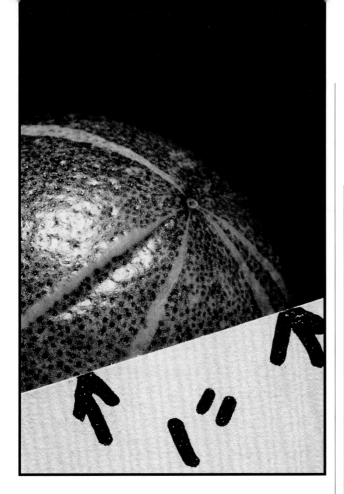

CLOSE-UP WITH INCH SCALE
To determine the extra exposure needed for extreme close-ups, a simple scale is all you need. One inch is 25.4mm; a 35mm frame is 24x36mm; and this fills about two-thirds of the short dimension of the film. Magnification is therefore about ⅔ life size, calling for about 2½x the metered exposure.

(though this should only matter with very fast lenses and a few other specialist designs); and partly because increased extension necessitates increased exposure.

At ten focal lengths, the subject is reproduced about one-eighth life size on the film (1:8). This means that you need to give about ¼ stop extra exposure. In practice, if you do not, it will not matter very much. But if you could focus to (say) one-fifth of life size (1:5), you would need to give ½ stop extra; at half life size, you would need 1 stop extra; and at life size, you would need 2 stops extra. These figures are all approximate, but they are more than accurate enough for all practical purposes.

For greater accuracy, use the chart at above right, or calculate the exposure factor for yourself: the correction factor is $(M+1)^2$, where M is the magnification. You can calculate M by eye, using a ruler in the field of view and

STRAWBERRIES
This is very dramatic, but some people find the apparently black strawberries disturbing; others love the effect. Film was Ilford 100 Delta, rated at its nominal speed and processed for 50 per cent longer than recommended in Paterson FX39 to expand the tonal range; exposure determination was by incident light reading using a Sixtomat Flash.

LINHOF TECHNIKA 70, 100MM F/5.6 APO-SYMMAR. (FES)

comparing it with the dimensions of the field of view. Thus a 10mm ruler which fills about one-quarter of the short dimension of a 35mm frame (24mm) is about 6mm long and about 0.6x life size. In practice, a 12mm ruler may prove handy – or 11mm if (as is usually the case) the viewfinder masks the full frame size and shows only a 22x34mm image.

MAGNIFICATION	EXPOSURE FACTOR
1:30 or 0.03x life size	1.07
1:20 or 0.05x life size	1.10
1:10 or 0.1x life size	1.21
1:9 or 0.11x life size	1.23
1:8 or 0.125x life size	1.27
1:7 or 0.14x life size	1.30
1:6 or 0.17x life size	1.36
1:5 or 0.2x life size	1.44
1:4 or 0.25x life size	1.56
1:3 or 0.33x life size	1.77
1:2.5 or 0.4x life size	1.96
1:2 or 0.5x life size	2.25
1:1.7 or 0.6x life size	2.56
1:1.4 or 0.7x life size	2.89
1:1.25 or 0.8x life size	3.24
1:1.11 or 0.9x life size	3.61
1:1 or life size	4

Beyond life size, the calculation $(M+1)^2$ for whole-figure magnifications is so easy you can do it in your head: 9x factor for 2x magnification, 16x factor for 3x, 25x for 4x and so forth. Intermediate factors are rather more of a problem –

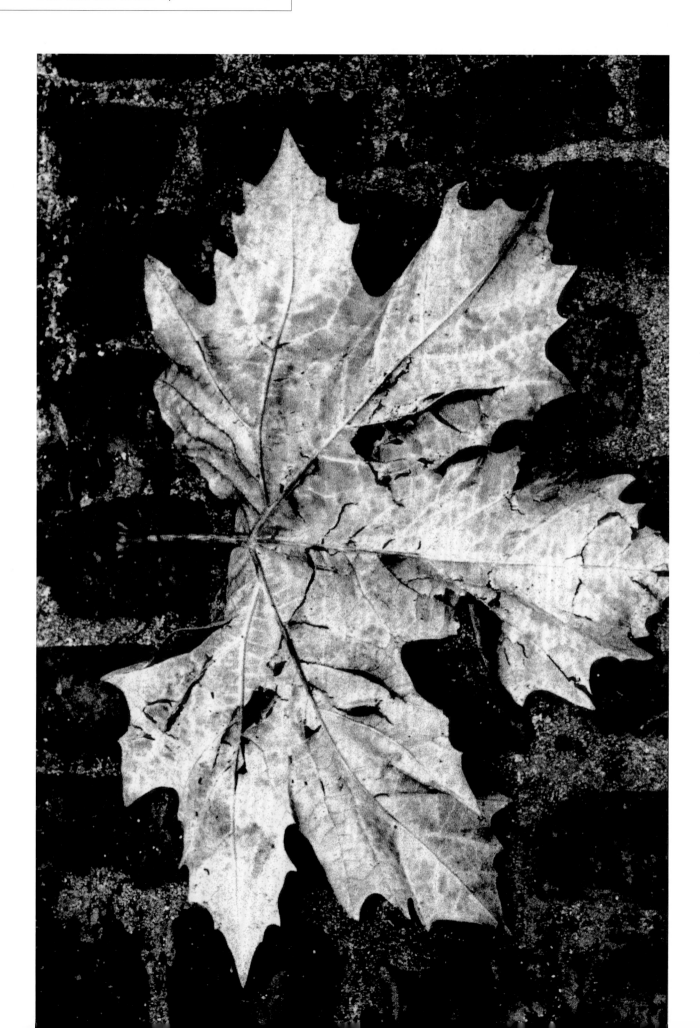

LEAF

Some dead leaves are just hard to resist... Frances shot this one with a 90mm f/2.5 Vivitar series 1 Macro on a Nikon F, using Tri-X rated at EI 320 and developed in Paterson FX39, taking an incident light reading with a Sixtomat Digital. She then printed it on grade 4 paper to make the background go very dark while retaining texture in the leaf.

2.4x life size, for example, requires 11.56x – but if you are doing this kind of photography you should regard a pocket calculator as a standard part of your equipment, and you should also know the reciprocity characteristics of the film in use (see page 188).

For actual metering, the easiest approach is to use an incident light meter, but for maximum precision (and for checking the overall brightness range) a spot meter is useful. Normally, these have no provision for focusing, and at distances less than 1m (40in) to 1.5m (60in) or so – consult the instruction book to find out which – you will need to use a close-up (dioptre) lens.

SOME LIGHTING TRICKS

Although it is more a matter of lighting than of exposure, it is worth knowing half a dozen small professional tricks. Number one is using small shaving mirrors as ancillary 'lights' to throw light onto parts of a still life. Number two is using white polystyrene ceiling tiles as 'bounces' or reflectors. Number three is using pieces of black card (or something similar) as 'flags' to shade areas of the composition, and number four is using black netting as a 'scrim' to reduce light without blocking it out entirely; support the scrim with a frame of wire or bamboo.

Number five involves black card again: cut holes in it to make a 'gobo' to provide an attractive dappled light, especially on backgrounds. Number six uses yet more black card, this time as a 'black bounce': if unwanted light is being reflected back into a composition, use a non-reflective black bounce (or a piece of black velvet) to stop it. Number seven – it's a baker's half-dozen – is (if at all possible) to avoid having the most reflective part of the subject nearest the light. In other words, if your subject contains both black and white elements, and the black is on the right, then light from the right. Otherwise, you run the risk of burning out the highlights of the light area, while losing the dark area in obscurity.

LEMONS

Frances used a Centon ring flash (from Jessops) on her 90mm f/2.5 Vivitar Series 1 Macro to light this extreme close-up, relying simply on the instructions furnished with the flash. Metering would have required calculations to allow for the extra extension, but there was no need.

NIKKORMAT FTN, ASTIA.

MONOCHROME PRINTING

In a perfect world, every negative would be perfectly exposed and perfectly developed, and would print straight onto grade 2 paper. The only reasons for doing any kind of print manipulation, such as dodging or burning, would be aesthetic.

But we do not live in a perfect world, which is why it makes sense to include a section on printing in a book on exposure. It is possible to compensate for badly developed films, and to a lesser extent for badly exposed films, at the printing stage; as we have already seen, of course, exposure and development are so intimately intertwined that they cannot really be considered separately.

Fortunately, the fact that our negatives are not always perfect does not necessarily matter very much. For contrasty negatives we have soft paper; for soft negatives we have hard paper. A negative has to be truly awful before we cannot at least get a print. The question is, how awful?

EXPOSURE AND DEVELOPMENT

If the information is not on the negative, it cannot be printed; this is self-evident. But by the wrong choice of paper, and the wrong choice of paper exposure time, information which is readily available on the negative can be thrown away. The amount of information on the negative is pretty much a function of exposure, while the way in which the information is presented is a function of development, so it makes sense to look at exposure first.

Over- and under-exposure

Within reason, an over-exposed negative is better news than one which has been under-exposed. A thin negative, with empty shadows, makes it harder to get a good print than one which is over-exposed. Admittedly over-exposure carries its own penalties, such as reduced sharpness, increased grain and (at the printing stage) longer exposure times, but at least the shadow detail is there on the negative.

Not only does an under-exposed negative have little shadow detail, though: a good deal of the detail it does have is going to be on the toe of the characteristic curve (see page 22), where quite large increases in exposure still result in quite low increases in density. A considerable subject brightness range is therefore going to be compressed into a very short range of negative densities.

On a 'perfect' negative, our 'typical' subject brightness range of 128:1, a log density range of 2.1, will correspond to a negative density range of 1.1; 'perfect' and 'typical' are in quotation marks because, as we know by now, they are distinctly disputable. On a badly under-exposed negative, that

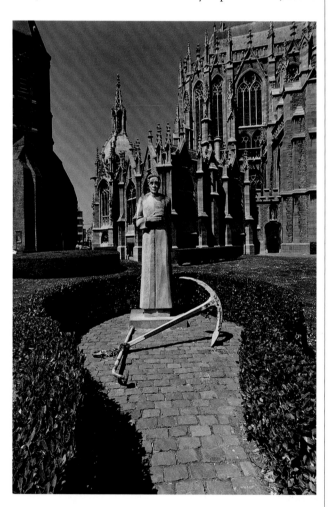

BRUGGE
Sepia toning, if lightly done, can look similar to warm-tone paper. Perhaps because we are so used to seeing Victorian pictures printed light, sepia often seems to work better when the print is lighter rather than darker.
NIKKORMAT FT2, 35MM F/2.8 PC-NIKKOR, ILFORD XP2 AT EI 250, INCIDENT LIGHT READING WITH SIXTOMAT DIGITAL. (FES)

AYIA SOFIYA, CONSTANTINOPLE
Blue toning is often used to convey mystery or moonlight – or both. Generally, a preponderance of dark tones works best, although this does not preclude bright highlights.
NIKKORMAT FT2, ILFORD SFX RATED AT EI 50 INCLUDING FILTER FACTOR FOR RED 25A FILTER, INCIDENT LIGHT READING WITH SIXTOMAT DIGITAL. (FES)

same brightness range may be represented by a negative density range of as little as 0.4. If it is much less than that, we cannot hope to get a print. Even if we do get a print, the tonality will of course be different from the tonality of a print from a 'normally' exposed negative, because it is taken from a different part of the curve with a different shape and slope.

On an over-exposed negative, there may well be no useful information on the toe of the curve, and all the usable information may be on the straight-line portion. If a compensating developer has been used (see page 31), there may even be information on the shoulder of the curve; without a compensating developer, over-exposure would need to be so gross as to render the negative too dense to enlarge, though it might still be possible to make a contact print, as discussed at the end of this chapter.

Development

If we over-develop an under-exposed negative, then the slope of the toe of the curve is increased and the subject brightness range represented by the toe is spread across a larger density range, as seen on page 30. Although true shadow detail is lost, this may not be pictorially significant. This is why 'push' films such as Kodak TMZ and Ilford Delta 3200 can be rated at EIs much higher than their ISO speeds – indeed, at ten times those ISO speeds and more.

With 'normal' development, as indicated above, the under-exposed negative will have a very short density range and will require a hard grade of paper; and if for some reason we under-develop, the density range will be even shorter and we will require a very hard grade of paper indeed.

Switching now to an over-exposed negative, if it is 'normally' developed it will print quite adequately on a middling grade of paper, though the tonality will be different from a 'normally' exposed negative because all detail will be taken from the straight-line portion of the curve, or (conceivably) from the shoulder.

If the over-exposed negative is under-developed, the slope of the curve will be lowered and a longer subject brightness range will be captured across a given range of negative densities. Instead of the 128:1 of our 'average' subject, we may capture 250:1

SOPHIE
Toning first in sepia, then in gold, can give wonderful peachy tones, but the technique generally works best with a high-key picture.
NIKON F, 90–180MM F/4.5 VIVITAR SERIES 1, ILFORD XP2 AT RATED SPEED OF ISO 400, INCIDENT LIGHT READING WITH VARIOSIX F. (FES)

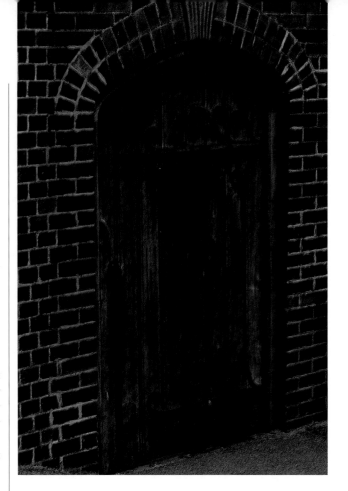

DOOR
One of the warmest conventional papers available is Bergger CB (Chaud Brillant), but even it needs to be developed in a warm-tone developer such as Agfa Neutol WA or (as here) well diluted Maco warm-tone in order to bring out the full warmth. A surprise is that it dries down warmer than it looks in the darkroom.
NIKKORMAT FT2, 90MM F/2.5 VIVITAR SERIES 1 MACRO, ILFORD XP2 SUPER RATED AT NOMINAL SPEED, CAMERA METER READING. (FES)

(log brightness range 2.4), 500:1 (log brightness range 2.7), or more. While this might seem desirable, there are two reasons why a 'normally' exposed and developed negative is generally preferable.

One reason is that many subjects have a tonal range of less than 128:1, let alone 250:1 or 500:1, and the picture will look hopelessly muddy if printed on a normal grade of paper. The other is that (once again) the tonality of a print made by printing a soft negative on hard paper will differ from the tonality of one made by printing a 'normal' negative on 'normal' paper.

Finally, an over-exposed and over-developed negative can generally be made to give a surprisingly good print on a soft paper, and a superb print on printing-out paper, as described on page 166. Yet again, the tonality will differ from a 'normal' print on 'normal' paper from a 'normal' negative, but the biggest single problem is likely to be the very long exposure times which are required to make an enlargement.

How far can you go?

What most people do not realise is that the illustrations in photographic books are often wildly exaggerated, in order to

make the differences clear. In an original print, subtle differences are far more visible than in photomechanical reproduction, but even with an original print, most people would be prepared to accept as excellent a picture printed from a negative which had been under-exposed by ½ to 1 stop; or over-exposed by 1 to 2 stops; or under-developed by 25 per cent; or over-developed by 50 per cent. They would accept it as excellent, that is, if it was printed on the correct grade of paper, rather than on grade 2, which is why, after all, different grades exist.

Intensification

A somewhat desperate remedy for under-developed negatives (though it can do little or nothing for under-exposed negatives) is intensification. Image quality suffers, tonality may be affected, and intensification of 35mm images is hardly ever worth the candle; but with large-format negs, and to a lesser extent with roll-film negs, intensification can make a difference of several paper grades. Unfortunately, the best intensifiers are all pretty lethal: uranium nitrate (which

CHILDREN, RHODES

This print on Forte RC warm-tone, developed in Agfa Neutol WA, has a slightly olive cast which some find attractive, and others dislike. Like most warm-tone pictures, it looks best when it is seen alone or in the company of similarly printed pictures, rather than being compared with other toned or coloured images.

NIKKORMAT FTN, 35MM F/2.8 PC-NIKKOR, ILFORD XP2 RATED AT EI 250, INCIDENT LIGHT READING WITH SIXTOMAT DIGITAL. (FES)

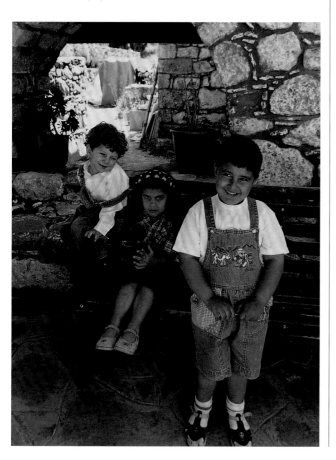

intensifies shadows more than highlights, and is therefore best for under-exposed negatives), mercuric chloride, mercuric iodide and potassium cyanide. Intensification is mentioned merely in passing for the interest of those who wish to pursue it further through older formularies, including especially *The British Journal of Photography Almanacs* prior to 1963.

PAPER GRADES

The most fundamental thing that we need to understand in paper grades is the ISO(R) range, which represents the log exposure range of the paper: in other words, the density range of a negative which is required to give a full range of tones on the paper, from white to black. A hard paper has a short ISO(R) range, so that a negative with a very limited density range will still give a good range of tones; a soft paper has a long ISO(R) range, so that a negative with a long density range will still print well without blocking up in the shadows or burning out in the highlights.

For reasons which are not entirely clear, ISO(R) numbers are represented as three-figure density ranges, normally to two significant figures, without the decimal point, so a log density range of 1.15 to 1.24 is rounded to 1.20 and represented as an ISO(R) range of 120. The ISO(R) ranges of the various grades of paper from different manufacturers are not standardised – one manufacturer's grade 2 may have a similar ISO(R) range to another manufacturer's grade 3 – but the ISO(R) ranges are generally (though not invariably) available from the manufacturers. Typical values are as follows:

Paper grade	00	0	1	2	3	4	5
ISO (R)	170	150	130	110	90	60	40

Because the numbers are rounded, even two papers with the same nominal ISO(R) range may exhibit subtle differences. This is particularly important at grade 5, when you are trying to wring the last drop of contrast out of the paper. A variable-contrast paper, filtered to grade 5, is likely to be only a whisker under ISO(R) 45 even in an ideal world – and with some enlarger heads or filter packs, it may be more like ISO(R) 50. A grade 5 graded paper, on the other hand, is likely to be even harder than ISO(R) 40, perhaps as low as ISO(R) 35.

It is not a bad idea to keep a box of grade 5 paper on hand for emergencies. Contrary to popular belief, it does not lose contrast as it ages, though the slower grades do: the rhodium which is used to create the contrast does not go anywhere, and nor does the silver, so the maximum density also remains the same. What it may require is a longer development time, because most emulsions tend to harden as they get older, which means that it takes longer for the developer to soak in. If the paper is very old – many years – or has been very badly stored, it may exhibit fog, in which case you will need to add benzotriazole or a similar anti-foggant to the developer, and the speed of the paper will drop; but within reason, grade 5 in particular lasts a very long time without deterioration.

CASKS, WOOD AND TYRE, GOA

It will probably not be evident in reproduction, but this print on Ilford Multigrade 4 RC Warm-tone (developed in Agfa Neutol WA) looks quite neutral when compared with the children on the bench on page 163, but it is distinctly warm when compared with a conventional non-warm-tone print.

LEICA M4P, 35MM F/1.4 SUMMILUX, PATERSON ACUPAN 200 RATED AT EI 125 AND DEVELOPED IN PATERSON FX39, INCIDENT LIGHT READING WITH VARIOSIX F. (RWH)

CONTRAST CONTROL VIA DEVELOPMENT

Paper contrast control via development is far less popular than it used to be, because of the widespread use of variable-contrast papers, which allow quick and easy control of contrast via filtration. If you have a variable-contrast enlarger head, you should be able to dial in a stepless contrast range from ISO(R) 50 or harder to around ISO(R) 150, though for the very hardest and very softest grades you may have to resort to filters. Even if you use discrete filters, you can select half-grades between the main grades, and this is adequate for the vast majority of pictures.

With graded paper, however, you have more of a problem if your negative is a little too hard for one grade and a little too soft for the other; and even if you use variable-contrast paper, there may be times when you want to go down to a quarter grade difference but cannot because you are using discrete filters – though of course you can obtain any contrast grade you like by split-contrast filtration, giving two exposures of different lengths through two different filters.

Unfortunately, there is less scope today for contrast control via development than there used to be, because modern papers are designed to develop to finality, or something close to it, very quickly, in most developers.

In the past, development would continue for five minutes or more in most commonly used developers, and although both contrast and maximum density continued to build throughout the development period, both were acceptable after three minutes or so. Today, only a few specialist developers (such as highly restrained warm-tone developers) take more than two or at most three minutes to develop the paper effectively to finality.

By appropriate developer formulation it is, however, possible to get about an extra half grade of paper contrast, or to wipe off about one grade, as compared with the ISO(R) figure. If the hard and soft developers are properly matched, it is even possible to sustain this sort of contrast variation without shifts in image tone. Such formulae used to be a lot more common than they are today, but one combination we have tried, and which works, is Tetenal Eukobrom (hard) and Centrobrom (soft).

You need two trays to make this approach work – actually, we use two slots in a Nova processor – and by dividing the development time between the two slots you can exercise extremely fine control over contrast. What is more, the contrast control is in the upper part of the characteristic curve, which is not influenced by pre-flashing, so this is quite a useful technique. Once you are producing reasonably consistent and well exposed negatives, you should be able to

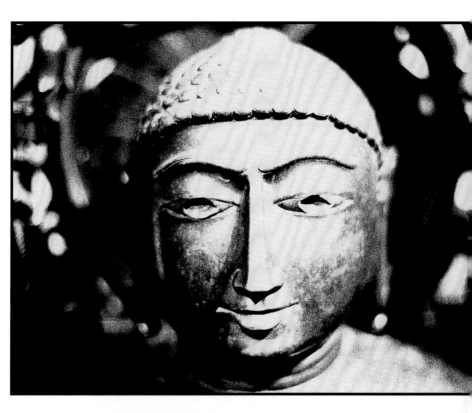

print all of them, just about perfectly, on grades 2 and 3 with a little assistance from variable-contrast developers – or grades 3 and 4 if you habitually use chromogenic films.

CONTRAST CONTROL, ENLARGERS AND LENSES

With a conventional film, contrast is influenced by the light source. Point source enlargers (almost never encountered) give the highest print contrast from a given negative contrast; then come condenser/diffuser enlargers; and then diffuser enlargers. Even among diffuser enlargers, there are variations: cold-cathode heads give the lowest contrast of all, closest in tonality to a contact print.

This is because of the Callier effect. In a condenser enlarger, the light passing through the negative is collimated, that is, it approximates to a parallel beam, while with a diffuser enlarger, it is flat, soft, and – well, it is diffuse. The more collimated the beam, the greater the effect of the scattering. Point source enlargers have the most highly collimated beams, and produce the highest contrast and sharpness, though this is something of a mixed blessing. It is quite common to print the negative from an oil immersion carrier, which conceals all scratches (the 'oil', normally a silicone, is of a similar refractive index to the film and emulsion).

As a rule of thumb, switching between a diffuser enlarger and a condenser/diffuser enlarger (the sort with an opal bulb and condensers) is equivalent to a change of one paper grade, so if a negative prints well on grade 2 in a condenser/diffuser enlarger it will require grade 3 paper in a diffuser enlarger.

Enlarger lens flare may be significant with older lenses, but with the best modern lenses it is likely to be minimal: a flare factor of 1.1 or less instead of 1.5 or more (see page 187).

Variable–contrast papers

Different enlargers, even of the same general design, may give different contrast effects with variable-contrast papers. Apart from normal manufacturing variation, and the tendency of

NUDE

This nude by Marie Muscat-King owes a good deal to the Victorians: the melodramatic expression and gesture, the ram's head (echoes of the Golden Dawn) and of course the use of draperies. The overall tone is flat and sombre, an effect accentuated by rating Paterson Acupan 800 at EI 400 and slightly under-developing in Paterson Aculux.

NIKKORMAT FTN, 35MM F/2 NIKKOR, INCIDENT LIGHT READING WITH WESTON EUROMASTER.

PAPER SPEED

It may seem odd to consider paper contrast before paper speed, but the simple truth is that within reason, paper speeds do not matter very much. As long as the paper is not hopelessly slow, or so fast that there is no time for dodging and burning at a reasonable working aperture, exposure determination is via test strips anyway. Consistent speed is far more important than absolute speed, and even consistency is not absolutely essential provided it does not vary within a single box. ISO paper speeds are not the same as ISO film speeds, but as there are few, if any, enlarging exposure meters calibrated in ISO paper speeds, this is fairly academic anyway.

some manufacturers to 'fudge' the grade spacing on variable-contrast heads to meet their customers' perceived demands, this can also be a result of different light sources. A light source which is rich in yellow – such as a tungsten lamp running at a relatively low temperature – will give very different contrast spacing, even with the same discrete filters, as one which is rich in blue. In extreme cases, such as some older cold-cathode heads, variable-contrast papers may be effectively unusable. At the very least, most cold-cathode heads require a CC50Y filter (or thereabouts) to give grade 2 contrast on variable-contrast paper.

Chromogenic films

Because the image in chromogenic films such as Ilford XP2 is made up of dye clouds instead of silver grains, there is no Callier effect and there are no differences in printing contrast between different enlargers.

PRINTING-OUT PAPER

Printing-out paper – POP – was invented in the late 1880s and was at the time of writing available from two sources, the Chicago Albumen Company in Massachusetts (for whom it was made by Kentmere in England) and Bergger in Paris, successors to the old Guilleminot company. It is called printing-out paper because the image is not developed: it simply prints out as a result of prolonged exposure to light.

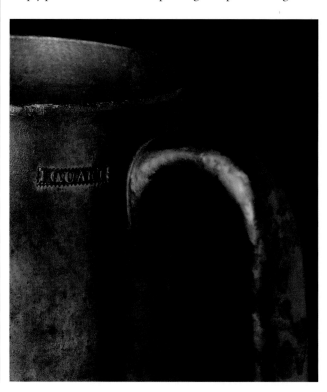

TANKARD

As with all 'alternative' processes, contact prints on printing-out paper (POP) are hard to appreciate in reproduction; but an original can capture texture in a way that is fascinating, and a wide range of colour is available through toning.

GANDOLFI VARIANT 4X5IN, 210MM F/5.6 SYMMAR CONVERTIBLE, ILFORD FP4 PLUS RATED AT EI 25 AND DEVELOPED IN PATERSON UNIVERSAL, PRINTED ON GOLD-TONED CENTENNIAL PAPER. (RWH)

SARAH AND ROB

Marie Muscat-King chose one of the least expensive films on the market, Paterson Phototec 400, for its creamy tonality, and rated it at EI 200 for extra richness. Although the film was in one sense over-exposed, she then printed the final image dark, in effect over-exposing twice. By varying EI, development regime and printing regime, an almost infinite variety of effects may be obtained.

NIKKORMAT FTN, 85MM F/1.8 NIKKOR, INCIDENT LIGHT READING WITH WESTON EUROMASTER.

one of the most forgiving processes in the world. As long as you have a negative with plenty of density, and plenty of contrast, it will give the kind of print quality which is barely obtainable with the very finest enlargements.

Negative exposure is not particularly critical, as long as it is generous: images which are several stops over-exposed, and which are so dense as to be unprintable via enlargement, can still be contact printed. There are stories in the literature of glass plates which were visually opaque, with minimum densities in excess of 3.0, and which took a couple of days to print out. You are working only with the straight-line portion of the curve, so you want a film which has a long straight-line portion and a very high maximum density.

Likewise, development is not too important, again as long as it is generous. You want a density range in excess of 2.0, which is readily obtained with some subjects but which may require very considerable over-development if the subject brightness range is limited to anything less than a bright sunny day. Many films cannot manage the kind of maximum slope which is needed to increase contrast to this extent.

ROOFTOPS AND WASHING, MERTOLA
An incident light reading with a Variosix F gave the exposure value for the white-washed highlights; spot readings with a Spot Master 2 confirmed that the tonal range in which Roger wanted to hold detail was inside a 7 stop range and could be held on normally processed Paterson Acupan 200 rated at EI 125 and developed in Paterson Aculux 2.

NIKON F, 90–180MM F/4.5 VIVITAR SERIES 1.

Self-masking
The magic of POP is that it is self-masking. As the image builds, the shadow areas obviously appear first, and as they do, the density on the surface of the POP masks the deeper areas of the emulsion, thereby slowing down the further darkening of those areas. The negative contrast is thereby strait-jacketed to the point where it suits the paper. The tonality is wonderful, and perfect prints are obtainable with the minimum of effort.

Although it is possible to make enlarged internegatives, they must of course be made from reasonably well exposed original negatives or transparencies, and they will lose that magical sharpness and tonal differentiation which is the

Printing-out paper is normally used in conjunction with a split-back printing frame of the type illustrated. The paper and the negative are sandwiched together; if the negative has not been varnished, it is a wise precaution to interpose a sheet of very thin, clear Mylar film between the two, lest silver salts from the unwashed POP emulsion contaminate the negative and cause staining. The frame is then exposed to daylight or any UV-rich source (we use a small sun lamp) and periodically the progress of the printing-out is examined by weak artificial light. When the density looks about right – which is to say, rather higher than it will be in the final print, because of losses during fixing – then the print is washed, toned, fixed and washed again.

Not only does a POP print have all the fascination of any contact print, with almost miraculously fine detail: it is also

SPLIT-BACK PRINTING FRAMES
The frame in the foreground gives a fairly clear idea of how printing frames work. With both springs undone, the back can be removed and the negative and paper inserted. With one spring locked, the back can be opened to inspect the progress of the print. The negative on the right is shown with a Mylar barrier and mask to be interposed between it and the paper to protect the negative from the free silver nitrate in POP.

FILMS AND DEVELOPMENT FOR POP

The films we normally use are Ilford FP4 Plus, which can run to a maximum slope (G-bar) of 1.2 or even 1.3, and a maximum density of 3.0, and Ilford Ortho Plus, which can go to a truly impressive G-bar of 1.8 and a maximum density of 3.5, though to get the maximum possible slope you need Ilford Phenisol or a similar highly active PQ developer with plenty of organic restrainer; other X-ray formulations should work equally well.

A G-bar of 1.2 allows a negative density range of 2.0 from a subject log brightness range of 1.7, about 50:1 or just over 6 stops, while a G-bar of 1.8 allows the same negative density range from a subject log brightness range of 1.4, about 25:1 or just under 5 stops. What is more, even at these maximum contrasts you can afford to over-expose by a couple of stops and still get excellent quality.

With more normal G-bars, such as 1.0, a negative density range of 2.1 corresponds to 7 stops and you can afford to over-expose the FP4 Plus by 3 stops and the Ortho by more than 4, and the resulting print will still put enlargements to shame. As a starting point for developing FP4 Plus, try twice the recommended time for a G-bar of 0.7; with Ortho, follow the instructions on the box.

It should, in theory, be possible to use a film such as Ilford HP5 Plus for landscapes on a sunny day, because it can achieve a maximum G-bar of 1.0 and a maximum density of 2.5 (corresponding to an 8 stop subject brightness range), but we have never tried it, because as soon as the subject brightness range falls below about 7 stops, the overall density range starts to fall below what will print well on POP. Also, exposure must be rather more precise than with the slower films, as you have at most 1 stop of latitude for over-exposure instead of 3 or 4 stops.

NEW YORK SKYLINE FROM THE ELLIS ISLAND FERRY

What makes this picture successful, at least in our opinion, is the excellent shadow differentiation which was obtained by rating Fortepan 400 at EI 200 and developing in a (slightly) speed-increasing developer, Paterson FX39.

NIKKORMAT FT2, 90MM F/2.5 VIVITAR SERIES 1, INCIDENT LIGHT READING WITH SIXTOMAT DIGITAL. (FES)

hallmark of contact prints, so POP is really limited to those who are willing to make big original negatives; but if you are, there is arguably no easier route to high quality, and no higher quality is attainable. Roger is so much in love with the process that while we were writing this book he ordered a 5x7in back for one of his Gandolfis, just to make POP prints.

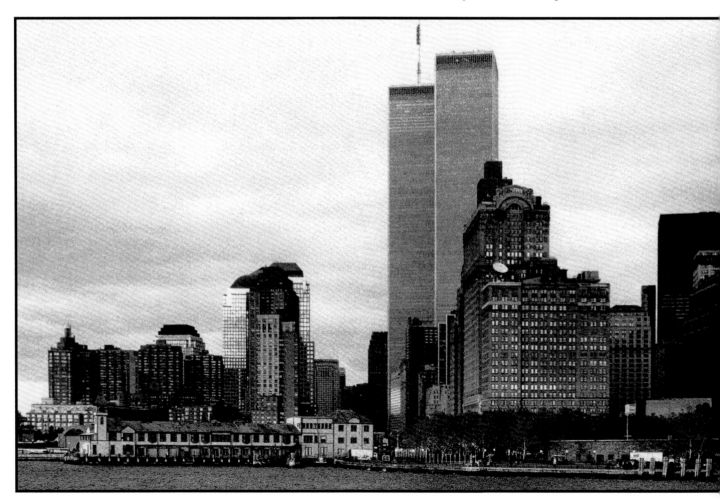

COLOUR PRINTING – AND COMPUTERS

Conventional wet-process colour printing from negatives offers considerably less scope than monochrome for easy contrast control, although it offers rather more scope for rescuing badly exposed negatives.

The former is because at most, there are likely to be only a couple of contrast grades of colour paper, and often there will be no choice at all. The only ways to exercise much control over contrast in conventional colour photography are via development, and via unsharp masking, to which we shall return shortly.

The latter is because, as noted on page 16, a colour negative can record a surprisingly large density range, but a print can only show colour across a considerably smaller density range. Quite considerable over-exposure, as much as 2 or 3 stops, will still permit excellent prints to be made, though under-exposure will quite soon result in degraded colours and poor blacks. A side benefit is that because of the nature of the chromogenic process, increased exposure means decreased grain, so you win there, too.

The penalties of over-exposure are still there: reduced sharpness, longer printing times, and longer exposure times or larger apertures (or both) at the taking stage. Even so, many people consider these to be relatively minor penalties to pay in return for enormous exposure latitude and the ability to correct colour at the printing stage. It is therefore a common

THREE BOATS, GOA

We were waiting for our Paterson Digital Lab to be delivered when Roger shot this on Fuji Reala; on a trip to India, with this book in mind, he shot almost exclusively negative film which he had previously used principally for snapshots. At the time, he used incident light readings, rating the film ⅓ to ⅔ stop slower than its ISO speed; today, he uses either the same technique or rates the film at its full speed and takes spot readings from the shadows, as for monochrome negative.

LEICA M4P, 35MM F/1.4 SUMMILUX, VARIOSIX F.

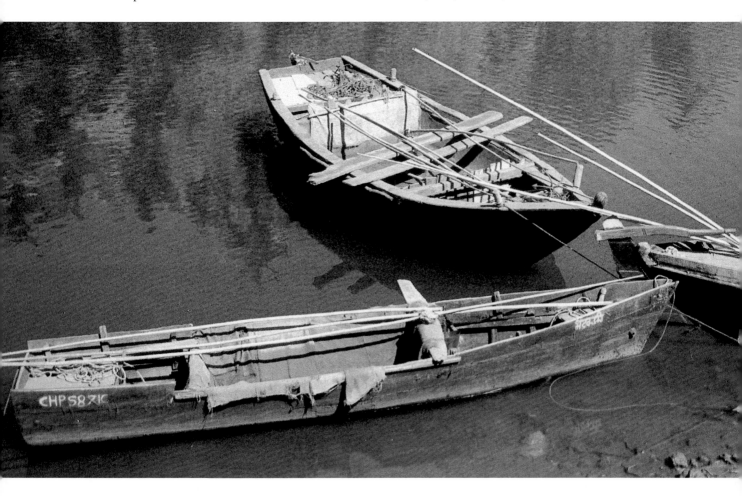

professional trick to rate colour negative films at least ⅓ stop slower than their ISO speeds, and quite possibly as much as 1 stop slower. The latter translates to exposure latitude of at least 1 stop under, and at least 1 stop over, and if you are shooting on medium format, the loss of sharpness from over-exposure is not usually very significant.

CONTRAST CONTROL VIA DEVELOPMENT

With both reversal and slide films, contrast can be influenced in much the same way as with monochrome, albeit to a lesser (and very variable) extent.

Varying the first developer time with a reversal film will affect contrast in much the same way as black and white: more development time means more contrast, and less means less. The effect on speed will be marked, but the effect on contrast will vary widely according to the film: the only possibility is experiment. Most manufacturers strive to keep contrast as constant as possible, reserving development changes as a means of controlling speed, so the scope for contrast control via development is likely to decrease, rather than increase.

Negative films have only the single developer, of course, and again, development times can be increased or decreased, and contrast and speed will increase and decrease with them. Because of the inherent latitude of negative films, the speed increases which result from increased development times can be utilised or not, though speed losses from decreased

development need to be remembered. A risk with some films is, however, 'crossed curves' as a result of varying development time, as described on page 26. Most modern films respond far better to pushing or pulling than older ones, but once again, manufacturers see this principally as a means of speed control (and they are mostly not too worried about that, except for a few specialist high-speed films), so the

LAURA'S LEGS

This is a tight crop – about one-sixth of the full image area – from a larger picture of a ballerina leaning against a barre. The tonality and texture reminded Roger of airbrush pin-up illustrations from the 1950s, so he cropped the picture accordingly. Exposure, rating Fuji 1600 negative film at EI 1250 with an incident light reading, is barely adequate; a spot reading would have led to more exposure, which would have been better.

LEICA M2, 90MM F/2 SUMMICRON, VARIOSIX F.

availability and usefulness of contrast control via development is once again likely to decline, rather than improve.

UNSHARP MASKING

The principle of unsharp masking is simple. You make a thin, unsharp negative from your camera original; sandwich it with the original; and print through the camera original and the unsharp mask together. Because the density of the unsharp mask is greatest where the camera original is thinnest, and vice versa, the overall contrast range can be compressed to whatever you need in order to fit the negative onto the contrast range of the paper. Unsharp masking can be used either with neg/pos printing or with pos/pos printing – and indeed there are those who would argue that it is extremely rare to be able to get a good pos/pos print without resorting to unsharp masking.

The basic technique is likewise simple: the original goes

ROSE
Whether you use a computer or (as here) more traditional hand-colouring media, partial colouring of a monochrome image is often more eye-catching than full natu-ralistic colouring. Generally, a light print colours most easily, and sepia toning is often effective.
NIKKORMAT FT2, 90MM F/2.5 PC-NIKKOR, PATERSON ACUPAN 200 AT FULL RATED SPEED, INCIDENT LIGHT READING WITH SIXTOMAT, HAND-COLOURED WITH SPOTPEN HAND-COLOURING PENS. (FES)

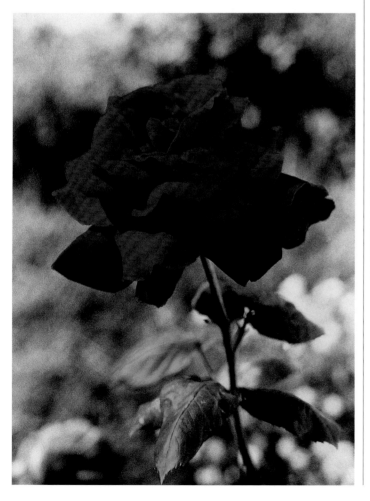

on top of a sheet of glass, and the masking film below it, so that the thickness of the glass introduces the unsharpness. The only real problem lies in keeping the contrast of the mask down while keeping the image colour of the unsharp mask neutral: developing to low contrast normally gives a brownish image which will lead (in effect) to crossed curves, because the effect of the mask depends on its differential density in the highlights and shadows.

Unfortunately, although the basics are simple, the practice is less so: cleanliness of the glass, working by touch in the dark, and making up strange developers all make it more difficult than it sounds. Those who use the technique maintain that it

BEACH, GOA

'Hand-colouring' with a computer is entirely feasible, but the effect is quite different from traditional hand-colouring.

NIKKORMAT FT2, 35MM F/2.8 PC-NIKKOR, ILFORD SFX WITH DEEP RED 25A FILTER, RATED AT EI 50 INCLUDING FILTER FACTOR, INCIDENT LIGHT READING WITH SIXTOMAT DIGITAL, 'HAND-COLOURING' BY RWH WITH PATERSON DIGITAL LAB AND ADOBE PHOTOSHOP. (FES)

is much less trouble than non-users think, but we have to admit that we have never tried it.

For those who are interested, it is covered in a number of books, and we felt that we would be remiss if we did not mention it in passing; but that is all we can do. Probably the best step-by-step description we have read is in Ctein's *Post Exposure* (Focal Press, 1997), which we commend to you.

COMPUTERS

At the time of writing, there were effectively two varieties of digital image capture. One was instantaneous, but offered low or very low resolution when compared with conventional wet-process films. The other could deliver quality comparable with silver, but involved long scanning times, which ruled out photography of moving subjects.

Although one might reasonably expect instantaneous image capture to improve, it has to be said that for the mass or

REBECCA AT THE WINDOW
Modern colour print films are so good and so saturated – this is Fuji 1600 material rated as EI 1250 – that they sometimes need to be desaturated somewhat to achieve maximum effect, as has been done here. Increasing exposure will decrease saturation in a traditional print, but computer manipulation (this is Adobe Photoshop) allows independent control of saturation and contrast.
LEICA M2, 35MM F/1.4 SUMMILUX, INCIDENT LIGHT READING WITH VARIOSIX F. (RWH, ART DIRECTED BY FES)

Film and exposure for scanning

Some films seem to scan better than others, though this may be a matter of personal preference and indeed pure luck. So far, one of the very best films we have found for scanning is that old, old favourite Ilford FP4 Plus, exposed and processed in the same way as for conventional wet printing. Among colour negative films, there seemed to be fewer clear winners or losers, and with colour slides, all seemed to work well.

A point worth making about slides for scanning, however, is that the old rules about 'reproduction density' seem no longer to hold good. Traditionally, the optimum density of slides for reproduction was normally reckoned to be about ⅓ stop greater than the optimum density of slides for projection. Today, the optimum densities are either identical, or (if anything) slightly lower for transparencies intended for reproduction.

For home users or small-scale professionals who scan their own transparencies, this ties in very well with the widespread use of scanners with only 8-bit colour depth (so-called 24-bit colour, because there are three colour channels – red, green and blue). These have some difficulty in extracting shadow detail from 'rich' transparencies. As 12-bit and even 16-bit colour depth become more usual, the ability to scan denser transparencies will return, but if there is no detectable increase in quality from using a denser transparency, the preference for photomechanical reproduction is likely to remain with thinner images.

Image manipulation

The great advantage of computers for 'straight' photography is that they allow colours to be individually or jointly manipulated: jointly to increase contrast and saturation, or individually for fine tuning or special effects. They give us, in effect, an almost infinite variety of 'paper grades', quite apart from the opportunities for retouching, creating composite images, and otherwise changing pictures around.

The great disadvantage, however, is that computers can seduce us into thinking that there is a way around the need for precision and care in the traditional aspects of the photographic process. There isn't. 'Oh, we can fix that in

TANKARD AND PEPPERS
There are no fixed rules in photography: if you can get an effect you like by breaking the rules, then break the rules. This is a Polaroid image transfer onto watercolour paper. When Edwin Land was alive, he apparently discouraged all such experiments.
LINHOF TECHNIKARDAN, 210MM F/5.6 SYMMAR CONVERTIBLE, POLACOLOR TRANSFER BY FES. (RWH)

snapshot market there was no great need for improvement: quality, although poor when viewed through the eyes of a photographer who knew what could be done, was quite adequate for many people.

It seemed likely, therefore, that silver-based image capture – traditional wet film – would survive for a very long time yet, though hybrid processing would become increasingly common. In other words, there would be silver (wet) capture; digital scanning and manipulation; and then a choice of output, whether via ink-jet or dye-sublimation or to CD-rom (or other data storage medium) or even to silver again, via a film writer or laser photographic paper printer. The last, incidentally, offered easily the best quality available at the time of writing, but the cost of silver output devices was very high indeed and this was reflected in the bureau prices charged for film output or prints.

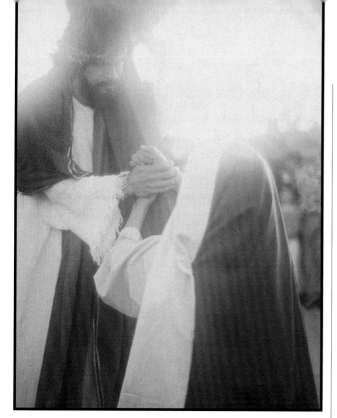

VERONICA

When Padre Julio Roman ran the parish of Our Lady of Guadalupe in Guadalupe, California, the Easter Passion Play drew audiences from scores of miles around. The version with increased saturation is somewhat overdone, but it makes the point; the optimum picture would be something between the two.

LEICA M4P, 50MM F/1.2 CANON, KODACHROME 64, INCIDENT LIGHT READING WITH LUNA-PRO F. (RWH)

Adobe Photoshop' is one of the commonest cries of designers, and of novice computer users. In practice, it is often a great deal quicker to make a little more effort at the shooting stage than it is to attempt to remedy sloppy technique in the computer: ten minutes' thought at the taking stage can save two hours' work at the computer. This is not to say that the computer does not introduce a wonderful new range of possibilities, but it is important to remember that (at best) it

PATERSON PRO 67 ENLARGER HEAD

This is one of those ideas which evokes the response, 'Why on earth didn't they do that before?' The same head has variable-contrast filtration on one side for monochrome, and colour filtration on the other side. To be sure, you can use colour filtration for monochrome, but proper VC filtration is easier and often allows a wider contrast range, especially at the contrasty end of the range. (Courtesy Paterson Group International)

is a complement to traditional photographic techniques, not a replacement for them.

Which is a pretty good place to finish; or at least, to finish the main part of the book, because there are still two appendices to come. The fascination of photography is that we never stop learning, unless we want to. Technical skill and aesthetic prowess feed off one another, in the opposite of a vicious circle: a benevolent circle, perhaps. For some people, we know that parts of this book will have seemed excessively technical, and we have to admit that you can be an excellent photographer without knowing more than a fraction of the theory behind the technique of exposure. But sometimes – just sometimes – you need a change from taking pictures, or from working in the darkroom, and you want to know why some things worked and others did not. We hope this book will have supplied some of the answers.

PATERSON DIGITAL LAB

A computer aficionado could put together a system like this for quite a bit less than Paterson charges – but the great advantage of the Paterson Digital Lab is that everything is ready installed, and everything works straight out of the box. This is an early model with the 'DigiLab' name, before Paterson realised that this had been trademarked by another company. (Courtesy Paterson Group International)

HAND-COLOURING MATERIALS

You can use almost anything for hand-colouring, including food dyes, but purpose-made materials offer better archival permanence and are easier to use. Frances uses a wide range of materials, from antique Johnson's of Hendon dyes ('Photo Tints') through several brands of modern dyes such as the Fotospeed shown here, Peerless watercolours, Marshall and Veronica Cass oils, coloured pencils and SpotPens. The jeweller's headband magnifier is invaluable for close-up work.

APPENDICES

APPENDIX I
SERIOUS TESTING

In Chapter 5 we suggested that there was little point in going any further with testing films than was described there. There are, however, those who want to take matters further. We firmly believe that doing so is, for most people, profoundly unlikely to improve their photography, for three reasons.

First, time taken in testing is time that is not spent in taking pictures, and taking pictures is far and away the best way to learn photography.

Second, few photographers work to laboratory standards. Unless they were particularly good experimentalists at school or at university, they lack the experience and mind-set necessary to do meaningful experimental testing.

Third, even if they can work to the necessary standards, there are so many other variables in exposure determination, processing and printing that their precision in one area is likely to be negated by variations in others.

Even so, we recognise that some people want to do serious testing as a matter of intellectual curiosity, which is why we have provided this appendix. There is little sense in trying to do the series of tests described below without a densitometer, as trying to compare different densities without one is very hard work indeed.

What follows is, we warn you, fairly demanding; but if you follow it through, even if you do not do the actual tests, you will have learned a great deal more about exposure and development. You will also have learned why the Zone System is a matter of opinion and expediency, rather than of eternal verity.

You need only the one test target, a good-sized grey card. Obviously, you will need to work at the same 20x the focal length of the lens in use. Testing is easiest with 35mm, simply because the film comes in long, cheap rolls, but the same technique can be modified for roll film or cut film, as detailed below. You need an 18 per cent grey card, and either a limited-area meter or an incident light meter, whichever you normally use. Through-lens metering systems, other than spot metering, may give misleading readings.

Set the film's ISO speed on the meter, and take your reading off the grey card if possible. Calculate a reading 6 stops below this; for instance, if your reading is $\frac{1}{60}$ second at f/8, it will be $\frac{1}{1000}$ second at f/16. You may find it useful to use a 4x (2 stops, ND 0.6) neutral density filter, as this will allow you to work at longer shutter speeds which are normally more accurate than shorter ones; this would allow $\frac{1}{500}$ second at f/11.

You certainly will find it useful to write the actual exposure in use on a piece of paper, in shot, as this will avoid confusion when it comes to taking the densitometer readings. If you work at 20 focal lengths or more – obviously, you cannot work at infinity – the extension factor for the lens can safely be disregarded, as it is less than $\frac{1}{10}$ stop. For the Maco test overleaf, we used an 85mm lens at 2m (80in) – 23 focal lengths.

For 35mm: Shoot a series of 25 exposures, in $\frac{1}{2}$ stop steps, from 5 stops below to 7 stops over the metered exposure. This is a brightness range of 12 stops, 4.0 log density units, 10,000:1.

For roll film: The full 25 exposure sequence will fit onto two or three rolls (four if you are shooting 6x9cm).

For cut film: This is, unfortunately, an entire box of film! You can, however, save some film by exposing a single sheet at 3½ stops down, and proceeding as described a few paragraphs below.

Setting up the target, taking the readings and making the exposures should take no more than half to three-quarters of

BROADSTAIRS

This is as long as a tonal range normally gets in a picture without deep shadows. The sky had to be burned in slightly – it was within the recording range of the film, but could not be transferred directly to the paper – but otherwise this is a straight print from 6x7cm Ilford XP2 Super rated at EI 200.

LINHOF SUPER TECHNIKA IV, 105MM F/3.5 XENAR, INCIDENT LIGHT READING WITH VARIOSIX F. (RWH)

BUILDING, BIRMINGHAM

Sometimes, the only way to approximate your original vision is in the darkroom – including the digital darkroom, as here. The negative was processed normally, scanned into a Paterson Digital Lab, and then adjusted for contrast and brightness until it matched what Roger had visualised some 25 years earlier. All technical details have been forgotten.

an hour. In all cases, develop the film in your usual way, or in accordance with the manufacturers' recommended time for a G-bar or CI of 0.62 or so (if you use a diffuser enlarger) or 0.57 or so (if you use a condenser enlarger). This should take another quarter to half an hour. Your total investment of time, so far, should be well under an hour and a half.

DENSITOMETER READINGS

If you are using 35mm or roll film, measure the density of the image of the grey card on each negative in turn. At first it will not register: it will be the same as film base plus fog. Somewhere between 4 and 5 stops below the metered exposure, you will get the first hint of density, 0.01 or thereabouts. At 1 stop more than the exposure required to give the minimum detectable density, you will probably find something in the range of D=0.03 to 0.05. Another stop again of extra exposure should see a respectable density. With the

DENSITOMETER If you are going to take sensitometry seriously, you need a densitometer. We use this Heiland **TRD-2** monochrome model, but we are considering a colour densitometer attachment for our Colorstar analyser: an analyser has, after all, much of the circuitry that is necessary for a densitometer.

film under test, we found D=0.10 at 2.5 stops below the metered exposure.

After D=0.10, the density should rise fairly steadily, in a more or less linear fashion, for quite a while: typically for 6 or 7 stops and possibly for a good deal more. Sooner or later, however, the rate of increase in density will start to level off. The graph shows the actual figures which we got from a roll of Maco 100 film developed for 7½ minutes at 20°C (68°F) in Paterson Aculux, with continuous agitation for the first 30 seconds and then for five seconds every 30 seconds; the development regime must, of course, be consistent and the developer must be fresh.

You will now have a set of negatives where the grey card varies in density from 0.00 to 1.10 or more. As you can see,

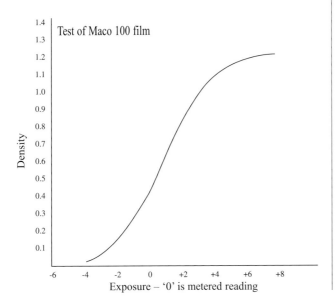

the film we tested had a distinct shoulder at a useful printing density. Once the film was dry, taking the readings and plotting the graph took less than 20 minutes.

In passing, we might add that film base density was 0.23 and fog was 0.07, so fb+f was 0.30. To separate film base density and fog density, scratch off a small area of emulsion while the film is still wet. You can then make one reading with no film in the gate; a second reading with the scratched-clean film base in the gate (to get film base density); and a third reading of film base plus fog.

INTERPRETING THE READINGS

Taking the metered speed as a starting point, everything from about 2 to 2½ stops below to about 3½ to 4 stops over was rendered pretty much linearly – about 6 stops of linear response, a subject log brightness range of 1.8.

In the shadows, there was still some density at 4 stops below (albeit only 0.01), and in the highlights, the shoulder does not tail off too sharply until it goes beyond 4½ stops. In other words, there was a measurable range across about 9 to 10 stops (subject log brightness range 2.7 to 3.0).

This subject brightness range is translated into a total negative density range of 1.19 (1.20 minus 0.01), though how much of this is 'usable' or 'printable' density will depend on the sort of enlarger you use and the grade of paper you print on. In theory, a contact print could hold the lot, but with an enlarged print you would be lucky to hold the extremes of the curve; you can safely ignore densities below about 0.03, and a total density spread of 0.05 across 3 full stops at the top end of the curve is also of limited usefulness. In other words, the useful density range is about 7½ stops – very slightly greater than 'average'.

Such a curve is not accurate enough to derive a reliable G-bar, but a log exposure range of 1.8 and a log density range of about 0.95 give a (very) crude slope value of around 0.53.

ZONES AND THE GRAPH

You can now chop your graph into 'Zones' of 1 stop each (of exposure) and see how they relate to negative density. We have done this in a separate diagram (right), just to avoid cluttering the original graph. The genius of the Zone system is that it divides the D/log E curve into recognisable, manageable chunks – but as soon as you work with real D/log E curves, you can see just how much of an approximation the Zone System is. Precise placement of Zones is a matter of opinion, not of unalterable fact.

The original Zone System used nine print Zones, symmetrical about Zone V, a mid-tone by definition. As films improved and coated lenses became more usual (thereby reducing flare), it was stretched first to ten Zones (with additional shadow detail, thereby destroying the symmetry) and then to eleven Zones, restoring the symmetry but – on Adams's own admission – leading to a situation in which Zones IX and X could not always be differentiated by all photographers.

The full eleven-Zone sequence is as follows:

Zone 0	The maximum black of which the paper is capable.
Zone I	The darkest tone distinguishable from Zone 0.
Zone II	The darkest tone with detectable texture.
Zone III	Very dark tones with detail.
Zone IV	Dark mid-tones.
Zone V	The mid-tone: an 18 per cent grey.
Zone VI	Light mid-tones.
Zone VII	Very light tones with detail.
Zone VIII	The lightest tone with detectable texture.
Zone IX	The lightest tone distinguishable from Zone X.
Zone X	Pure, paper-base white.

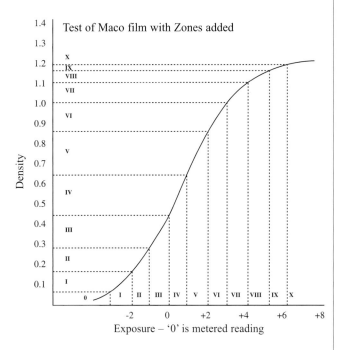

sensitometry and exposure theory. The Zone System is, in a sense, a special case of sensitometry, and its highly specialised vocabulary is of less use than broader theory.

SHEET FILM TESTING

Returning to sheet film, if you have a single sheet exposed at 3½ stops down, the chances are that the density will be in the range of 0.01 to 0.10. If it is around 0.01, expose and develop a second sheet with 2 stops more; if it is at or around 0.05, expose and develop a second sheet with ½ or even ⅓ stop more. This should give you a negative with a density of close to 0.10.

Now expose another sheet with 7 stops more than the one which shows D=0.10. It should give you around D=1.1. If it does, you are in the right ball-park already: both exposure and development are pretty much where you want them.

If the density was less than 1.1, shoot another sheet at the same exposure, and develop it for longer; if it was more than 1.1, cut development time. For developing times up to eight minutes, try increments of half a minute, or for longer developing times, try increments of a whole minute. Increments of a quarter of a minute are either meaningless,

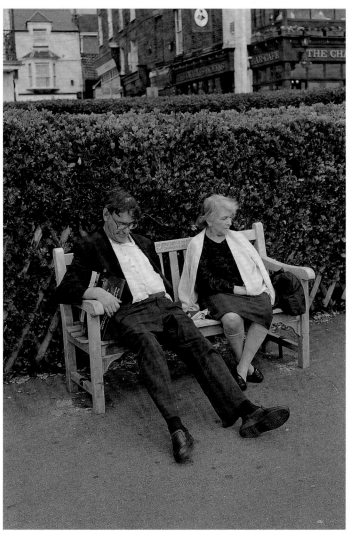

It is almost impossible to hold Zones IX and X apart if you are shooting on 35mm. They are difficult to separate with roll-film enlargements, fairly readily separable with cut-film enlargements using cold-cathode or other very diffuse sources, and surprisingly easily separable with contact prints.

The relationship between print Zones and negative Zones is easy to see, and we have already touched upon the Zone System on pages 77 to 77. The Zone System is without doubt important, but we make no apology for not treating it more fully. There are already plenty of books on the Zone System, and it is in any case our belief that while the naming of the Zones themselves is a work of genius, much of the rest of the Zone System actually stands in the way of understanding

SUNDAY AFTERNOON, BROADSTAIRS
In order to hold texture in the bright white shirt, a film with slightly lower contrast than usual proved useful. This was the then-new Ilford XP2 Super, which is about half a paper grade contrastier than the old XP2, but which still held the requisite exposure range without going too flat when printed on grade 1½ paper.
LINHOF SUPER TECHNIKA IV, 105MM F/3.5 XENAR, FILM RATED AT EI 200, INCIDENT LIGHT READING WITH VARIOSIX F. (RWH)

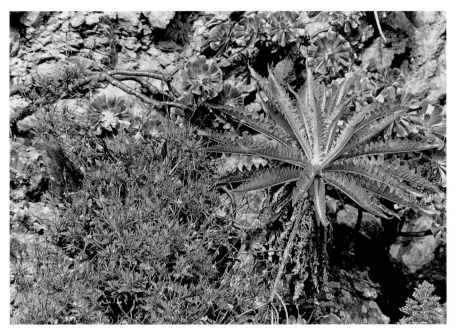

your chemistry and so forth. Running through the whole loop – exposure, processing, measuring neg densities, printing, measuring print densities – involves maybe two hours' work. Quite honestly, though, we wouldn't bother to re-do the tests on the above film: we'd just give it an extra half minute, which we are confident would give 7 stops across the required density.

If you do decide to repeat the test, then with 35mm or roll film you might as well repeat the whole test with all the exposures. With cut film, you need only repeat the test with two sheets, exposed 7 stops apart, until you get the results you want. Then is the time to expose a whole box of 25 sheets, if you want to.

XEROPHYTES

If someone gives you a roll of unfamiliar film, always bracket your exposures, even in monochrome: as often as not, 1 stop over will be more pleasing than the rated ISO speed. Modify exposure for subsequent rolls on the basis of experience. This is Orwo 100, which surprised and delighted us with its tonality at its rated speed, using the through-lens meter of a Nikkormat FTn.

VIVITAR SERIES 1 135MM F/2.3. (FES)

or indicate that your developing time is too short: at less than four or five minutes overall, consistency is very hard to achieve.

TEST PRINTS (ALL FORMATS)

The next thing to do, regardless of format, is to make two test prints, one from the negative with a density of 1.1 or so and one from the negative with the density of 0.10 or so. The first should be exposed to give you a print density of 0.05 or so. Now print the second at the identical exposure. It should give you a print density which is about 0.10 below the maximum density of which the paper is capable. Use your favourite paper, though of course you don't need a whole sheet. This is maybe a quarter of an hour's work in the darkroom, though you will have to wait for the prints to dry (or use a hair dryer).

In the case of Multigrade IV RC, the dark print would have a density of about 2.05, and the density difference between the two prints would be about 2.0. If the density of the dark print is equal to a maximum black (2.15 to 2.2), then you need to develop your film less aggressively, and if it is much less than 0.10 below a maximum black, you need to develop more aggressively.

Suggested changes to the development regime are the same as those suggested a few paragraphs back. When your '7 stop' negative pair prints as described, measure their densities. You now have the density range which prints perfectly on your preferred paper, using your enlarger, your enlarger lens,

DENSITY, DEVELOPMENT TIME AND EI

Regardless of format, it would be surprising if you had run more than two or three sets of tests in the first cycle, and by then you would know a very great deal.

First and foremost, you would know what density range you needed on the negative in order to print on a given paper, and as long as you stuck with that paper, you would never need to make another sensitometric test print: the densitometer would tell you all you needed to know, straight from the negative, so you could test any film/developer combination in an hour or two.

Second, you would have established a standard development time – this time is what Zone System users call 'N' development, for 'Normal'.

Third, you would have established a personal EI, though this is a question fraught with difficulty.

Our criterion is that from the metered point, we should have 4 stops of differentiated shadow tones (in Zone terms, Zones IV, III, II and I) and 3 stops of differentiated highlight tones (Zones VI, VII and VIII). From the graph shown on page 181, this would mean that we should rate this ISO 100 film, developed as described, at about EI 32 to EI 40. At 3 stops under ISO 100, we have (just) usable shadow detail at D=0.04. If we gave it twice as much exposure, thereby rating it at EI 50, this would be 4 stops down from our metered exposure; dropping it to EI 36 or so, we would have perfectly good shadow detail (D=0.10) at 4 stops below our metered exposure.

SKYSCRAPER, NEW YORK

This style of photography was extremely popular in the 1930s: Margaret Bourke-White and Alexandr Rodchenko were leading exponents. Fortepan 100, cadged as a sample from Charlie Satter of Satter Omega, turned out to be the perfect material to recreate the style of the time.

LEICA M2, 35MM F/1.4 SUMMILUX, INCIDENT LIGHT READING WITH SIXTOMAT DIGITAL, FILM RATED AT EI 80. (FES)

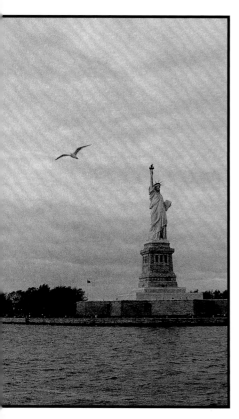

STATUE OF LIBERTY
Fast films and dull days seldom make a good combination. The composition and sharpness are unexceptional, but the overall effect is just muddy. A harder grade of paper merely blocks up detail without giving more contrast where it is needed, in the mid-tones.
NIKKORMAT FTN, VIVITAR SERIES 1 90MM F/2.5, KODAK TRI-X – WHICH ROGER SHOULD HAVE DEVELOPED MORE AGGRESSIVELY, THROUGH-LENS METER. (FES)

In practice, EI 40 would probably be fine. Rating it at this speed with this development regime would mean that we had around D=0.07 at 4 stops down and D=1.11 at 3 stops up. Look at the Zone-annotated graph on page 181, and you will see that going to EI40 will increase the differentiation in Zone IX at the expense of Zone 0.

Once you know the shape of the curve, you can confidently meter shadow areas which are 3 stops down from the mid-point, give 3 stops less exposure than the meter indicates, and know that you will have slight but useful shadow detail in those areas. You can also meter highlights which are 2 stops up, and be confident of highlight detail there, too. If your total metered range is greater than 7 stops, you know roughly where detail on the negative will start to disappear at either end, and you can increase or decrease development to compensate for this.

DEVELOPING FOR INCREASED CONTRAST

As we have seen, increasing development time increases contrast, and decreasing development time decreases it. With the densitometer, you can quickly and accurately discover just how much difference they make, without ever making test prints. Begin by making a duplicate set of test exposures of your grey card – except that you can now start just before the first step you know will give a measurable density, and you can stop just after the range you want to capture.

With the Maco film that we used for our tests, for example, you would start with an exposure just 4½ stops down from an ISO 100 metered exposure, and you would then make 16 exposures, ending up with one which was 3 stops above the metered exposure (in fact, if you were shooting 645, you could stop at 2½ stops over, to save film). Develop these tests for 30 per cent longer than your 'standard' or 'normal' time, take your densitometer readings, and plot another graph.

You would be looking for a density range of 1.1 corresponding to an exposure range of 1.8. If you didn't get it, you could fine-tune your development time until you did – and you might also find that the effective film speed had increased slightly. If your log exposure range were within 0.1 of 1.8, though, you might decide to skip a re-test, and simply adjust your development time by half a minute to a minute one way or the other. This would almost certainly be more than accurate enough: there is no sense in endless testing for its own sake. What you end up with, either way, is your 'N+1' development. This captures a subject brightness range of 64:1, log range 1.8, in your useful negative density range.

The second test would again run from 4½ stops under, but it would stop at 2 stops over – just 14 exposures. Again, you could get perfectly usable results on a single 12-exposure roll by going from 4 stops under to 1½ stops over. A good starting point for development would be 60 per cent more than 'normal'. Your graph should show a density range of 1.1 across a log exposure range of 1.5. In Zone terms, this is N+2, holding a subject brightness range of 32:1 or log range 1.5.

The third test could use just 12 exposures, from 4½ stops under to 1 stop over (again, on 6x7cm you would get usable results by going from 4 stops under to ½ stop over). Develop this for twice the 'normal' time, and look for a density range of 1.1 across a log exposure range of 1.2. Note that some fast films will have difficulty in reaching this kind of contrast without fog. This would be 'N+3' development in Zone terms, holding a subject brightness range of 16:1 or log range 1.2.

DEVELOPING FOR REDUCED CONTRAST

Going in the opposite direction is more problematic, and even 'N-1' is likely to give you negatives which are flat and dull, while 'N-2' and 'N-3' negatives are likely to be unprintably soft. The drill is, however, obvious. You make yet another set of exposures, beginning at 4 stops down from the ISO 100 metered grey card and going up to 7 stops above. Develop for 20 per cent less than 'normal', and look for a density range of 1.1 across a log exposure range of 2.4.

TIME/GAMMA CURVES

Most manufacturers publish time/gamma curves, which will enable you to make a good guess as to the necessary changes to development time for different slopes. They may also publish time/gamma/speed charts, which will also give you a good idea of whether you will need to change the effective film speed as well.

Of course, these figures are good only for the developer specified, but often you can work by analogy. For example, where figures are given for Perceptol (Ilford), D-76 (Kodak) and Microphen (Ilford), you can treat Perceptol as being broadly typical of all fine-grain developers (such as Kodak Microdol or Paterson Acufine), D-76 as being fairly typical of all 'standard' developers, and Microphen as being more or less typical of all speed-increasing developers. There are considerable theoretical objections to this, but it will give you a reasonable starting point.

PRINTING

All of the above assumes that you want to represent your subject brightness range – whatever it may be – on a single, middling grade of printing paper. But two things mitigate this necessity.

The first is that it is not always a good idea to expand or contract the tonal range of a scene to make it fit onto the maximum range that the paper can handle, or at least, that it is not a good idea to carry it to excess. A foggy day should, after all, look foggy; and a bright, sunny, contrasty day should by the same token look bright and sunny and contrasty. Minor modifications of development will not normally look too unnatural, but major modifications may.

The second is that paper is available in a wide range of contrast grades, so it should be more than possible to get prints which most people would regard as excellent from negatives which are a little too contrasty or a little too flat, merely by printing them on a different grade; and it is also the case that often, a little more contrast, or a little less, will give you a print that you like more. If that be so, do not be afraid to use hard or soft paper – and remember that if you adopt the simple, iterative, empirical method of testing which is advocated on page 60, even 'imperfect' negatives will normally be readily printable on either hard or soft paper.

It is, however, indisputably true that the 'ideal' negative and the 'normal' grade will generally give the best compromise on highlight and shadow detail, and the further you go from these goals, the more your prints are likely to depart from perfection.

CONTACT PRINTING STEP WEDGES

A step wedge is simply a piece of film which has been fogged to a series of set densities, typically 0.1 log density units (⅓ stop) apart.

If you place a step wedge in contact with an unexposed film, and make a contact print, you can test development times (though not film speed) by developing the contact print. If you 'lose' steps at either end, you are over-developing, while you can calculate the gamma by plotting the density of the exposed and developed film against that of the step wedge. The main problem lies in getting a good, even, short exposure

THISTLES

Thistles are a hard, spiky sort of subject, but they do not exhibit much visual contrast. Printing on grade 4 or harder seems to echo their spikiness; the highlights are burned out, but does it matter?

NIKKORMAT FTN, VIVITAR SERIES 1 90MM F/2.5, ORWOPAN 100, EXPOSURE AS INDICATED BY CAMERA METER. (FES)

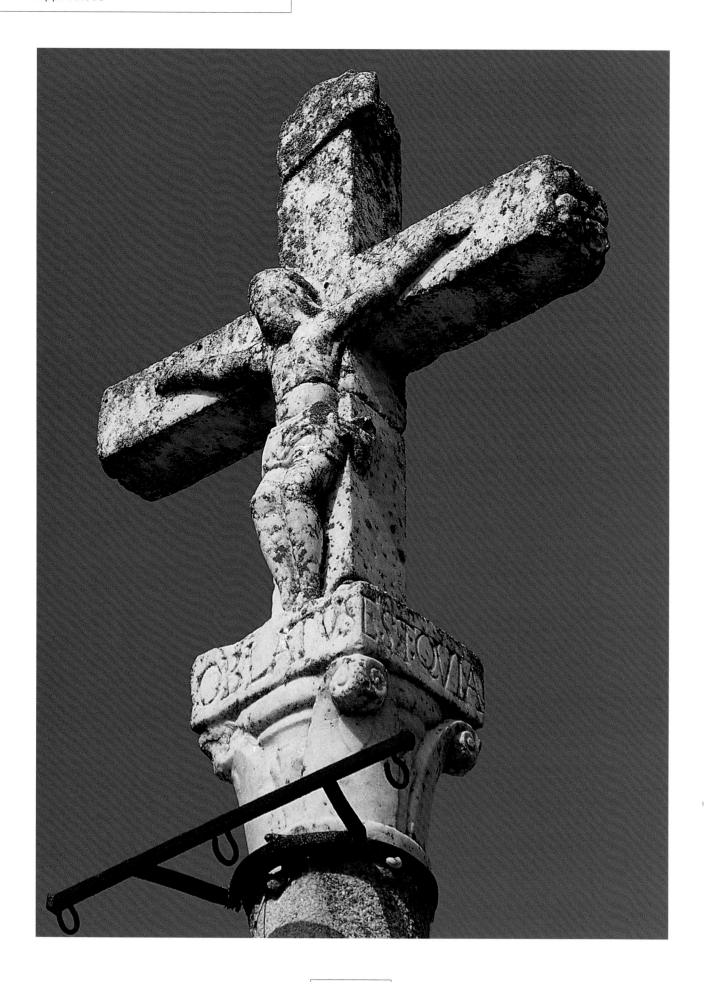

BLUE SKY AND CRUCIFIX

A blue sky is an excellent mid-tone. The meter reading here was from the sky, with a Variosix F, but 1½ stops less exposure were given in order to hold detail in the crucifix; the sky is therefore a little muddy.

NIKON F, 35-85MM F/2.8 VIVITAR SERIES 1, KODAK EKTACHROME 200. (RWH)

to more or less daylight-coloured light. The easiest approach is probably to crank the enlarger head up well, and print through an 80B filter; the yellow of tungsten light may be misleading.

Although the general rule (the Bunsen-Roscoe Law) is that exposure is equal to the intensity of the light multiplied by the duration of the exposure ($E=IT$), for precise sensitometric purposes there can be significant differences between exposures which are varied by altering the intensity of the light, and those which are varied by altering the duration of the exposure. This is why step wedges are more useful than test strips which are obtained by varying exposure.

APPENDIX II
RULES OF THUMB

The rules of thumb given below vary somewhat in reliability, but all will normally result in improved exposures as compared with a straight meter reading.

Backlighting Give 2 stops more than the reading indicated by a broad-area reflected light meter. See page 121.

Bracketing In colour, bracket ⅔ or 1 stop either side of the metered reading on location, and ½ or ⅔ stop in the studio under controlled lighting. In monochrome, there is little point in less than a 1 stop bracket. If you know you have a tendency to over-expose, make your under-exposure bracket first; if you have a tendency to under-expose, make your over-exposure bracket first. See page 68.

Chromogenic films Ilford XP2 normally requires paper which is slightly harder than a conventional film, conventionally processed.

Contrast adjustment For low-contrast subjects, increase development times of monochrome films by 30 to 50 per cent; for high-contrast subjects, decrease development times by around 15 per cent. See page 66.

Dark fur Give 1 to 2 stops more than the reading indicated by an incident-light meter. See page 118.

Enlarger lens flare The film density ranges corresponding to the ISO(R) ranges on page 163 are for contact prints or perfectly flare-free enlarger lenses. Otherwise, you will need to allow for lens flare; a good rule of thumb is that a negative density range of 1.3 will be reduced to around 1.1 (Grade 2) with a good, average lens.

Highlight readings If you take a limited-area reading of the brightest highlight area in which you want texture, you should give approximately 2⅔ stops more exposure than the meter indicates if you are using colour slide films, and approximately 2½ stops more if you are using monochrome negative films. See page 124.

SUNSET

To meter a sunset, point the meter (without an incident light dome) straight at the sky, but to one side so that the sun does not over-influence the reading.

LEICA M4P, 35MM F/1.4 SUMMILUX, FUJI PROVIA, GOSSEN LUNA PRO F. (RWH)

UNDERGROUND RESERVOIR, CONSTANTINOPLE

Sometimes you have to add a bit of guesswork into your exposure calculations. Even with a spot meter (a Minolta Spotmeter F) there was not a big enough area of a single tone to meter, so Roger took an incident light reading from a similar light at an equivalent distance.

LEICA M2, 35MM F/1.4 SUMMILUX, FUJI RSP RATED AT EI 2500 AND PROCESSED AS FOR 3200.

Mid-tones Deep blue sky and green grass are both useful mid-tones for limited-area or spot readings.

Monochrome film speeds For a starting point in determining working film speeds, as compared with the manufacturer's ISO rating, give up to ⅓ stop extra exposure for 35mm, up to ⅔ stop extra exposure for 120, and up to 1 stop extra exposure for large format.

Moonlight The light of the full moon is about one-millionth of full sunlight; exposures can be calculated using the 'sunny 16 rule' (see below), and increasing them a million times. Also, because the moon is illuminated by full sun, the exposure for the moon itself is always determinable by the Sunny 16 rule. Remember that long exposures will result in apparent movement of the moon, as a result of the rotation of the earth; it will start to look like a white sausage.

WILDFLOWERS AND CITY WALL, MERTOLA

Many amateurs would be satisfied with any of these exposures, which are ⅔ stop apart, but the metered exposure (left) and the lighter exposure (centre) are the most successful. Still wider brackets will often mean losing the 'perfect' exposure.

NIKKORMAT FT2, 35MM F/2.8 PC-NIKKOR, FUJI SENSIA 2 RA ISO 100, INCIDENT LIGHT READING WITH VARIOSIX F. (RWH)

Reciprocity failure Most films are designed to be exposed across the range ⅒ second to ⅟₁₀₀₀ second. Outside this range, some (not all) may require extra exposure; see manufacturers' data sheets for precise details. Maximum increases are likely to be as follows: at 1 second and ⅟₁₀,₀₀₀ second, give ½ stop to 1 stop more exposure; at 10 seconds give 1 to 2 stops more; at 100 seconds, give 2 or 3 stops more. Colour films may also require corrective filtration.

Shadow readings If you take a limited-area reading of the darkest shadow area in which you want texture, you should give approximately 2⅓ stops less exposure than the meter indicates if you are using colour slide films, and approximately 3 stops less if you are using monochrome negative films. See page 125.

Skin tones The palm of the human hand, regardless of race, is normally 1 to 1½ stops lighter than a mid-tone. See page 125.

GRAN CANARIA

If you base your exposure on a limited-area highlight reading, give 2⅔ stop more exposure in colour or up to 4 stops more exposure in mono – though even in mono, 3½ stops is safer, representing the practical limit with 35mm.

NIKKORMAT FT2, 35MM F/2.8 PC-NIKKOR, ILFORD XP2, LUNASIX. (FES)

Sunny 16 rule In full sun, with the sun behind you, the correct exposure is 1/ISO (arithmetic) at f/16. Thus ISO 125 film demands ⅟₁₂₅ second at f/16, while ISO 1000 film demands ⅟₁₀₀₀ second at f/16. If you need to round off exposures, give extra exposure for negatives and less exposure for transparencies: IS0 400 should work well at ⅟₂₅₀ second for negatives, ⅟₅₀₀ second for transparencies. See page 37. For side-lit subjects, give up to 1 stop more; for back-lit subjects, up to 2 stops more.

Sunsets Meter and expose as for stained glass (see above), taking care not to include the sun itself in the area metered. See page 115.

Ultra low light Take an incident light reading with the bare meter cell, and give 5x the indicated exposure. See page 129.

Snow To retain texture in snow, give 1 to 2 stops less exposure than is indicated by an incident light meter, and 3 stops more than is indicated by a limited-area reflected light reading. See page 134.

White fabric To retain detail on white fabric, give 1 stop less than the reading indicated by an incident light meter. See page 117.

Stained glass Take a straight, broad-area reading from the window, as if it were reflected light (actually, of course, it is transmitted light). Use this as your base exposure. Under-exposing by up to 1 stop will intensify colours without blocking up the darkest glass. See page 115.

LIGHTHOUSE, RHODES
A pure deep blue sky is an excellent mid-tone, but as soon as there are even wispy clouds like this, you run the risk of under-exposing if you do not modify the reading.
NIKKORMAT FT2, 90MM F/2.5 VIVITAR SERIES 1, ILFORD SFX RATED AT EI 50 INCLUDING FILTER FACTOR FOR DEEP RED 25A FILTER, ½ STOP EXTRA EXPOSURE COMPARED WITH BLUE SKY READING USING SIXTOMAT DIGITAL. (FES)

INDEX

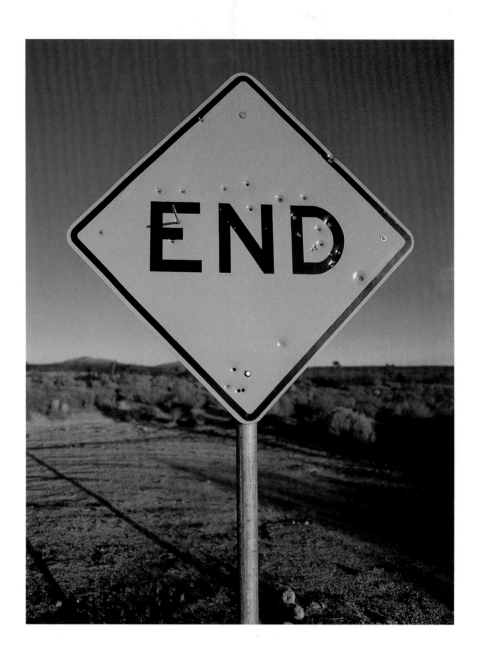

END

Let's be honest: we've been looking for an excuse to use this as the last picture in a book since we shot it in 1983, under-exposing Ektachrome 64 to 'pop' the colours. Exposure technique is not an end in itself: it is one aspect of a multi-dimensional process which also encompasses subject, composition, sharpness and a lot more. Ultimately, the only way to improve is to practise, and if we have done nothing else, we hope that we have encouraged you to take more pictures, on the grounds that you can take better pictures than we can. We would be the last to argue; but we hope that this book (and the others we have written) will help you to judge which of your pictures are more successful, and why.

MAMIYA RB67, 90MM F/3.8 MAMIYA-SEKOR, WESTON MASTER V. (RWH)